Writing
About the
Humanities

Third Edition

Robert DiYanni

New York University

PEARSON

Prentice
Hall

Upper Saddle River, New Jersey 07458

Library of Congress Cataloging-in-Publication Data
DiYanni, Robert.
 Writing about the humanities / Robert DiYanni. — 3rd. ed.
 p. cm.
 Includes bibliographical references and index.
 ISBN-13: 978-0-13-615141-8
 ISBN-10: 0-13-615141-8
 1. English language—Rhetoric. 2. Humanities—Research—Methodology—
Problems, exercises, etc. 3. Criticism—Authorship—Problems,
exercises, etc. 4. Academic writing. I. Title.
 PE1408.D593 2007
 808';.042—dc22

 2007044655

Editor-in-Chief: Sarah Touborg
Senior Editor: Amber Mackey
Assistant Editor/Project Manager:
 Alexandra C. Huggins
Editorial Assistant: Christina De Cesare
Director of Marketing: Brandy Dawson
Marketing Assistant: Irene Fraga
Executive Marketing Manager:
 Marissa Feliberty
Senior Managing Editor: Mary Rottino

Production Liaison: Jean Lapidus
Composition/Full-Service Project Management:
 Laserwords/Pine Tree Composition
Project Manager: Jessica Balch
Image Permission Coordinator: Craig Jones
Color Scanning: Cory Skidds
Senior Operations Supervisor: Brian Mackey
Cover Design: Bruce Kenselaar
Printer/Binder: Courier Stoughton
Cover Printer: Courier Stoughton

Credits and acknowledgments borrowed from other sources and reproduced, with permission, in this textbook appear on page 193.

Pearson Education, LTD.
Pearson Education Singapore, Pte. Ltd.
Pearson Education, Canada, Ltd.
Pearson Education–Japan
Pearson Education Australia PTY, Limited

Pearson Education North Asia Ltd.
Pearson Educación de Mexico, S.A. de C.V.
Pearson Education Malaysia, Pte. Ltd.
Pearson Education, Upper Saddle River,
 New Jersey

V036 10 9 8 7 6 5 4

ISBN-13: 978-0-13-615141-8
ISBN-10: 0-13-615141-8

CONTENTS

6

Writing About Drama and Theater 105

7

Writing About Film 127

8

9

PREFACE

Like its predecessors, this third edition of *Writing About the Humanities* is designed for students in introductory humanities courses, but it can be used by students in introductory history, literature, and art history courses as well. The book's opening chapters provide overviews of and consider approaches to the writing process in general, and to writing about the humanities in particular. The two concluding chapters deal with writing based on research. In between, five chapters explore and explain how to write about particular disciplines, including art and architecture, music and dance, fiction and poetry, drama and theater, and film.

The third edition of *Writing About the Humanities* expands on the second edition and offers new material on art and architecture, music, and film. A new appendix provides information on making oral presentations, adding a necessary component to a text designed to improve communication skills. Also, a new section titled Critical Thinking has been added to each of the discipline-specific chapters, encouraging students to contemplate deeper issues. In response to market requests for additional writing samples, two student papers—one on sculpture and one on architecture—have also been incorporated into the text. Moreover, there are now many more exercises and writing assignments, a suite of guidelines for analysis and writing for each discipline, and a selection of new images.

Among the book's distinctive and practical features are the following:

- Multiple approaches to artworks, including responding, interpreting, and evaluating
- Interpretive analysis involving observing, connecting, inferring, and concluding

- Guidelines for writing, including prewriting, drafting, revising, and editing
- Numerous exercises and writing assignments
- Sample student papers in the different disciplines
- Samples of professional writing in the various disciplines
- Written texts and visual images for analysis and writing
- Research writing guidance, including using Internet sources
- Critical Thinking exercises and questions

For assistance with *Writing About the Humanities*, I would like to thank the reviewers, who provided valuable suggestions, many of which I have utilized in this revision. My thanks to Michael W. Smith, Bluefield State College; Robert Mitchell, Florida Community College at Jacksonville; Elizabeth Bresnan, De Anza College; and David A. Hatch, Brigham Young University.

Thanks also to Bud Therien at Prentice Hall for sponsoring the book and to Alexandra Huggins and Sarah Touborg, who have lent it their support and expertise. A word of thanks also to those who have contributed papers, including my NYU students, Emily Sheeler and Paul Jorgensen, for their papers on architecture and sculpture, and my children, Karen and Michael DiYanni, for their papers on music and painting, respectively. And, finally, once more an appreciation to my wife, Mary DiYanni, for her patience, devotion, and steadfast love.

Robert DiYanni

An Overview of the Writing Process

Although we use the phrase "the writing process," there is no one single writing process that every writer uses all the time. Instead, there are many different writing processes—as many as there are people who write. Different writers follow a writing process in their own individual ways. Some writers produce many drafts; others, only a few. Some writers compose at the computer keyboard; others write first with pen on paper. Some writers write only in the morning; others, at night. Some writers require absolute silence; others need background music or conversation. You may prefer to write in your room or in the library, at a small desk or on a large table, with a laptop computer, or on a desktop in the computer lab. Regardless of individual writing behaviors, writers confront common elements when they write.

All writers need to identify their topic and develop an idea about it. All writers need to create an organization that suits the evidence they use to develop and support their ideas. And all writers need to find a way to begin and end their writing, preferably in an engaging or memorable way. In working toward achieving these goals, writers typically follow an overall three-stage process consisting of prewriting, drafting, and revising. Two additional steps follow these stages: editing and proofreading.

PREWRITING

Prewriting refers to your preliminary efforts to do formal writing—the writing of essays and papers, reports and research projects. Prewriting strategies include making lists, jotting annotations, posing questions, and freewriting. We use the following sonnet by William Shakespeare (no. 73) to illustrate these prewriting strategies:

That time of year thou may'st in me behold
When yellow leaves, or none, or few, do hang
Upon those boughs which shake against the cold,
Bare ruined choirs where late the sweet birds sang.
In me thou see'st the twilight of such day
As after sunset fadeth in the west,
Which by-and-by black night doth take away,
Death's second self that seals up all in rest.
In me thou see'st the glowing of such fire
That on the ashes of his youth doth lie,
As the deathbed whereon it must expire,
Consumed with that which it was nourished by.
This thou perceiv'st, which makes thy love more strong,
To love that well which thou must leave ere long.

Making Lists

One of the simplest ways to prepare yourself to write is to list items that relate to the topic you will write about. If you are preparing to write an analysis of Shakespeare's sonnet "That time of year, thou may'st in me behold," you might list the details you observe during your readings of the poem. Your list might look something like this:

that time	me
yellow leaves	black night
no leaves	glowing fire
few leaves	ashes
cold	deathbed
bare boughs	rained choirs
twilight	sunset
love	youth

Such a list can help you isolate particular kinds of details or images that the poem includes. You might notice, for example, that the poem includes images of time, of death, of cold and warmth. You might then divide your list of details and images into groups of similar kinds. Here is a list of details similar to the first one, but this time the images are grouped with others related to them.

yellow leaves	twilight	cold	sunset
few leaves	sunset	ashes	glowing

no leaves *night* *deathbed* *nourished*
bare boughs *consumed*

This simple grouping of listed details helps you make connections better than the preliminary random list of observations. But this list, too, represents merely a place to begin thinking about your topic. As you think further about your subject, you should try to narrow your focus, to consider how details from your list might be used as evidence to support an interpretation of the poem.

Annotating

As an alternative to making a list, you might simply annotate Shakespeare's sonnet, making notes about your observations in the margins. When you annotate a text, you make brief notes about it, both in the margins and in the space above and below it—wherever you have room to write. You can also annotate within the text of the work by underlining and circling words and phrases, or bracketing words, phrases, lines, or stanzas.

Like making a list, writing annotations about a work offers a convenient and relatively painless way to begin writing about it. Annotating can get you started zeroing in on what you find interesting, engaging, or important about a work. You can also identify details you find confusing or puzzling. And your annotations can serve as starting points for thinking when it comes time to write a formal paper or report.

Here is an example of annotation applied to Shakespeare's sonnet:

That time of year thou may'st in me behold

That time of year thou may'st in me behold
autumn When yellow leaves, or none, or few, do hang
Upon those boughs which shake against the cold, *tree limbs/choir stalls?*
Bare ruined choirs where late the sweet birds sang. |1
twilight In me thou see'st the twilight of such day
& As after sunset fadeth in the west, ——→ *fading sun = ? end of day —life*
sunset Which by-and-by black night doth take away,
& Death's second self that seals up all in rest. |2 *sleep = death*
night In me thou see'st the glowing of such fire
That on the ashes of his youth doth lie,
As the deathbed whereon it must expire, —— *die [out] fire & life*
used→ Consumed with that which it was nourished by. |3
up This thou perceiv'st, which makes thy love more strong,
To love that well which thou must leave ere long.

Asking Questions

Another preliminary writing strategy is to ask yourself questions about your topic. Asking questions prompts thinking, because questions beg to be answered. Questions provoke thought; their very openness of form invites response. In the process of thinking about your subject, narrowing your focus, and considering evidence and examples you could use to support your ideas, you can ask yourself questions about the details and images you have listed and the connections you have been making among them. You can also ask yourself questions about your annotations, some of which may themselves be questions.

Questions can complicate your thinking, and thus move you beyond simply presenting information and offering easy explanations of facts. Here are a few questions you could ask yourself regarding Shakespeare's sonnet:

- What season is the poet/speaker describing?
- With what time of day is that season associated?
- Why does he say "in me" you can see that season?
- Why are the "choirs" "bare" and "ruined"?
- What is death's "second self"?
- What is described as fading?
- Who is dying?
- Who is speaking, who is spoken to, and what is their relationship?

EXERCISE

Choose a work of art. Annotate it, list your observations about it, and ask yourself some questions about it.

Focused Freewriting

Like the other techniques of prewriting described so far—listing, annotating, and questioning—focused freewriting is a form of preliminary writing for yourself, rather than a type of writing you do for others. Like those other kinds of prewriting, focused freewriting can help you generate ideas and get started thinking and writing about a work of art without your having to worry yet about how to organize your ideas or how to provide evidence to support them.

Focused freewriting is writing that is unstructured and unplanned, although it is centered on a single topic. When you freewrite around a central topic, such as the images in a poem, you jot down the first thoughts that come into your head, without worrying about where your thinking might lead you. One of the goals of freewriting, in

fact, is to find out where this form of relaxed thinking and writing takes you.

When you freewrite, you do not worry about organization or grammar or punctuation. You try to write quickly—partly to free up your unconscious and partly to make the task of writing easier. Writing freely in this way breaks down inhibitions and releases intellectual energy that enables you to get some thoughts on paper or screen, thoughts you can later develop and analyze in more formal kinds of writing.

Freewriting is useful for many kinds of writing assignments. It is often a good way to begin simply because it is writing that you do for yourself, rather than writing that you will show to an audience—a teacher or classmates, for example. In this respect, freewriting frees you of the responsibility to be correct, to be profound, even to be interesting—except to yourself.

You can use freewriting in conjunction with other prewriting techniques, such as making lists and asking questions. One way to do this is to select one of the more interesting (to you) items on your list or from your annotations and begin freewriting about it. Another is to take a couple of your more provocative questions and begin answering them in freewriting.

Here is an example of freewriting about Shakespeare's sonnet:

Freewriting Sample

That time of year—what time—autumn when leaves fall. Speaker compares himself to season. Poem turns on idea of seasons of life. Then shift to day/night.

Does night or twilight Fall? Day Life; Night Death. Fire is Life; Ashes death. Puzzling line about fire consumed what it's nourished by.

Poem set up as sonnet—14 lines; rhymes; 4-line sections rhyming conclusion—couplet.

Meaning of conclusion?? We love things we are soon to lose. We love them more because we have them only a little while longer??

Lots of images—details about day and night—fire and burning and going out—birds and leaves and trees. Figure out section by section how images work to convey ideas.

In this example the writer jots down thoughts as they come. Ideas are hinted at rather than developed. Overall, the freewriting lacks focus but includes some promising leads for the writer to explore. When you use freewriting as a preliminary strategy, be sure that you do it more than once. Use your initial freewriting to see where your mind takes you with the topic. Use later freewriting to focus on one or another aspect, issue, or question raised in your earlier freewriting.

EXERCISES

1. Do some focused freewriting on a work you expect to write about or have been assigned to write about. Start your freewriting by considering an item from one of your lists, annotations, or questions.
2. What did you discover from your freewriting? To what extent did you think of things while you were writing that you didn't realize you were going to write? To what extent did you write things that you didn't know you knew? To what extent did you find yourself getting into a rhythm, coming up with ideas, examples, and perspectives to express about the topic?

Summarizing and Analyzing

As a step toward more formal academic writing or preparing a paper or report on a humanities topic, you may need to summarize the gist or central idea of a written text or work. A summary provides an interpretation or explanation in your own words of a work's themes or a writer's central idea in a work. A succinct account of a work, a summary condenses or compresses its thought.

Writing a summary requires careful reading, in part to assure that you understand the work you are summarizing. Writing a summary helps you analyze because it requires that you consider carefully a work's details and structure. Writing a summary requires essentially two kinds of skills: identifying the central idea of the work you are summarizing and recognizing the evidence that supports that idea. In writing a summary, you build on the observations, connections, and inferences you make while reading a literary, philosophical, or historical text; observing a work of painting, sculpture, or architecture; or listening to a work of music.

A summary differs from an analysis in that analysis presents the evidence for the writer's ideas whereas a summary, most often, simply expresses the central idea of the work of art without providing the evidence. Frequently, summary and analysis are woven together in academic writing about the humanities. Consider the following example, a brief summary and analysis of the imagery in Shakespeare's sonnet:

Sample Summary and Analysis

Perhaps the first thing to mention about the metaphorical language of the sonnet is that its central images appeal to three senses: sight, hearing, and touch. The images of the first four lines include appeals to each of these senses: we *see* the yellow leaves and bare branches; we *feel* the cold that shakes the boughs; we *hear* (in imagination) the singing birds of summer.

These images collectively become metaphors, ways of talking about one thing in terms of something else. Autumn, for example, is "that time of year" when leaves turn yellow and tree branches become bare of leaves. Shakespeare compares the barren branches to an empty choir loft because the chorus of singing birds has departed with the coming of colder weather. And because Shakespeare's speaker says that "you" (we) can behold autumn *in him*, we realize that he is talking about aging in terms of the seasons.

In lines 5-8 the metaphor of autumnal aging gives way to another: that of twilight ending the day. These lines describe the setting of the sun and the coming on of night. The emphasis here is on "black" night taking away the light of the sun; the sun's setting is seen as a dying of its light. The implied comparison of night with death is directly stated in line 8, where night is described as "death's second self." Like death, night "seals up all in rest." But while night's rest is temporary, the rest of death is final.

These metaphors of autumn and evening emphasize the way death comes on gradually. Autumn precedes winter and twilight precedes night just as illness precedes death. The poem's speaker knows that he is in the autumn of his life, the twilight of his time. This metaphor is continued in a third image in lines 9-12 of the sonnet: the dying of the fire, which in its dying out of light and heat symbolizes the dying out of the speaker's life. In addition, the speaker's youth is compared with

```
"ashes," which serve as the "deathbed" on which he
will "expire."
```

Literally, these lines say that the fire will
expire as it burns up the fuel that feeds it. In
doing so, the fire glows with light and heat. The
glowing fire then becomes a metaphor for the
speaker's life, which is still "glowing," but
which is beginning to die out as it consumes it-
self. Like the dying fire, the speaker's youth has
turned to ashes. Also like the dying fire, the
speaker's life is "consumed with that which it was
nourished by." Literally, the fire consumes itself
by burning up the logs that fuel it. The fire,
like the speaker's life, in its very glowing burns
towards its own extinction.

WRITING

Once you have done some prewriting you are ready to write a draft, or
first attempt, at your essay, paper, or report. When you draft a piece of
writing, you do so fully aware that you will have an opportunity to revise,
to make changes later. This is important so that you do not worry about
trying to achieve perfection with your first draft. First drafts tend to be
rough drafts, even though you may have employed one or more prewrit-
ing strategies to help you get started writing. Writing a first full draft,
however rough, enables you to acquire an overview of what you want
to say, what you want to include in your writing. Even though your
sense of what will be included may change when you revise, it is help-
ful to try to generate in your first draft an overview of the writing as you
envision it from beginning to end.

The Purpose of Drafting

The purpose of this draft is simply to write down your ideas and to
see how they can be developed and supported. Think of the rough draft
as an opportunity to discover what you think about the subject and to
test and refine your ideas. Don't worry about having a clearly defined
thesis or main idea in mind before beginning your draft. Instead, use
your first draft to discover an idea, to clarify your thinking.

In drafting your paper, consider your purpose. Are you writing to
provide information and make observations about a work, a philosoph-
ical idea, an historical event? Are you writing to argue for a particular way
to interpret it? Ultimately, all explanations are interpretations, and all

interpretations are forms of argument; that is, interpretive explanations are persuasive attempts to convince others to see things the way you do. In developing your draft of an interpretive explanation, you will be arguing for the validity of your way of seeing, not necessarily to the exclusion of all other ways, but to demonstrate that your understanding of the work, idea, or event is reasonable and valuable.

Your draft provides an occasion for you to identify your central idea or thesis and to provide evidence in its support. Your evidence may take the form of examples, facts, statistics, quotations from authoritative sources, personal stories, and other forms of information. Try to be as specific as possible in both identifying your central idea and in providing particulars to make it clear and interesting to your readers.

Moreover, since your readers will respond as much to how you support your arguments as to your ideas themselves, you will need to concentrate on providing evidence that your thinking is careful and thorough. Most often this evidence will take the form of observations you make about the work, idea, or event. Additional evidence may come from secondary sources, from the comments of experienced observers, whose interpretations may influence and support your own thinking.

In marshalling evidence for your ideas from your observations about the work itself and from the views of others, keep the following guidelines in mind:

- Be fair minded. Try to avoid oversimplifying or distorting either the work or what others have written about it.
- Be cautious. Qualify your claims. Limit your discussion to what you can confidently demonstrate.
- Be logical. See that the various elements of your argument fit together and that one part of your discussion does not contradict another part.
- Be accurate. Present facts, details, and quotations correctly.
- Be confident. Believe in your ideas and present them with conviction.

One last point about drafting—try to write your first draft quickly. If you get stuck in the midst of your draft, leave some blank space and skip ahead to a part that you find easier to write. You can return to the spaces while completing your first draft, or you can fill them in when you revise.

Organizing Your Draft

Another important aspect of your draft is organization. You need not worry about this too much at first, but you should have some sense of

what to begin with, how to conclude, and how to shape the evidence you include in the middle sections of your essay, paper, or report. You will be able to make adjustments in your organization when you revise. But it is important to have an overall sense of how your writing is unfolding even in the first draft.

As you organize your writing, try to envision it as a three-part structure with a beginning, middle, and ending. The beginning introduces your central idea or your thesis. The middle presents evidence and develops your idea. The ending provides a perspective on your idea and reminds readers of your supporting evidence.

The beginning or introduction leads your readers into your writing. The ending leads them out of it. These parts are relatively short in comparison to the middle, which includes the explanations, examples, and evidence to support your ideas. It is this larger and more complex middle part that you need to think about from the standpoint of organization.

If your writing requires (or if you decide to provide) historical background for your topic, for example, you will need to decide whether to put that background all in one place or to spread it throughout your essay, paper, or report. Should you present your most important and interesting examples and evidence first or last? If you have three or four aspects of your subject to discuss, should you begin with the easiest or least complex first, or might you want to put that aspect in the middle or at the end, just before your conclusion? If you begin with one rather than another aspect of your subject, will that make it easier or more difficult for you to move to the others?

Among the more common strategies for organizing writing are the order of importance (climactic order) and the order of time sequence (chronological order). In climactic order, you present your least important or complex ideas, examples, and evidence first and your most important or complex ideas, examples, and evidence last. In chronological order, you present events and ideas in the sequence in which they developed or the order in which they actually occurred.

REVISING

Once you have written a full first draft, however rough, you are ready to revise. Ideally, you should leave some time between your first draft and your revision. Get away from your draft awhile—at least overnight, if possible, preferably even longer.

Revision is not something that occurs only once at the end of the writing process. Redrafting your essay, paper, or report to consider the

ordering of paragraphs and the use of examples is one significant approach to revision. Other aspects of revision involve conceptual, organizational, and stylistic issues.

Conceptual revision involves reconsidering your central idea or thesis. As you write a first or even a second draft, your understanding of your topic and what you want to say about it may change. You might decide that your original idea is too simple, too vague, or simply unconvincing. You may end up discarding that idea and substituting something else in its place. In working through your first draft, you might actually change your mind about your idea and reverse the direction of your thinking.

Organizational or structural revision involves asking yourself whether the arrangement that you used in your first draft best presents your present line of thought. Is your organizational framework clear? Does it make sense? Does your introduction clarify your topic and state your idea? Do your supporting details provide evidence in a way that is both sensible to you and should be clear and persuasive to your readers? Does your conclusion follow logically from the unfolding of your idea in the middle?

You can use the following questions as guidelines for revising:

Revision Guidelines

- To what extent are you satisfied with your idea, with your thesis as it is currently formulated? How might you change it to make it more accurate, more complex, and more interesting?
- Are you satisfied with your organization? To what extent can you identify the overall organizational plan of your essay? Where does its beginning end? Where does the ending begin? And how is the middle set up, arranged, organized?
- To what extent are your sentences concise and clear? Can you eliminate words without altering your meaning?
- To what extent have you maintained a consistent tone? If your tone shifts at one point or another, was this by design, or was it an accident?
- How can you determine whether your level of language—your word choice, sentence structure, idiom, and tone—is appropriate for your topic and your audience?

EDITING

When you edit your completed revised draft, you should look for errors in grammar, spelling, usage, mechanics, and punctuation. Your guide to these matters should be a current college handbook, most

likely one that has been assigned or required for one of your English courses. You may also use the spellchecker on your computer. Be careful, though, with spellcheckers because they do not tell you when you've used the wrong word—*there* instead of *their*, for instance.

Editing Guidelines

- How can you check for grammatical errors: inconsistencies in verb tenses and problems with subject–verb agreement, pronoun–antecedent agreement, sentence fragments, comma splices, and the like?
- To what extent do you need to check on tricky verbs such as *lie* and *lay*, on questions of usage concerning *who* and *whom*, on aspects of mechanics such as the use of capitalization and italics?
- Why might it be necessary for you to check for errors in spelling or punctuation? How should you go about this checking?

PROOFREADING

As a final step, proofread your writing. When you proofread, you should look to see that you have made the kinds of corrections necessary during the editing stage. If you notice that you need to correct a spelling error or that you need to add a punctuation mark, you can do so in black ink. (You need not print out an entire copy again because of a few minor mistakes.) You can even add missing words, such as *a* or *the*, for example.

You can use the following guidelines to help you proofread carefully:

Proofreading Guidelines

- Read the final draft aloud to hear mistakes.
- Read your final edited draft one line at a time, focusing on individual words and sentences, rather than on your ideas and examples.
- Read some paragraphs backward, last sentence first.
- Look for omitted words in sentences and omitted letters in words.
- If you discover too many mistakes requiring correction, retype individual pages—or the entire paper—as necessary.

Finally, make a copy for your instructor and an extra copy for yourself, in case your work is mislaid. An extra hard copy may also be needed if your computer hard drive malfunctions or if the file on your floppy disk is accidentally erased.

CONSIDERING PURPOSE AND AUDIENCE

Much of what you say, and especially the way you choose to say it, depends on your purpose or aim in writing, and on an understanding of your audience. If, for example, your purpose is to summarize the artistic achievements of the ancient Greeks, you will write an explanatory paper that provides many examples of their numerous artistic, literary, and theatrical achievements. If you are writing to analyze the development of a particular style of Hellenistic architecture or sculpture, you would provide more analysis and less information, and your analytical approach would be deep rather than wide. If, however, you were writing to evaluate the influence of ancient Greek political achievements or to challenge a common view of their importance or influence, you would develop a more argumentative piece of writing, one heavier on providing evidence for the claims you would make.

Similar considerations will affect your writing for differing audiences. For example, the extent to which your audience shares a common basis of information or expertise should govern the extent to which you use technical language in an essay, paper, or report. The type of audience you are writing for will affect the amount of detail you include, the kinds of examples you use to illustrate and explain your ideas, and the amount of background or contextual information you decide to provide. In writing for students in your introductory humanities class, with a variety of different majors, interests, and backgrounds, you could not write about a technical aspect of a subject—poetic meter, for example—in the same way you could for students in an advanced poetry course. The more advanced students of poetry would be presumed to possess the technical understanding of poetic meter that others could not be expected to have. As a result, you would make different decisions about language and context in writing about the same subject for those two different audiences.

As a writer, you should always consider what your audience needs to know to understand your ideas. Thinking about your audience's needs will increase the chances of them finding your writing to be interesting, as well as ensuring that they understand and appreciate your ideas. You

can use the following questions as guidelines to help you remember to consider your audience when you write:

Audience Guidelines

- Who are my readers? Are they "experts" in the subject I am writing about? Or are they "generalist" nonexpert readers?
- What assumptions can I make about my audience?
- What response can I reasonably expect from my audience? Why?
- To what extent is my topic or idea something my audience may disagree with? What can I do to win the audience over?
- What is the most appropriate tone to use when writing for this audience?

CONSIDERING TONE

You don't write the same way for all readers in all situations. You adjust your tone—your attitude toward the subject as expressed by the style you use and the decisions you make as writer. You establish the tone of your writing according to your purpose or reasons for writing and the audience for whom you are writing.

Academic writing—the writing you do for your college courses—will often require a formal tone, like the tone established by environmental historian William Cronon in the passage quoted on pages 16–17. This is so because your instructors consider the essays, papers, reports, and research projects you produce to be serious intellectual efforts. You will attempt to demonstrate in your writing that you can use the language of the discipline—of literature or art history, for example—to analyze and explain, to inform and persuade your readers about an idea you have concerning an interesting issue or an important topic.

The tone of academic writing will almost always require you to be reasonable and objective, serious and thoughtful. These qualities are typically valued in such writing. Your purpose in academic writing is less to entertain than to explain and analyze, thereby demonstrating your command of ideas.

Just because academic writing avoids casual forms of expression does not mean that it must be dull or uninteresting. Despite its formality, academic writing can accommodate wit and humor as well as personal experience, engaging stories, and surprising details. Your tone in all the writing you do for your college courses will depend in part on

your subject, and in part on your purpose in writing, as well as on your sense of what is appropriate for your audience—typically, your instructor and your classmates.

What follows are excerpts that illustrate variations in tone achieved with differences in word choice, sentence structure, idiom, and organization. Following each excerpt is a brief commentary that identifies the writer's tone and explains how it is achieved.

Here is a descriptive passage from an essay by Jane Brox about the influenza epidemic of 1918:

> In ordinary times, the bankers, lawyers, and mill owners who lived on Tower Hill opened their doors to a quiet broken only by the jostle of a laden milk wagon, the first stirrings of a wind in the elms, or the quavering notes of a sparrow. It was the height of country; the air, sweet and clear. Looking east from their porches they could survey miles of red-brick textile mills that banked the canals and the sluggish Merrimack, as well as the broad central plain mazed with tenements. To their west was a patchwork of small dairy holdings giving over to the blue distance. But for the thirty-one mornings of October 1918 those men adjusted gauze masks over their mouths and noses as they set out for work in the cold-tinged dawn, and they kept their eyes to the ground so as not to see what they couldn't help but hear: the clatter of motorcars and horse-drawn wagons over the paving stones, as day and night without ceasing the ambulances ran up the hill bringing sufferers from the heart of the city and the hearses carried them away.
>
> It had started as a seemingly common thing—what the linestorm season always brings, born on its wind and on our breath, something that would run its course in the comfort of camphor and bed rest. At first there had been no more than six or eight or ten cases a day reported in the city, and such news hardly took up a side column in the papers, which were full of soldiers' obituaries and reports of a weakening Germany. As September wore on, however, the death notices of victims of the flu began to outnumber the casualties of war. Finally it laid low so many the Lawrence Board of Health set aside its usual work of granting permits to keep roosters, charting the milk supply, and inspecting tenements. The flu took up all its talk—how it was to be treated, how contained, how to stay ahead of the dead. The sufferers needed fresh air and isolation, and their care had to be consolidated to make the most of the scarce nurses and orderlies. So the board took a page from other stricken cities and voted to construct a makeshift tent hospital on their highest, most open land that offered the best air, which was the leeward side of Tower Hill where a farm still spread across the slope.

Comment

The style of this passage is notable for its long complex sentences laden with precisely evoked images. With a profusion of specific details, the writer recreates the time and place she describes: Lawrence, Massachusetts, in October 1918. Some of her longer sentences break in the middle, punctuated with semicolon or colon. Others make use of interrupting dashes that set up what comes after them. Throughout the passage, Brox sets her description of the action in a larger context—the context of "ordinary times" and the context of the first world war, with deaths from the flu outnumbering deaths from the war. The details in the first and last sentences of the passage convey a sense of quiet beauty that is violated by the deathly reality of the disease, which is recorded by the writer with controlled objectivity.

Brox writes as an essayist who uses detailed description in the service of local history. Her aim is to recreate the feeling of a particular place and time during the influenza epidemic of 1918, in much the same way historians like Barbara Tuchman in *A Distant Mirror* have recreated what it was like to live during the time when the Black Death (bubonic plague) raged during the European Middle Ages.

Here is a second example, this one from William Cronon on the idea of wilderness:

> The time has come to rethink wilderness.
>
> This will seem a heretical claim to many environmentalists, since the idea of wilderness has for decades been a fundamental tenet—indeed, a passion—of the environmental movement, especially in the United States. For many Americans wilderness stands as the last remaining place where civilization, that all too human disease, has not fully infected the earth. It is an island in the polluted sea of urban-industrial modernity, the one place we can turn for escape from our own too-muchness. Seen in this way, wilderness presents itself as the best antidote to our human selves, a refuge we must somehow recover if we hope to save the planet. As Henry David Thoreau once famously declared, "In Wildness is the preservation of the World."
>
> But is it? The more one knows of its peculiar history, the more one realizes that wilderness is not quite what it seems. Far from being the one place on earth that stands apart from humanity, it is quite profoundly a human creation—indeed, the creation of very particular human cultures at very particular moments in human history. It is not a pristine sanctuary where the last remnant of an untouched, endangered, but still transcendent nature can for at least a little while longer be encountered without the contaminating taint of civilization. Instead, it is a product of that civilization, and could hardly be contaminated by the very stuff of which it is made. Wilderness hides its unnaturalness behind a mask that

is all the more beguiling because it seems so natural. As we gaze into the mirror it holds up for us, we too easily imagine that what we behold is Nature when in fact we see the reflection of our own unexamined longings and desires. For this reason, we mistake ourselves when we suppose that wilderness can be the solution to our culture's problematic relationships with the nonhuman world, for wilderness is itself no small part of the problem.

Comment

Cronon's tone, although challenging, is nonetheless academic in ways that Brox's tone in the influenza essay excerpt is not. Cronon introduces a quotation from Thoreau, a standard move in academic writing, and he also provides historical perspective, another common strategy.

The complex sentence structure Cronon employs is also academic, as is his use of qualification. Note, for example, how the qualifications he makes at the beginning of the third paragraph are especially well suited to the complexity of his idea. Moreover, Cronon's carefully controlled language creates an effect of a reasoned discourse in which an original idea is being thoughtfully considered. Cronon attempts to persuade through thoughtful analysis of a complex historical situation: the relation of human beings to their natural environment. Cronon makes his case tactfully but with a hint of warning.

THE AURAL/ORAL DIMENSION OF WRITING

Although we often read silently, it is beneficial on occasion to read some writing aloud. Poetry, of course, benefits from oral reading, from voicing the writer's words and lines the better to hear the sounds created in the poem—the sounds and rhythms that make it poetry, in fact. But prose, too, benefits from being heard aurally. By the way, the word used for speaking aloud is *oral* and for hearing what is read aloud *aural*. Every "oral" reading is also an "aural" one, even if the only one present is the reader who is reading aloud, for that reader is also a listener.

Why is it beneficial for a writer to read a draft of an essay, paper, or report aloud? The answer, quite simply, is that reading aloud slows things down. By slowing down, you can focus and concentrate more on the words and sentences of your writing and thus can better observe whether your words and sentences look and sound right. Another reason for reading your writing aloud is that in voicing your words you add an additional sense—the sense of hearing—to the one you use ordinarily when reading your writing: your sight. Adding hearing to seeing doubles the attention you give your writing and increases your

chances of picking out places that need work. The ear often prompts the eye to see.

You can go even further with hearing your writing by reading your work aloud into a tape recorder. By doing that, you can concentrate during playback on the way your writing sounds. You can attend especially to the phrasing and the rhythm of your writing, as well as to meaning.

Still another way to use reading your writing aloud to your advantage is to imagine yourself reading for an audience—or actually reading your writing to an audience, a few friends, classmates, or family members. Reading aloud for your audience will prompt you to emphasize certain words, phrases, sentences, or sections. Quite possibly, in reading your work aloud to different audiences, you might find yourself shifting the emphasis or reading with a different tone for each.

Adding the aural dimension to your writing can make you a more careful and attentive writer and also a more appreciative and observant reader of others' writing—if you are also willing to slow down and read aloud the work of others as well.

2

An Approach to Writing About the Humanities

Why write about works of art? For these reasons at least. First, because writing about a work of art leads us to read, observe, or listen to it more attentively, to notice characteristics about it we might overlook in a more casual reading, looking, or hearing. Second, because writing about works of art stimulates us to think about them. Putting words on paper provokes thought, gets our minds into gear. Third, we may wish to clarify our *feeling* about a work of art, as well as our *thinking*. We may wish to express what a particular work of art prompts us to think or feel, perhaps to endorse the ideas it conveys, perhaps to take exception to its subject, form, or execution. Writing about a work of art empowers us by allowing us to absorb it into our knowledge and experience.

This chapter presents an approach to works of art and ways to write about them. It encourages you to ask questions about the works you read, look at, and listen to—different kinds of questions, which lead to different kinds of responses. Three types of questions are essential:

- Questions that invite your *reaction* to the works you read, view, or hear
- Questions that encourage you to *interpret* those works
- Questions that require you to *evaluate* them

These types of questions and their associated forms of response lead to three ways of writing about works of art:

- Writing to understand works of art
- Writing to explain works of art
- Writing to evaluate works of art

In writing to understand works of art we are concerned primarily with how to make sense of them for ourselves. Our emphasis is on responding to the works emotionally as well as acquiring some sense of their qualities and power. The kind of writing associated with these goals is exploratory, and may assume the forms of freewriting, annotating, listing, and making notes.

In writing to explain works of art, we are concerned largely with interpretation, with making inferences based on our observations about art-works. (An inference is a statement about the unknown that is based on the known or the observed.) This type of writing to explain is more formal than the informal types of writing you do to understand a work of art for yourself. It is also more explanatory than exploratory.

In writing to evaluate works of art, we are concerned primarily with considering their value and their values. We make judgments about their quality, measuring them against aesthetic criteria and considering the social, moral, and cultural values they reflect, display, or endorse. Our emphasis in writing to evaluate is to arrive at conclusions about how we value works of art and why we value them as we do.

RESPONDING

When we listen to a song, watch a film, look at a photograph or painting, read a poem or story, or view a sunset, something happens to us. We feel something. Our emotions are stirred. Our thoughts are stimulated. In short, we react.

Consider, for example, a recent occasion when you did one of these things. Can you describe what you felt? Can you explain what it was about listening to that song, reading that poem or story, seeing that painting, watching that movie that moved you to feel the way you did, that stimulated you to begin thinking? Think of some text, some work of music, literature, art, or film to which you responded strongly—one that made you think or feel deeply. Most likely that work, whatever it was, has become part of you. It has become what we might call an "identity touchstone," because it expresses something important to you as an individual. In some personal and powerful way, you have made that work your own.

Interestingly enough, you may very likely discover that others have made that same work or text their own—even though they may not have responded to it exactly as you did, though they may have seen in it things other than those you saw. Regardless of how others view this work or what they make of it as they appropriate it for their own identity, you have probably made it a part of your own inner life. In fact,

depending on how powerfully you were affected, the particular work you have identified may have been for you a door opening out to other experiences or kinds of knowledge. Or to change our image, it may have provided a key to unlock your understanding of the world, other people, or yourself. It may have provided you with a standard by which to judge other similar works or a frame through which you perceive and understand your experience.

Now think of some text or work that, upon first encounter, you didn't understand. Perhaps it was a painting you looked at or a poem or novel you read. Perhaps it was a song whose lyrics puzzled you or a film you couldn't make much sense of. You may have dismissed it as boring or stupid or meaningless. And perhaps, for you at the time, it was. Or you may have felt that there was indeed something to the work, even though you had trouble figuring it out. Such a questioning of your response is healthy and valuable, primarily because it starts you thinking about both the text and your reactions to it. On one hand, it invites you to reflect on yourself, on why you didn't like or understand the work. On the other hand, it may lead you back to take another look, to reconsider what you read, saw, or heard.

On those occasions when you are moved by a work, when it makes a strong impression on you, one that is meaningful, you begin to live with that work and let it live in you. You may begin to engage in a dialogue with the work so that it may affect how you think and see, and even live.

To respond fully to any work of art, we have to invest ourselves in it. We have to immerse ourselves in it, give it time to work on us, speak to us, engage our hearts and minds. When this happens, we will have made our study of texts more than a mere academic exercise. We will have made it something that matters in our lives.

Responding to a Painting: Vincent van Gogh's *The Starry Night*

Look at the reproduction of Vincent van Gogh's painting *The Starry Night*. Spend a few minutes with the reproduction and write brief answers to the following questions:

- What was your *first* reaction on seeing this work here? Why do you think you reacted this way?
- What do you find most striking about the painting? What observations can you make about it?
- What is your overall impression of the painting? Which of the following best describes your sense of it: calm, peaceful, energetic,

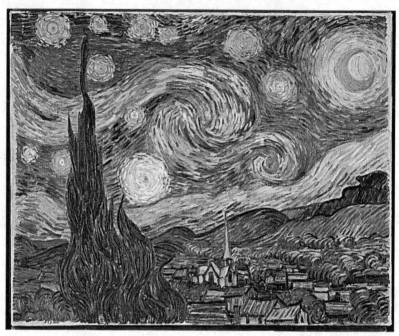

Vincent van Gogh (1853–1890), *The Starry Night*, 1889.
Oil on canvas, 29 × 36 1/4″ (73.7 × 92.1 cm). The Museum of Modern Art, NY, U.S.A. Acquired through the Lillie P. Bliss Bequest (472, 1941). Digital Image © The Museum of Modern Art/ Licensed by Scala-Art Resource, NY.

frenzied, intense, casual, comfortable, feverish, photographic, visionary? Why do you have the impression you do? Can you think of other adjectives that better suit your impression of the work?

- If you have access to a color reproduction, how do you react to van Gogh's colors? Consider the colors of the various stars, of the moon, of the sky, of the cypress tree that dominates the left foreground of the picture.

- How do you react to van Gogh's swirling, sweeping, circular lines? to the thickness of his brushstrokes? to the relationship in size and color between the depiction of nature above and town below?

- How do you respond to van Gogh's departures from reality in the details of the painting. Would you prefer a painting of stars and moon and sky that more closely resembled a photograph? Why or why not?

WRITING EXERCISES

1. Using the previous set of questions, formulate a response to van Gogh's *The Starry Night*. Write freely about what you notice, about how you feel, and about what you think. A couple of paragraphs will do.

2. Van Gogh's *The Starry Night* has inspired many poems. Here is one by the contemporary American poet, Anne Sexton, on whom van Gogh's painting made a strong impression. Read Sexton's poem a few times, and then jot down a few sentences revealing your response to it.

Responding to a Poem: Anne Sexton's "Starry Night"

That does not keep me from having a terrible need of—shall I say the word—religion. Then I go out at night to paint the stars.

—Vincent van Gogh in a letter to his brother

The town does not exist
except where one black-haired tree slips
up like a drowned woman into the hot sky.
The town is silent. The night boils with eleven stars.
Oh starry starry night! This is how
I want to die.
It moves. They are all alive.
Even the moon bulges in its orange irons
to push children, like a god, from its eye.
The old unseen serpent swallows up the stars.
Oh starry starry night! This is how
I want to die:
into that rushing beast of the night,
sucked up by that great dragon, to split
from my life with no flag,
no belly,
no cry.

Here are a few questions to guide your thinking about Sexton's poem.

1. Look first at the epigraph Sexton includes with her poem. To what extent does van Gogh's comment suggest why he painted the stars? How did the act of painting them affect van Gogh?

2. What does Sexton emphasize in her first stanza? What comparison does she make? What contrast does she identify in the painting? What personal statement does the speaker of the poem make?

3. What seems to be the emphasis of the second stanza? What impression of the sky does this stanza suggest to you? Why?

4. What do you make of the last five lines, which are really a continuation of the second stanza?

5. What does your reading of Sexton's poem add to your experience of van Gogh's painting? Does it alter your perception of it in any way? Do you see things you didn't notice before? Or do you see them another way?

6. Does Sexton's poem affect your response to the painting? Why or why not?

Even though you probably do not see van Gogh's *The Starry Night* the way Anne Sexton does or make the same sense of it as she does, by looking at her poem carefully and considering its relationship to van Gogh's painting, you can understand her response. Her view of the painting, what she notices about it, and how she interprets it (the black-haired tree, the hot sky, and the dragon in the sky, for example) may enable us to see things in the painting we had not at first noticed ourselves. This does not mean, however, that we accept Sexton's view of the painting. Nor does it mean that we accept the speaker's apparent death wish.

The Starry Night in Context

You have been looking at one work of art, van Gogh's *The Starry Night*, in the context of another: Sexton's poem about van Gogh. Now consider how a self-portrait by the painter, shown opposite, and an excerpt from a letter he wrote to his brother, Theo, shed light on *The Starry Night*.

Here are a few questions to prompt your thinking:

1. What do you notice about the background of the self-portrait? What do you notice about the way van Gogh painted his clothing?

2. How would you describe his face? Consider the eyes, nose, mouth.

3. What else do you find noteworthy about the self-portrait?

4. What connections can you make between the two paintings?

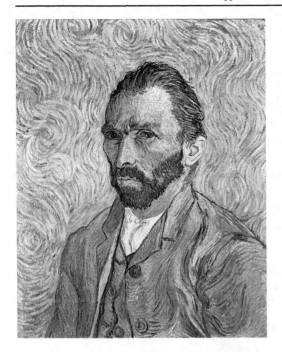

Vincent van Gogh, *Self-Portrait*, Saint-Rémy, September 1889, oil on canvas, 25H 21H″ (65 ×54 cm). Musée d' Orsay, Paris.
Corbis/Gianni Dagli Orti

Here is the excerpt from van Gogh's letter to his brother, Theo:

> For my own part, I declare I know nothing whatever about it; but to look at the stars always makes me dream as simply as I dream over the black dots of a map representing towns and villages. Why, I ask myself, should not the shining dots of the sky not be as accessible as the black dots on the map of France? . . .
>
> I go out at night to paint the stars, and I dream always of a picture like of the house this with a group of living figures. . . .
>
> These colors give me extraordinary exaltation. I have no thought of fatigue. . . . I have a terrible lucidity at moments when nature is so beautiful; I am not conscious of myself any more, and the pictures come to me as in a dream. . . .
>
> Ah! portraiture, portraiture with the thought, the soul of the model in it. That is what I think must come.

WRITING EXERCISE

Write another paragraph or two about *The Starry Night*, incorporating what you learned from either the self-portrait, the letter excerpt, or both.

Responding to Walt Whitman's "When I Heard the Learn'd Astronomer"

In the same way that you have been responding to van Gogh's painting, by considering its visual details and reacting to its elements, so, too, can you respond to the language and details of a work in writing such as a novel, play, or poem. In the following poem, Walt Whitman describes the reaction of a person (the poem's speaker) listening to an astronomy lecture. Whitman also hints at the speaker's response to actually looking at stars in the night sky. As you read, consider why the speaker responds the way he does, and how you yourself might respond, or perhaps have responded, in a similar situation.

When I Heard the Learn'd Astronomer

When I heard the learn'd astronomer,
When the proofs, the figures, were ranged in columns before me,
When I was shown the charts and diagrams, to add, divide, and measure them,
When I sitting heard the astronomer where he lectured with much applause in the lecture room,
How soon unaccountable I became tired and sick,
Till rising and gliding out I wander'd off by myself,
In the mystical moist night-air, and from time to time,
Look'd up in perfect silence at the stars.

WRITING EXERCISES

1. Write a paragraph in response to Whitman's poem. Have you ever had an experience similar to the one Whitman describes in the first stanza? Have you ever felt "tired and sick" while listening to a lecture and wanted to get up and walk out? What did you do? Why?

2. Characterize the experience of the stars the speaker describes at the end of the poem. Have you ever stood out on a clear night and simply looked at the stars? Why? What was it like?

INTERPRETING

In the previous section on responding, the emphasis was on your feelings and personal response to works of art; here it will be on your thoughts, on your ideas about them. In that section you were encouraged to be subjective and impressionistic. In this section on interpreting, you will be asked to be more objective and analytical. Instead of

eliciting your responses and feelings, you are now urged to think about the author's or artist's ideas and your own understanding of the works you see, read, and hear. The concern here is with interpretation.

When we interpret, we seek the artist's or author's view rather than our own; we ask what the work means, what it suggests rather than how it affects us. Interpretation aims at understanding, at intellectual comprehension rather than the emotional apprehension of responding. Thus you will now be shifting gears—moving beyond an informal and personal account of works and world to a more formal and public consideration of their significance.

But what is interpretation? And how do we actively engage in the process? Essentially, interpretation is making sense of something—a poem, a painting, a person, an event. We go about interpreting a work in the following way:

- We make *observations* about its details.
- We establish *connections* among our observations.
- We develop *inferences* (interpretive guesses) based on those connections.
- We formulate a *conclusion* based on our inferences.

To understand a work we need, first, to notice its details. You already began to do this in making observations about Vincent van Gogh's *The Starry Night* and Walt Whitman's "When I Heard the Learn'd Astronomer." You need now to move beyond those more or less informal observations to a more careful and formal set of observations. This more formal way of making observations is associated with our analysis and interpretation.

To begin understanding any text or work, you must observe its details closely. In reading a story, for example, we notice details of time, place, and action. We attend to dialogue and action, noticing not only what characters say and do, but their manner of speaking and acting as well. In listening to a musical work, we attend to its melody and harmony, its instrumentation, its changes of tempo and dynamics (its loudness or softness). In looking at a painting or photograph, we observe the size, shape, and color of its figures. We notice their relative positions in foreground or background. We pay attention to shape, line, color, brushstroke. We attend, in short, to a work's elements or characteristic features.

But it's not enough simply to notice such things. That's only the first step. We must push on to establish connections and discover patterns among the observations we make.

Interpreting van Gogh's *The Starry Night*

In viewing van Gogh's *The Starry Night*, for example, you almost certainly noticed the intensity of its colors and the thickness of its brushstrokes. You may also have observed the way each star is surrounded by a circular burst of light. You probably realized, further, almost immediately upon seeing the picture, how it is not a realistic representation of the night sky, but rather the painter's expression of how he perceived the stars in the night, and perhaps how he felt about them. We could go on and list other observations about the work's details. But our point is simply that we do not observe these or any details in a vacuum. We seek to relate a work's details, to bring them together, to connect them into a coherent whole—and thus to make sense of the work as a whole.

To do that we have to literally "leap" to our third interpretive aspect: *inference*. There is no way around "the interpretive leap." We must make this inferential jump, even though it's risky, even though we may not be certain about our idea. But infer we must if we don't want to remain stuck with saying things like "I don't have any idea what this artist/writer is up to." So, then, what inferences are you willing to make about *The Starry Night?* How can you relate the details you noticed into a pattern that suggests a meaning?

Notice that you are asked to consider *a* meaning, not *the* meaning. Because works of art convey multiple meanings, there is no single, definitive, absolute, and final way to understand them. Your goal should be simply to develop the habits of mind that lead you to formulate your ideas and to engage in richly inferential thinking.

Be aware, however, that although multiple interpretations of a work can be valid, every interpretation is not necessarily valid. Nor are all interpretations equally compelling or persuasive.

EXERCISES

Use the following questions to work toward interpreting Van Gogh's painting.

1. What do you think the painter may be expressing in *The Starry Night?* What attitudes, feelings, and ideas are communicated to you as you look at and think about it?
2. Think of other ways of "reading" the stars. How do astronomers read the stars? astrologers? sailors? lovers?

Once you begin making inferences about a work, you are actually already interpreting it. Although we usually reserve the word *interpretation*

for a formal statement of the work's meaning, in a more general sense, your acts of observing and relating details about the painting are essentially interpretive. They are aspects of a single process—interpretation.

Interpretation requires you to take some intellectual risks. It invites you to speculate or wonder about the significance of an artwork's details. Remember that interpretation is not a science; it is, rather, an art that can be developed with practice.

Be aware as well that the four interpretive actions—making observations, establishing connections, developing inferences, and formulating conclusions—occur together and not in a series of neatly separated stages. Our acts of interpretation are continuous as we read, look, and listen. We don't delay making inferences, for example, until after we have made all our observations. Instead, we develop tentative conclusions *as* we read and observe, *while* we make connections and develop inferences. We may change and adjust our inferences and provisional conclusions both during our reading of a work and afterward, as we think back over it. We suspect that you will find yourself doing just that as you reread Whitman's poem.

Interpreting Whitman's "When I Heard the Learn'd Astronomer"

You can follow the same procedure to interpret Whitman's "When I Heard the Learn'd Astronomer." To guide you through the process of interpretation, the following questions have been organized according to the interpretive steps outlined earlier—observing, connecting, inferring, and concluding. Use the questions to direct your rereading of Whitman's poem. Make notes either in the margins of this book or in another convenient place.

Making Observations

1. What do the following words have in common: *proofs, figures, columns, charts, diagrams, add, divide, measure?* Why is it important that these words occur in the first four lines but not in the last four lines of the poem?
2. How many sentences make up the poem? In how many stanzas is it cast? Why? If you were to split the poem into two sections, where would you break it? Why?
3. How many human figures are central to this poem? How many times does the poet use the word *I?* Why is it repeated?

Establishing Connections

4. What relationship exists between the first four lines and the last four lines of the poem? Can they be seen as representing a problem and its solution? a cause and its effects? Why?
5. What is the relationship between the words mentioned in question 1 and the following: "mystical moist night-air" and "perfect silence"?
6. Identify the relationship between each of the following pairs of details: the noise of the first four lines and the quiet of the last four; the speaker's sitting and his standing up and walking out; his being inside and outside; his being with others and his being alone. (By the way, can we be certain that the speaker is male? Is it important? Why or why not?)

Developing Inferences

7. What do you infer from the fact that the speaker gets up and walks out of the lecture room?
8. What do you infer from the applause the lecturer receives?
9. What do you infer about the speaker's experience as it is described in the last line?

Formulating a Conclusion

10. Would you say that this poem is about education? about different kinds of education? different ways of learning? If so, how would you characterize these ways of learning? If not, what is the poem about?
11. Is it a poem about nature? about our relationship with nature? about nature's effect on us? in what sense? Can the poem be "about" both education and nature—and other things as well?

WRITING EXERCISE

Write a couple of paragraphs formulating your interpretation of the poem. Identify an idea the poem suggests. You can use the ideas you discovered as you worked through the questions on observing, connecting, inferring, and formulating a conclusion.

Interpreting a Song: Franz Schubert's "Erlking"

Now that you've had a chance to put the interpretive process into action, consider a work in another medium—a song by the Austrian

composer Franz Schubert (1797–1828). Schubert's "Erlkönig" (German for "erlking" or "elfking") is a *lied*, or song for voice with piano accompaniment. As the composer of the work, Franz Schubert wrote the music, but he did not write the lyrics. The verbal text of the song is a poem by the German poet Johann Wolfgang von Goethe (1749–1832).

Before listening to the music, read through the lyrics a few times. Consider the story the poem tells. Make sure you can identify the characters described and that you can follow what happens. Here, then, is the poem that Schubert set to music.

Erlkönig

Wer reitet so spät durch Nacht und Wind?
Es ist der Vater mit seinem Kind;
Er hat den Knaben wohl in dem Arm,
Er faβ t ihn sicher, er hält ihn warm.

"Mein Sohn, was birgst du so bang dein Gesicht?"
"Siehst, Vater, du den Erlkönig nicht?
Den Erlenkönig mit Kron und Schweif?"
"Mein Sohn, es ist ein Nebelstreif."

"Du liebes Kind, komm, geh mit mir!
Gar schöne Spicle spiel ich mit dir;
Manch bunte Blumen sind an dem Strand,
Meine Mutter hat manch gülden Gewand."

"Mein Vater, mein Vater, und hörest du nicht,
Was Erlenkönig mir leise verspricht?"
"Sei ruhig, bleibe ruhig, mein Kind:
In dürren Blättern säuselt der Wind."

"Willst, feiner Knabe, du mit mir gehn?
Meine Töchter sollen dich warten schön;
Meine Töchter führen den nächtlichen Reihn
Und wiegen und tanzen und singen dich ein."

"Mein Vater, mein Vater, und siehst du nicht dort
Erlkönigs Töchter am düstern Ort?"
"Mein Sohn, mein Sohn, ich seh es genau:
Es scheinen die alten Weiden so grau."

"Ich liebe dich, mich reizt deine schöne Gestalt;
Und bist du nicht willig, so brauch ich Gewalt."
"Mein Vater, mein Vater, jetzt faβ t er mich an!
Erlkönig hat mir ein Leid's getan!"

Dem Vater grauset's, er reitet geschwind
Er hält in den Armen das ächzende Kind,
Erreicht den Hof mit Müh und Not;
In seinen Armen das Kind was tot.

The Erl-King

Who rides so late through the night and the wind?
It is the father with his child;
He holds the boy in his arm,
grasps him securely, keeps him warm.

"My son, why do you hide your face so anxiously?"
"Father, do you not see the Erl-King?
The Erl-King with his crown and tail?"
"My son, it is only a streak of mist."

"Darling child, come away with me!
I will play fine games with you.
Many gay flowers grow by the shore;
my mother has many golden robes."

"Father, father, do you not hear
what the Erl-King softly promises me?"
"Be calm, dear child, be calm:
the wind is rustling in the dry leaves."

"You beautiful boy, will you come with me?
My daughters will wait upon you.
My daughters lead the nightly round, they
will rock you, dance to you, sing you to sleep!"

"Father, father, do you not see the Erl-King's
daughters there, in that dark place?"
"My son, my son, I see it clearly:
it is the grey gleam of the old willow-trees."

"I love you, your beauty allures me,
and if you do not come willingly, I shall use force."
"Father, father, now he is seizing me!
The Erl-King has hurt me!"

Fear grips the father, he rides swiftly,
holding the moaning child in his arms;
with effort and toil he reaches the house—
the child in his arms was dead.

Earlier, when we looked at van Gogh's paintings *The Starry Night* and *Self-Portrait*, you were encouraged to pay attention to the thickness of van Gogh's brushstrokes and the vibrancy of his colors. As you listen to Franz Schubert's music, you should listen for different things. On first hearing, listen to the words and try to follow the story of the poem's action. You will be listening to a song sung in German. But you can follow along, listening to the German while reading the line-for-line English translation.

During this first hearing, you will also hear a piano accompaniment. In fact, the work begins with the piano as it introduces what becomes a dominant musical motif, or pattern of sound throughout the work. You can't miss it, as it is an insistent, repeated pattern of loud notes that Schubert uses to imitate the galloping of a horse. The horse is being ridden by a man who is carrying his young son with him as he rides. The poem/song describes how the son tells the father that the erlking is coming to take him away. The father thinks that the son is hallucinating and tries to console him. Upon reaching home, the boy dies in his father's arms.

Upon a second hearing, once you know the basic outline of the story the song describes, you can listen for the way the composer creates a series of different voices in the music. Even though there is only one singer, we have the sense that we are hearing four different voices: the father, the son, the erlking, and the narrator of the story. As you listen to the music, try especially to hear how the singer changes his voice to dramatize the differing voices of these four characters. We expect that you will hear how Schubert pitches the child's music higher than the music for the other characters.

You may also hear, perhaps on a third hearing, how the composer depicts the increasingly frantic nature of the child's desperation by raising the pitch of his voice each successive time he cries out to his father. As the song progresses, the composer makes the child's cries sound more helpless and desperate. The composer creates this effect by making the child's part a little louder, a bit more intense, and slightly higher in pitch each time.

On the third or perhaps even fourth hearing of the song, you may discover that the father's music is different from the child's. His melody is more controlled, less desperate, and more authoritative. The most beautiful melody of all, however, is that given to the erlking, who tries to enchant the child and snatch him away to fairyland. You may actually hear all of this on first or second hearing, but you will need a few additional hearings to sort out and really appreciate Schubert's musical accomplishment. You might also be interested to know as a sidelight that Schubert was only seventeen when he wrote this song, his first of more than six hundred, and one of his most highly regarded.

Through the musical means we have mentioned, and by means of others as well, which are too technical for our discussion here, Schubert accentuates the terror and pathos of Goethe's poem. By changing the music from stanza to stanza to reflect the developing dramatic action, Schubert brings out the emotion of the lyrics. One of his most successful musical enhancements occurs at the end. Following the abrupt termination of the piano's insistent rumbling is a dramatic pause between the words "In his arms the child" and the final words, "lay dead." It is a wonderfully expressive use of sound and silence.

WRITING EXERCISES

1. Select one of the songs on the tape, or one of your own favorites, and write an interpretation of it. Include in your discussion, as far as you are able, some attention to how the music brings out and accentuates the meaning of the words.
2. Go to the library and read about the life of Franz Schubert. If you have the time and inclination, see what you can find out about the legend of the erlking (a Danish legend, we understand). Or see what you can find out about the popularity of Schubert's song. Consider how your research enhances your understanding and appreciation of the song.

EVALUATING

In the previous sections, on responding and interpreting, you were encouraged to consider your personal responses and your understanding of different kinds of artworks. In doing so you were also (though perhaps without realizing it) assessing their values. You are now invited to focus specifically on the social, cultural, and moral concerns of some artworks. In doing so, you will begin to realize the importance of cultural attitudes, social conventions, and moral beliefs in the works we see, hear, and read.

What Is Evaluation?

But what is meant here by "evaluation"? Normally, when we speak of evaluation, we mean making a judgment about quality, about the success a particular work of art achieves—the artist's accomplishment or the work's expressive quality. Another way to think about evaluation, however, is as an appraisal or judgment of the cultural, moral, and aesthetic ideals that artworks reflect, support, or embody. This type of evaluation concerns a work of art's values, along with the values of the time and culture in which it was created, as well as the particular values we ourselves bring to our acts of evaluation.

In responding to and interpreting works of art, we bring to bear cultural, moral, and aesthetic beliefs. Our cultural values derive from our lives as members of families and societies. These values are affected by our race and gender, and also by the language we speak. Our moral values reflect our ethical norms—what we consider to be good and evil, right and wrong. These values are influenced by our religious beliefs and sometimes by our political convictions as well. Our aesthetic values determine what we see as beautiful or ugly, well or ill made.

Changing Values

Over time, with education and experience, our values often change. Through contact with other languages and cultures, we may come to understand the limiting perspective of our own. When we live with people other than our immediate families, for example, we may be persuaded to different ways of seeing many things we previously took for granted. Some of our beliefs, assumptions, and attitudes about religion, family, marriage, sex, love, school, work, money, and other aspects of life are almost sure to change.

As our lives and outlooks change, we may alter the way we view particular works. A film that we once admired for what it reveals about human behavior or one whose moral perspective impressed us may come to seem trivial or unimportant. On the other hand, we may find that a painting or a piece of music we once disliked later seems engaging and exciting. And just as individual tastes may change over time, so do cultural tastes in music, literature, and art. Culture evolves; moral beliefs, aesthetic ideals, and social attitudes change.

Works of art themselves are intimately involved in such change. Works of art often, in fact, reflect or embody cultural changes, such as shifts in social attitudes, moral dispositions, and behavioral norms. In addition, works of art can also affect us and lead us to change our own perceptions, understanding, and perspective.

What we value in a particular work or how the works of particular artists and performers are valued in their time and later is largely a function of cultural and social attitudes, as well as of changing ideas about what is or is not considered acceptable or proper to a given art. In the same way that clothing styles change from decade to decade (and even from year to year) so, too, do musical and artistic styles—although not as rapidly. In popular music, for example, the music of Prince was once in fashion; so was the music of Pink Floyd and, further back, that of the Beach Boys. Today it may be Gwen Stefani, Beyoncé, or Tim McGraw who draws crowds of enthusiastic admirers. Once it was Frank Sinatra and Bing Crosby. You will see this in greater detail when you

study the literature, music, or art of a country like France or a continent like Europe.

Similar fashions affect the fate of classical composers as well. Georg Friedrich Handel, whose *Messiah* is one of the most popular of classical choral compositions, was immensely popular. Handel's popularity, however, did not rest on works like *Messiah* (an oratorio that he had not yet written) but on his nearly forty operas in the Italian style—with each one more enthusiastically received than the one before—until Italian operas went out of fashion. Handel, a good businessman, reacted swiftly to the demise of Italian opera in his time by developing a new musical form, the oratorio, which became popular almost immediately. His operas have languished largely unperformed for more than two hundred years—until the past few years, when they have again been rediscovered. (*Messiah* continues to retain its appeal, even for many people who are not serious enthusiasts either of religion or of classical music.)

WRITING EXERCISES

Select one of the following questions and write a few paragraphs in response to it.

1. List three or four books you've read or films you've seen at different times in your life. Then select one and write a few paragraphs explaining how your later encounter with the book or film differed from your first reading or viewing.
2. Think about a television show or type of show (police drama, doctor or lawyer show, soap opera, situation comedy, reality show) that you know. Discuss a few ways that the show's changes reflect the changing values of the times.
3. Identify a concert or theatrical production you attended that affected you or impressed you strongly. Consider why you were affected the way you were. Consider, also, whether your evaluation of the performance changed over time and, if so, why.

Considerations in Evaluation

When we evaluate artworks we consider the cultural assumptions, moral attitudes, and social convictions that animate them, especially in relationship to our own values. Our consideration may involve looking into the circumstances of their composition, the external facts and internal experiences of the artist's life, the attitudes and beliefs he or she may have expressed in letters or other comments. From even this brief list, we can see how complex evaluation can be.

Complicating matters even further is how we encounter the works we do. We come to paintings, poems, songs, and other works of art after many preliminary acts of evaluation by others. The artists who created them decided that they were valuable enough to preserve. The publishers who originally presented them to the public valued them, perhaps more for their potential profit than for the feelings, attitudes, ideas, or artistry they display. All who respond to works of art, whether teachers or students or the general public, will not value them the same way. Nor should they. Just as our personal responses to works of art and our interpretations of them differ, so, too, do our evaluations of them in terms of both their artistic success and their values.

WRITING EXERCISE

Select a work of art, music, or literature and write a short paper exploring its values.

3

Writing About Art and Architecture

In addition to the general principles of interpreting and writing about the humanities discussed in previous chapters, we now begin to attend to the particular aspects of writing about specific disciplines—here, writing about art and architecture.

This chapter, "Writing About Art and Architecture," provides some reasons for writing about paintings, sculptures, photographs, buildings, and monuments. It also offers guidance in learning to look at works of art and architecture so as to better understand and appreciate their formal and functional qualities.

Why write about works of art? We write about artworks in part because writing about them helps us to better understand and appreciate them. Writing forces us to concentrate on seeing what is before our eyes so that we will have something to say. Writing about a work of art encourages us to slow down and observe more carefully than we might do otherwise. And writing about a work of art allows us to express our feelings and develop our thinking about what the work says to us, why it says what it does, and perhaps how it conveys it as well.

PAINTING

Before writing about a painting, you need to look carefully at it (or a reproduction of the work). In doing so, you will be making observations about the following elements: genre, medium, composition, perspective, texture, contour or shape, line, space, color, light. Let's take these up briefly, one at a time.

By genre we mean the type or category of painting a particular work belongs to—a portrait, for example, a still life, or a landscape. Some paintings contain elements of two or more genres, as for example, Leonardo da Vinci's famous *Mona Lisa*, which, though primarily a

portrait, also contains a background landscape. In viewing a painting, begin by focusing on its most immediate generic elements—on what seems most important. If there is action, identify what is happening. If there are multiple figures, consider their relation to one another. If still life objects are portrayed along with figures, consider the relationship of figures to objects, and so on.

In Chapter 1, you looked at a portrait of Vincent van Gogh, along with his painting *The Starry Night*. The kinds of questions that guided your examination of reproductions of those paintings were specific to those works. In this chapter, we will provide some broader questions you can use when viewing paintings in different genres.

When looking at a portrait, for example, you should consider the extent to which the portrait emphasizes surface features of the sitter— his or her clothing, for example—or whether it somehow probes beneath to reveal something of the figure's personality or character. This is not an easy matter, however, as viewers interpret details of facial expression, body posture, and gesture differently.

Use the following questions to help yourself slow down and absorb portraits:*

Guidelines for Viewing Portraits

- How much of the figure does the artist portray?
- What do the figure's clothing and accessories contribute to our understanding of the picture's period and its social world?
- What does the angle at which the figure is presented suggest about the figure's attitude? How do the figure's facial expression and bodily posture convey his or her personality?
- Does the picture seem to emphasize the individuality of the figure (perhaps by presenting him or her against a dark background and with minimal attention to details of dress and accessories)? Or does the picture seem to emphasize the social or political impor- tance of the figure (perhaps by accentuating accessories and details of dress)?
- Is the figure presented still or in motion? from the front, in pro- file, in three-quarters view?
- In portraits of two or more figures, do the figures look at or touch each other? What is suggested by their contact or lack of it?

*For the questions about painting and for those on sculpture, architecture, and photography, I am indebted to the fifth edition of Sylvan Barnet's *Writing About Art*.

Landscapes, too, can be approached with some common questions in mind. If the landscape does not contain human figures, focus on the artist's rendering of the natural scene. Consider the kind of scene depicted and what the artist seems to emphasize in its rendering. Is a storm depicted, for example, or a broad vista? What image of nature is suggested in the work?

Here are some additional questions to ask yourself when viewing landscapes:

Guidelines for Viewing Landscapes

- What does the landscape suggest about the natural world?
- What relationship exists between nature and the human figures depicted? In looking at van Gogh's *The Starry Night*, for example, you notice that the stars and sky occupy about three-quarters of the canvas, with the village much smaller in scale.
- Can the landscape be interpreted symbolically? How might it be read from a psychological, spiritual, economic, or political perspective?
- What social implications might the landscape bear?
- To what extent might its origin or cultural context help us interpret it? Chinese landscape paintings sometimes bear inscriptions that comment directly or indirectly on the work's significance.

In viewing any work of art, you should also pay attention to its title, which often provides information about genre, historical and other contexts, and the medium in which it was created, such as fresco or oil. A work's medium represents a conscious choice on the part of the artist and, as such, merits attention. Here are some questions to consider about medium:

- If a painting, is it painted in oil, in tempera (pigment dissolved in egg), in gesso? Is the paint layed on in thin layers, or thickly and heavily (impasto)?
- Is the painting done on canvas? on paper? on wood? on silk? With what effects?
- If a drawing, was it done on paper with a high or low degree of absorbency? with a wet medium, such as ink applied with a pen, or a dry medium, such as chalk or pencil?

An artist's choice of medium affects the qualities of color in a painting. The intensity or brightness of a color is referred to as its "value"; that is, its relative lightness or darkness of hue. *Hue* refers to the name of a color: blue or red, for example. Hues that are vivid are said to be

of high saturation and, correspondingly, pale hues are described as being of low saturation.

Be careful about making large claims for color in a painting, as a work's colors may have changed over time—as the restoration of Michelangelo's painting of the Sistine Chapel ceiling has recently shown. (Over the centuries, the colors of the ceiling had darkened to a sombre value. When cleaned, the painting's colors were revealed to be far brighter than most viewers of the ceiling had ever imagined.) Remember, too, that the colors of objects in a painting may appear darker or lighter, brighter or less intense, in relation to other objects and colors included in the painting.

The color of a painting is related to the effects of light produced in it. Try to identify the light source in the paintings you view. Where does the light seem to come from? Is the light bright or muted? Does it produce sharply defined contrasts in the painting, or not? Are some areas of the painting—a particular figure, or a part of a figure such as a face—highlighted? If so, to what effect?

Besides color and light, a number of other considerations can be addressed when you look at paintings. Here are a few more questions you can use to enhance your ability to see aspects of paintings so you will have more to say about them when you write:

Additional Questions About Paintings

- What is the focus of the composition? What is emphasized?
- Is the composition balanced? symmetrical? harmonious? With what effects?
- Does the work emphasize diagonal or vertical lines, which suggest motion and energy? Or is it mostly horizontal, which suggests tranquility? (Look back at van Gogh's *The Starry Night* to see the thrusting vertical made by the cypress tree.)
- Does the work convey a sense of depth or recession in space, or do the figures and objects appear lined up in a flat plane?
- What is the shape and size of the work? (Be aware that, when looking at reproductions in books and at slides, a work's size may be distorted. A tiny painting and a giant canvas pictured on a half-page spread look similar in size, when in reality, they differ dramatically.)
- What is the scale, or relative size, of objects and figures in relation to the size of the canvas or other medium on which they are painted?

Doing Comparative Analysis

We would like you to do some comparative analysis by looking at two paintings of family groups. The first is by the American painter Charles Willson Peale (1741–1827); the next, by the French artist Edgar Degas (1834–1917).

We will make a number of observations about the Peale painting and then ask you to make observations about Degas's painting. Before we begin our notes on the Peale family portrait, however, we invite you to look at the painting for about ten minutes and to jot down a list of all the things you notice. At the end of ten minutes, write a few sentences about the painting, conveying your overall reaction to it and your sense of the general impression it conveys.

Comments

Peale's painting reveals a pleasant family, seemingly satisfied with their lives together. The group portrait includes fourteen figures. Nine are immediate living family members, three are busts (most likely of other family members), and one is the family dog. The additional figure is the family nurse, who stands back slightly, indicating perhaps her less intimate relationship to the group.

The family is painted as a tightly knit unit. Some of the family members sit around a table; others lean on and over it. One, a small child, sits on it. And except for the nurse, the members physically touch one another.

In noting these details and others, such as the smiling faces, the colors of the clothing, the fruit, the artist at work, we make connections among them and form inferences about the meaning of the painting. We may agree that Peale has portrayed a content and cheerful family united in easy familiarity. The family seems comfortable in its relaxed informality.

But we may notice other things as well. Consider, for example, how the figures are arranged in two groups, six on the left and four on the right. (The dog sits somewhat outside the family circle.) The artist is able to preserve the portrait's unity by means of the table with the child sitting on it. Notice how the left arm of the central figure almost touches the other child's arm and the dress of the woman next to her. Notice also how the fruit fills up the space between the groups, effectively linking them. And notice, too, how the hands of four figures in the larger group are directed toward the smaller group on the right. Finally, consider how the extreme left and right figures look toward each other. Such details unify the family and the composition. This

Charles Willson Peale, *The Peale Family*, 1773 and 1809. Oil on canvas, 56-1/20″ × 89-1/2″, ca. 1770–1773, 1808 neg #34501, acc. # 1867.298.
Collection of The New-York Historical Society

unity is part of the work's meaning as we understand it. It contributes to our sense of the domestic tranquility, the agreeable pleasures of family harmony that Charles Willson Peale depicts.

EXERCISES

1. As you look at the Degas painting, make a list of similarities and differences you notice between it and the Peale family portrait. Which seem to predominate, the similarities or the differences? How would you describe the feeling Degas's painting conveys? What leads you to that conclusion?

2. Look carefully at the figures in Degas's painting, especially at their facial expressions and their positions. What do you notice? Based on your observations, what do you infer about the family's relationships? What do you think might be the father's relationship to his daughters? to his wife? What about the relationships between daughters and mother? Based on what you see in Degas's painting, do you think the two girls have the same relationship with their mother? Why or why not?

3. How does Degas's portrayal of the Bellelli family compare with Charles Willson Peale's portrayal of the Peale family?

Edgar Degas, *The Bellelli Family*, 1859. Oil on canvas. Reunion des Musees Nationaux/Art Resource, NY. Photo by Erich Lessing.
Musee d'Orsay, Paris, France

Sample Student Essay About an Artist

The following essay about the modern Mexican painter, Frida Kahlo, provides a portrait of the artist. The student writer, Jeannie Tran, refers to two of Kahlo's self-portraits, but she reserves mentioning them until the end of her essay. You can find them reproduced in color on the Internet.

Ms. Tran begins by describing her own experience seeing one of Kahlo's self-portraits in a museum. She uses this experience to launch her essay about Kahlo. In addition she describes in some detail a photograph of Kahlo taken by Manuel Alvarez Bravo. The writer analyzes this photograph, using its details as a way to interpret and explain Kahlo's life and work.

In addition, you will notice how Ms. Tran also uses Kahlo's own words, taken from her diaries. Each of these elements—the words Kahlo wrote, the self-portraits she painted, Bravo's photograph of her—contributes to the portrait of Frida Kahlo painted in words by Jeannie Tran.

Look carefully at the accompanying reproduction of one of many self-portraits painted by Frida Kahlo (p. 47). Use the guidelines for viewing a portrait on p. 38. Consider this painting in relationship to what Jeannie Tran reveals about Kahlo in her essay.

Jeannie Tran

Dr. Robert DiYanni

A Portrait of Frida Kahlo

When my father took my picture in 1932 after the accident,
I knew that a battlefield of suffering was in my eyes. From then on,
I started looking straight at the lens, unflinching, unsmiling,
determined to show that I was a good fighter to the end."

Frida Kahlo

At the beginning of this year, while at the Museum of Fine
Arts, I glimpsed for the first time a Frida Kahlo self-portrait.
I was repulsed by what I saw. I saw thick, dark eyebrows, the slight
yet still distinguishable mustache, the sexual and often violent
innuendoes. At once, I dismissed it as tasteless and vulgar.

But she seemed to cry out to me—"*Look at my face, look at my*
eyes, much is written there, much is hidden from view. My real self
is in my painting." I lingered.

Manuel Alvarez Bravo's portrait of Frida Kahlo presents her
sitting beside a metallic, reflecting ball, resting as if in a
Flemish painting, elegant and timeless, inhabiting her own world.
Her long, dark, braided hair, with colorful ribbons and yarns,
crowns her head. She dons her traditional native costume,
mexicanista clothes—a *Mazahua* gown, *huaraches*, and a *rebozo*.
Adorned with pre-Columbian jewelry: heavy, clay beads, a jadeite
pendant, and Aztec motif earrings, she displays an ethnic pride and
could be of royal Mexican ancestry. She dresses this way in part
because her husband Diego Rivera encourages her to. She wants
people to surround her, and she wants them to turn around and look
at her, to look at her. She exists in the reflected light of oth-
ers. She "was going to make the world fall head over heels in love
with Niña Frida." She loves and loves to be loved. She is strong
and quite beautiful.

She sits her sadness on an elbow. Her intense eyes question and
seduce the photographer. Framed by the thick, outstretched wings of
a bird, her eyes reveal her ever-present pride; a faint mustache
bequeaths her sensuous semi-smile. Inner explosiveness boils
beneath her mask-like face. Her stolid stare penetrates us, and we

can feel all her inner pain. It is terribly disconcerting yet wonderfully, fascinating. Aloof and prepossessed, she emanates a strange and magical beauty.

She sits as still and intense as the pre-Columbian objects that surround her. Standing out from the objects she resembles, Kahlo seems caught in time, alone, impassive, and strangely dispassionate, her face the mask she so often painted.

By the dark rings around her eyes, by the tired, almost fragile body, by her stoic, indifferent gaze, we can sense her sadness and her quiet suffering. Still, undaunted by even her numerous afflictions, she maintains an everlasting pride and perpetual desire to live.

Whenever she could, Frida Kahlo took charge of her life and her history. Born in 1907, she changed her birth date to 1910, the year the Mexican Revolution resounded through her country. The daughter of a Mexican mother and the German photographer Guillermo Kahlo, she recounted her youth in her diary, "My childhood was marvelous because, although my father was a sick man [suffering from epilepsy], he was an immense example to me of tenderness, of work and, above all, of understanding for my problems." Kahlo's meticulous attention to detail in her work—her tiny brush strokes, her colors, her painting formality—all were influenced by her father's photography.

As a child, Kahlo contracted a mild case of polio that left one leg less developed than the other. She compensated for her deformity by becoming an athlete: She skated, boxed, played soccer, and became an excellent swimmer. But at school, the children still taunted her, shrieking, "Frida, pegleg! Frida, pegleg! Frida, pegleg!" The parents uttered in disgust, "Que niña tan fea." ("What an ugly girl.") They hurled insults that hurt her, but she dauntlessly responded: "Feet. Why do I need them if I have wings to fly?"

At age eighteen, Kahlo's life changed forever: a grotesque streetcar and bus accident sent a handrail piercing through her body. The diagnosis included a "fracture of the third and fourth lumbar vertebrae, three fractures of the pelvis, eleven fractures of the right foot, dislocation of the right elbow, deep wound in the abdomen produced by a metal bar that penetrated through the left hip and came out through the vagina, tearing the left lip."

She wrote in her journal, "I did not want to live, nor did I want
to die." This traumatic experience would haunt her for the duration
of her life, but three months after, she told her mother,
"I haven't died, and I have something to live for: painting."
Painting, indeed, became her only medicine.

In 1929, Kahlo married muralist Diego Rivera. By her own
account, the two major events in her life were accidents: "the
first" she said, "was when a streetcar knocked [her] down, and the
second was Diego." Kahlo desperately wanted a child with Rivera.
However, she suffered three miscarriages, which only increased her
yearning to become a *madre*. Poor health, however, continued to make
a successful pregnancy impossible.

Kahlo's relationship with Rivera was tempestuous, full of pas-
sion, camaraderie, betrayals, and tenderness. Rivera openly pursued
numerous love affairs; during 1934, he began an affair with Kahlo's
sister, Christina. Though deeply pained by Rivera's infidelities,
she dismissed them and said, "I cannot love him for what he is
not." When Rivera left her, life left her. Consequently, Frida too
took on several paramours; she writes "balconies must be open for
women to fly out. I fly after Diego. I have flown after all men and
women who have attracted me." The best description of the the bond
between them is conveyed in Kahlo's poem, "Portrait of Diego":

> Diego. *Beginning*
>
> Diego. *constructor*
>
> Diego. *my baby*
>
> Diego. *my boyfriend*
>
> Diego. *painter*
>
> Diego. *my lover*
>
> Diego. "*my husband*"
>
> Diego. my mother
>
> Diego. me
>
> Diego, universe
>
> Diversity in *Unity*
>
> Why do I call him *My* Diego?
>
> He never was not ever will be mine.
>
> He belongs to himself.

She revealed her suffering on canvas. It was the painful circumstances of her life that infused her work with its spirit and its meaning. She invented and recreated herself through her art—she painted her face, her body, her broken spine, her death. The intensity of her paintings prompted André Breton to write, "[they] are like a ribbon around a bomb."

Her portrait, *The Broken Column*, explicitly manifests her pain and suffering. She maintains a stoic gaze as nails impale her naked body; a shattered column and the straps of a corset support her. Amidst this excruciating torture, Kahlo remains strong within. In another of her many self-portraits, *Diego and I*, she gazes out, two tears streaming down her face, a disarray of hair strangling her, Diego on her mind. She grieves.

Frida declared, "I paint my own reality." Even though her art was not monumental, they were powerful in their autobiographical content and profound in their understanding of her physical and mental anguish.

Throughout a demanding and difficult life, Frida molded and modeled many roles, defining her ethnic origins, her passion and devotion to Diego, and all that she loved around her. Her self-portraits—paintings and photos—invite us to penetrate that mask she so consciously designed. Frida's face revealed the truth she lived and struggled for.

And I saw that her visage, her life was a façade, and only her art revealed her true self.

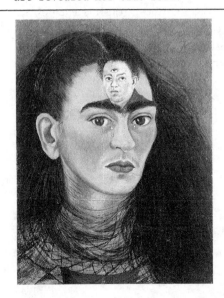

Frida Kahlo, *Diego and I*, 1949, oil on masonite, 11-5/8″ × 8-13/16″. Reproduction authorized by the Instituto Nacional de Bellas Artes y Literatura.
Courtesy of Mary-Anne Martin/Fine Art, New York.

CRITICAL THINKING: *Feminism and Painting*

In the last few decades feminist scholars of art have begun an intensive and extensive study of works by women, particularly neglected women artists. These feminist scholars have brought economic, historical, and sociological perspectives to the study of works by women, and they have raised questions about how women have been portrayed in art created by men. Consider, for example, the extent to which paintings that include both men and women depict the men clothed and the women unclothed.

A work fitting this description is Edouard Manet's *Le Dejeuner sur L'Herbe* (Luncheon on the Grass). In this painting two fully clothed men sit in a park-like setting with a pair of naked women. Why, we might ask, are the men clothed and the women not? Why is the nude woman in the foreground looking directly out at the viewer? Why is there a second, semi-clothed woman in the background? What is suggested about the relations of the men and women in the painting? To what extent do feminist considerations enhance your understanding and appreciation of this painting?

PHOTOGRAPHY

We are so familiar with photographs that it may be difficult to think of them as works of art. And, in fact, many photographs are literally snapshots taken without conscious artistic intent. Nonetheless, it is worth looking closely at the kinds of photographs that have been taken with thought and care—with a concern for what the photograph expresses as well as for its ostensible surface image.

It is important to realize that what a photographer sees when taking a photograph is more than and often quite different from the resulting photographic image. In other words, any photograph is a selection from a wealth of details that the photographer did not include in the finished picture. Moreover, photographers often doctor their photographs, cropping and otherwise altering the image as it was originally photographed by the camera.

Without going into the intricacies of the photographic process, we can see that photographers control and select, arrange and shape the images they finally put forth, just as painters do with their finished canvases. Here are a few questions to guide your consideration of photographs. You can also use some of the questions associated with paintings.

Guidelines for Looking at Photographs

- What does the photograph depict? That is, what is its subject?
- What is the relationship among the figures depicted?
- Is it in color or black and white? How does the color or lack of color fit the subject of the photograph?
- Who took the photograph, under what conditions, and for what purpose? Was it an individual or a group project?
- What is its title, and was the title provided by the photographer, or was it added later? Under what circumstances?
- What are the photograph's dimensions? Has it been trimmed or cropped or otherwise altered? With what effects?
- What details are visible? What is focused on most sharply? Is any part of the photograph left fuzzy or in soft focus? With what effects?
- What kind of lighting does the photograph suggest or exhibit? Under what lighting conditions was it taken—indoors or out? What effect is created by the lighting?
- What process was used to develop the photograph?
- What does the photograph "say" or suggest?

Sample Student Essay Using a Photograph

In the following sample student essay, Ariane Harracksingh describes a photograph of her family—a kind of family portrait. She presents this photograph in words only. There is no image to accompany her description. As you read her description of this family photograph and how Ms. Harracksingh uses this photograph as a jumping-off point for a series of reflections, be sure to see what purpose the photograph serves for her essay.

The student writer also writes briefly at the end of her essay about another photograph of another family. As you read what Ms. Harracksingh says about this photograph, try to visualize the picture that she decribes. Consider, too, why she included this photograph in her essay, how it relates to the first one she describes, and what purpose the two photos, together, serve.

Family Portraits

by Ariane Harracksingh

Pray God you can cope I stand outside this woman's work
this woman's world . . .

—Kate Bush,

"This Woman's Work"

i

My mother sits with her hands folded in her lap. I stand behind her
with my hand on her shoulder. I stand close, smiling, trying to
convey feelings of warmth and unity I know aren't there. Next to me
stands my brother, his left hand slightly raised near his belt and
his right hand at his side. My mother turns slightly towards him.

ii

The empty space in our family portrait is the space for my father.
Posed, he would have hidden my brother's moving hands.

My brother never did learn to keep still, one of the symptoms
of his no-male-role-model disease, an epidemic that infects count-
less innocent sufferers. The disease's symptoms are generally more
visible in its male victims. The females, more often than not, suf-
fer internal injuries. Fatherless, they face the world without the
protection of being Daddy's Little Girls. They suffer silently with
their mothers; the more visible victims, the young boys, are inca-
pable of concealing its effects.

The disease was particularly hard on my brother.

iii

I have always regarded my home life as unusual. I have long
been aware of the pressure my relatives (my grandparents espe-
cially) exerted on my mother in urging her to remarry. This type of
blatant pressure, however, was at least confrontable, unlike the
pressure exerted by strangers. Unsolicited disapproving looks came
from the elderly, along with inquisitive stares from men, the awk-
wardness of my father's absence doubly apparent in their unspoken,
unwarranted judgments. In their opinion, as in that of my grandparents,

remarrying was the one thing my mother should have done—immediately after my father divorced her. With their accusatory glances, they intimated that my mother had driven our father away, when instead she should have given in to his abuse. She should have given up her pursuit of a medical career. She should have given us a father.

iv

Symptoms of our affliction showed even in school, especially when there was a father-son picnic on an afternoon Mom couldn't get off from work. My brother, discreetly grateful, would take me instead. We sat on the bleachers and watched the activities, content to be regarded as orphans or latchkey kids, as long as we just didn't seem fatherless. But no matter what we did that fact was obvious. There was clearly no man around the house. There was only my brother, a boy trying to emulate what he thought was a man. A man he never knew.

Fortunately, the idea of a happy family is not unattainable. A breath of life remains in this social structure, its cohesion directly linked with responsibilities once shirked and now fulfilled in other roles, as grandparents and relatives lend their support to the double-duty mothers. The units they form create strength upon which new family structures will be built.

v

My friend Molly's family portrait depicts such strength. In it stand three women, dressed casually. Behind them are trees, suggestive of life and growth. But it is the foreground that is extraordinary. The three women are of equal height, and, with lens angled, their faces form the picture's only horizontal line. Looking out from the same level, they all appear genuinely happy to be standing beside each other. Molly stands in the middle with her daughter Merle to her left, while to her right stands her lover, Laura.

From talking with Merle, you would never know how different her family is. The reaction to Merle's family situation, however, is typically a disguised, unconfrontable attack against her parents' sexual orientation. But, as with my family picture, in time that of Merle, Molly, and Laura will also be seen as a representation of what it is: a family portrait.

EXERCISES

1. Select a photograph that interests you. It can be a classic photograph you find in a textbook; it can be an image from an advertisement or a billboard; it can be a personal photograph familiar to you and perhaps family or friends. Describe the photograph in a paragraph of 6–10 sentences in such a way that someone who cannot see the actual photograph forms a mental image of what it depicts.
2. Explain in another short paragraph what about the photograph engages you, appeals to you, interests you.
3. If it's a personal photograph, tell its story in still another paragraph. If it's an image you found elsewhere, invent a story of how and why the photography may have been taken.
4. Write a final paragraph summing up the significance of the photograph. What does it "say" or "suggest" to viewers. What meaning(s) does it convey and embody?
5. Follow the fours steps above in analyzing the following photograph by the contemporary American photographer Tina Barney.

Tina Barney, *Reunion*, 1999, TB #7 (Westwater Family)
Courtesy of Janet Borden, Inc.

CRITICAL THINKING: *Photography and Truth*

A picture, it has been said, is worth a thousand words. And it has often been remarked how photographs capture the truth of a scene, rendering its reality as the scene exists in actuality. However, we might want to ask ourselves a few questions about these commonly accepted notions.

1. To what extent do photographs, snapshots in a moment of time, tell a "truth"? What kind of truth?
2. To what extent are photographs limited by the moment of their shooting? That is, if they were taken a short time before or after, would the "truth" they tell differ?
3. To what extent are photographs affected by the angle or perspective from which they are taken?
4. To what extent can photographs be "arranged" to suggest something real or historical that was actually staged by the photographer?

EXERCISE

After jotting some brief notes of reflection to these four questions, write a couple of paragraphs explaining your thoughts about the truth(s) that photographs reveal. Explain how you would go about determining whether a photograph was telling a truth, or whether it was somehow staged, slanted, or otherwise manipulative.

SCULPTURE

For sculptures that are portraits, some of the questions listed earlier for paintings can be applied. Consider in particular whether the sculpture represents an individual or a type; that is, whether your sense is more of a particular person or of a category or a symbol—of a ruler or a deity, for example. Paradoxically, you may find that an image that seems highly specified and individualistic is simultaneously more broadly representative or symbolic.

Other kinds of questions to ask yourself about works of sculpture are these:

Guidelines for Analyzing Sculpture

- Why was the sculpture made? What purpose was it designed to serve? How or what does it represent?
- What kind of pose does it hold? Rodin's *Thinker* sits very differently from the sitting pose of Abraham Lincoln in the Lincoln Memorial. What is implied or conveyed by the figure's pose?

- Is the figure draped or nude? Michelangelo's nude *David* can be contrasted with Bernini's draped *David* (see below). What does the drapery reveal about the body beneath it? What does it conceal? To what extent does the drapery accentuate motion or a pattern echoed by the figure or its larger context (as, for example, its placement on a throne or in a wall niche)?
- What material is the sculpture made of—clay, wood, granite, marble? Is its surface smooth or rough? What do the medium and texture "say" about the figure represented?
- To what extent is the figure carved, and to what extent is it modeled or shaped? How does its surface absorb, hold, reflect light and shadow? To what effect?
- Is the subject depicted in motion or still? What does its silhouette suggest?

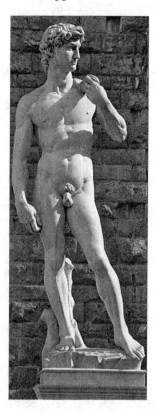 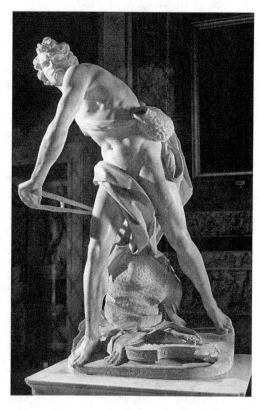

Left: Michelangelo, *David*, 1501–04, marble, height 13'5" (4.09 m). Galleria dell' Accademia, Florence. © Roger Antrobus/CORBIS *Right:* Gianlorenzo Bernini, *David*, 1623, marble, height 5'7" (1.7 m). Galleria Borghese, Rome. © Gianni Dagli Orti/CORBIS

- Is the figure now, or was it once, painted? With what colors and to what effect? What does the color of its paint or its material contribute to the impression that the figure makes?
- How big is the sculpture? Michelangelo's *David* is larger than life, whereas Bernini's is life size. What is the effect of the difference?
- What was the original site of the sculpture? Has it been removed from that site? If so, what is the difference between viewing it at the original site and in a museum? Is the sculpture mounted on a base? To what extent is the base part of the sculpture?
- What is the best position from which to view it?

EXERCISE

Write a short essay in which you compare the two sculptures of David by Michelangelo and Bernini. Use the questions on sculpture to guide your analysis. In developing your comparison, you may choose one of two basic structures. You can use what is known as the **block method**, or you can use the **alternating approach**. In the block method, you discuss one work in its entirety before taking up the other one. In other words, you present everything you have to say about each work separately—first one work and then the other. In the alternating approach, you weave back and forth between the works, highlighting first one feature of each work, then moving on to discuss another. Throughout your paper, you would be discussing both works together with reference to each aspect under consideration.

- When you **alternate**, consider whether your readers stay with you as you zigzag back and forth between works you compare. Be sure to make the overall point of the back-and-forth comparative movement clear—perhaps in a concluding sentence (for a paragraph) or in a concluding paragraph (for an essay).
- When you use the **block** method, consider whether your readers understand the point of the comparison. Be sure to remind readers how the comparison works, how the details about the second work you discuss relate to comparable details about the first one discussed. Emphasize similarities between the two by using such words and phrases as "like," "just as," "in the same way," and "another important connection." Emphasize differences with words and phrases such as "Unlike X, Y . . ." or "Although X and Y share . . . they differ in this or that way."

EXERCISES

Use the guidelines for viewing sculpture to analyze two sculptures entitled *The Kiss*, one by Auguste Rodin, a nineteenth-century French sculptor, the other by Constantin Brancusi, a twentieth-century Romanian sculptor. Rodin is best known for his realist marble sculpture, *The Thinker*; Brancusi is best known for his abstract sculptural work, most notably, *Bird in Flight*.

Consider the following questions as you take another look at each of these two very different renditions of people kissing.

1. What is the dominant impression created by each sculpture? How does the sculptor create that impression?
2. What geometric forms do you discern in each sculpture? How has each sculptor used that form in his work and to what effect?
3. To what extent do you think Brancusi's work derives from and comments on Rodin's sculpture? How would you characterize the relationship between these two sculptures? Why?

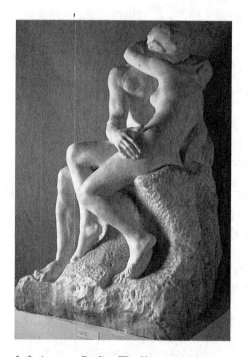

Left: Auguste Rodin, *The Kiss* Musee Rodin, Paris, France/SuperStock *Right:* Constantin Brancusi, The Kiss Musee National D'art De Moderne, Paris/Centre National D'art De Culture Georges Pompidou/SuperStock

Student Essay on Sculpture

In the following essay, "The Function of Art," a student writer, Paul Jorgensen, considers three ancient Greek and Roman sculptures as he develops an argument about their purpose and function.

The Function of Art

Any schoolchild can look at the Augustus from Primaporta and see how the Zeus from Ancient Greece has similar characteristics. A more educated onlooker will look at the same two pieces of statuary and see how the Romans emulated the Greeks with the artistic output of their civilization. Yet does this mean that the Romans had the same purposes in mind when adopting Greek art as their own?

This may seem like drawing a bow at a venture. Already, it would seem I've just shot wildly hoping to strike some vital point. Who says that art has to have a purpose? Can't art just have an aesthetic value? It certainly can be but that's like saying *Animal Farm* is just a fun read. Art expresses something more than mere aesthetic values because of the amount of time involved. An artist spends years chipping away at a piece of marble. I would hope that he has a reason for doing so that goes beyond mere looks.

To the Greeks, this reason is to express perfection. The Zeus (or the Poseidon or the lowly spear thrower or whatever else it may be interpreted as) is an example of such perfection in their sculp-ture. He stands with emphasized musculature. He is significantly larger than life at nearly seven feet tall. He exhibits contraposto in the twisting of the body, particularly in the rear leg. The face is calm with deep-set eyes and wavy hair. He does have this somewhat awkward feature though. The arms are too long. If they fell to his side, they would easily come down to his knees. Yet, considering the height of the work, this is actually an attempt to make the statue appear perfect to the viewer. The distortion caused by perception works as well here to show an exact proportion as the slight lift of flooring at the Parthenon creates the perception of perfect angles.

Other statuary in the Greek world exhibits many of these con-ventions. The Kritios Boy, the Spear Bearer, and many other works all have the same wavy hair, similar facial characteristics, con-traposto, and defined musculature. Actually, these conventions are

so similar in style that few Greek statues could be identified as representing an actual person. This fact leads to confusion in regards to the identity of the "Zeus" sculpture and other Greek works. Greek sculpture depicts an idealized form of man rather than any particular individuals.

One might conclude from this that the function of Greek art was to celebrate the perfection of man. A rebuttal might be made that art, instead, celebrates the perfection of the gods. However, this is, really, just another way of saying the same thing. Since the gods look like and behave like mortals, this is no distinction at all. Or, if a distinction does exist, it is not pertinent to any but the most intensive studies of Greek culture. As such, this argument can safely be discarded. Besides, the Greeks created the Olympics to determine the personal greatness of individuals in sport. This implies that the focus of Greek art was on the perfection of mortals rather than on divine entities.

Roman sculpture, however, differs from Greek sculpture in portraying the likeness of specific individuals. The face of Augustus from Primaporta is clearly the face of Augustus. A Roman Patrician with Busts of His Ancestors has three distinct faces in the same overall work. Phillipus the Arab is a bust that exhibits a clear demarcation from the Greek stylistic conventions reserved for faces. None of these figures could be confused for one another.

In spite of the individuality of these likenesses, there is no doubt that the Romans were idealizing these figures to at least some extent. The Augustus from Primaporta, despite the striking nature in which it captures Caesar's likeness, omits small details from the face, such as wrinkles. Hence, it looks somewhat classical and perfected. It even has the classical wavy hair. If we disregard some of the typical Greek idealizations, we see that the statue is given a kind of divine perfection from the presence of Cupid, a symbol of the Julian connection to Venus.

The colossal head of Constantine the Great is another example of this perfected individuality. Again we see the curly hair adorning his head. He is shown to be of great importance and, hence, quality through his stature; the head itself towers over the surroundings at eight feet tall. Gold was flecked in the eyes to indicate a divinely inspired wisdom.

This is propaganda. The Greeks had created a way to make a man look like an ideal. The Romans recognized this and saw an advantage that the Greeks had ignored. While the Greeks had made man ideal, the Romans idealized individuals. The Greeks merely elevated the position of man as a whole, whereas the Romans gave political leaders an aura of greatness or divinity above the common man.

Although clearly of great use, this usage of art as propaganda is still only a possibility. The true function of Roman art may involve any number of other things. However, consider this: the nature of the typical Roman. He is practical. There is a great deal of evidence for this. Romans created roads, aquaducts, concrete, and the arch. Considering the vast amount of territory the Romans controlled, these things were practical necessities. To administer a large empire, soldiers needed roads to get to the outlying regions. Aquaducts allowed for the carrying of water over long distances. Concrete and arches allowed for the quick erection of buildings in newly conquered areas. If the ruler of such a vast territory with such an ethnically diverse population is considered inferior to other mortals (or maybe even just mortal) then he faces an uprising. It would seem that Greek art appealed to the practical nature of Romans in creating propaganda against such an uprising. If this artistic form is considered to be a practical necessity, like roads, then the Roman character makes the function of Roman art as propaganda inevitable.

CRITICAL THINKING: *Art Forgeries*

Among the problems confronting art dealers and purchasers is the problem of forgery, the deceptive practice of creating artworks that appear to be original masterpieces but are only copies. Among recent forgeries is that of an ancient Greek sculpture, a *kouros*, or young male standing figure, purchased by the J. Paul Getty Museum in California. The work appeared to be a sixth-century BC figure, but in reality it was a fake. The museum purchased the statue after extensive geological analysis indicated that its marble had come from an ancient quarry site and because it had appropriate papers to designate the history of its ownership, which had been forged as well.

In a recent book, *Blink*, Malcolm Gladwell explains how the forged sculpture was created, why some people were fooled by it, and how some experts knew, seemingly intuitively, that the Getty *kouros* was a fake, even though many details suggested its authenticity. What do you think is necessary for an expert to detect a forgery? To what extent do you think that tests, such as those done on the dating of a work's materials, are enough to decide its authenticity? To what extent is an art historian's experience of value in making such determinations?

ARCHITECTURE

Like paintings, sculptures, and works of literature, works of architecture can be viewed in relation to their time and place of construction. In fact, works of architecture, because they are made for a practical purpose, must be considered in relation to the societies reponsible for producing them. The question is less academic than practical.

A work of architecture, such as a church or a public building, can be considered from the standpoint of its purpose or function—why it was made; its structural soundness—how well it is made; and its design—how beautifully it has been made. We take up these three essential architectural aspects briefly, one at a time.

First, purpose. Was the work constructed for a single specific purpose, as for example a Buddhist temple or a Gothic cathedral for worship? Has the original purpose of the building been supplanted by another at a later period, as for example converting a ruler's palace into a legislative assembly hall or a museum? Has the building been expanded, contracted, remodeled, renovated, restored, or in any way altered? If so, with what results?

How does the building fit into its surrounding context—its neighborhood, its building site? Is it integrated into its surroundings, or does it stand out from them? Was this the original intention of the architect? To what extent have its surroundings changed? How well is it related to other buildings and structures that have been erected since it was constructed?

Second, structure. How solidly is it built? Has it held up over time? Is it structurally sound? To what extent do its interior spaces fit the purposes for which they were originally designed? That is, to what extent does form follow function? To what extent might the form be symbolic—representing tranquillity or energy, for example?

Of what materials is it made? What associations do its materials have—marble and granite suggest power and prestige, durability and dignity. Wood is humbler but can suggest simplicity and rusticity if left "natural," and if smoothly sanded and painted, something more communal, perhaps more "finished."

Third, design. It perhaps seems strange to ask what a building suggests or expresses in the way we might consider a sculpture or a painting expressive. Nonetheless, a building's size and scale, its shape and form, color and texture, speak to the same kinds of aesthetic issues and responses that works of art do. What does a structure's design contribute to its "meaning"?

And, more specifically, you can ask other kinds of questions about architectural structures:

Guidelines for Analyzing Architecture

- Is it ornamented or decorated in any way, and if so, how, and to what effect? How are its interior spaces arranged, divided, allocated?
- What are its walls and floors made of—brick? wood? marble? To what effect?
- What colors are its walls and floors and ceilings?
- Does the building seem warm and inviting? Or does it seem cold and forbidding? Why?
- How is it lighted? What place does natural daylight have in its design? What aesthetic effect does light—both natural and artificial—have on the overall feeling the building creates?
- To what extent does the building represent either a particular individual's architectural philosophy or a sociocultural architectural style or perspective?
- To what extent does the building reflect the architectural style from an earlier era? To what purpose, and with what effect?

An Architectural Proposal

The following essay—an op ed piece published in the *Wall Street Journal*—argues for the inclusion of a large open-air theater as part of the architectural concept for the site of the former World Trade Center. The writer, Joan Breton Connelly, a professor of art history, does not put forth a complete architectural proposal for the site. Rather, she explains why a particular kind of open-air theater should be included as part of the plan.

Let's Look to Ancient Forms for a Memorial

Joan Breton Connelly

Beginning in the sixth century B.C., Athenians gathered on the south slope of the Acropolis to watch the great dramatic works that have survived to this day. In time, the Athenians' Theater of

Dionysos grew to seat some 15,000 viewers who regularly came to participate in dramatic festivals that gave emotional catharsis to their lives.

So central was theater to the ancient Greek experience that it became a required component of every Greek city plan. When Alexander the Great marched eastward, founding over 70 cities, each aspired to boast a council house, a temple, a stadium and, importantly, a theater. Even at Kandahar and Bagram in distant Afghanistan, Greek theaters rose to embrace and enthrall scores of viewers, binding them together in a meaningful communal experience.

Among the very highest honors awarded to an Athenian citizen was the right to have his or her name inscribed upon a seat in the city's theater. Politicians, generals, and others of distinction were granted the privilege by which generations that followed could read and remember the names of those who had contributed so mightily to their community.

To this day we can see the names of those who died over 2,000 years ago. We know nothing of the life of a priestess named Athenion who served in A.D. 134. But when we run our fingers across her name, engraved on a seat that still stands in 21st-century Athens, she is present to us across the ages.

Today, as we follow the important and necessary debate over what should be built at Ground Zero, we participate in a discussion that is as old as humankind itself. At the very core of the debate are some strikingly profound tensions: those between creativity and memory, freedom and discipline, imagination, and will.

We should consider, as at least one component of the rebuilding, the possibility of a World Trade Center Memorial Theater. Imagine an open-air theater, with a sweeping semicircular grandstand of at least 3000 seats, one inscribed for each life lost on Sept. 11. The viewer would look down from the great expanse of benches into the orchestra, a circular stage area below and its backdrop: that great stretch of exterior wall salvaged from the ruins of the Trade Towers just weeks after the attack.

A theater is defined by the experience of its viewers. It shifts and changes with the events that occur within its embrace. A Memorial Theater could be a place of quiet contemplation, where loved ones would visit the inscribed names of the lost, sit and remember and look down upon the surviving bit of superstructure

that bears witness to their suffering. It could also be a place of public oratory for the countless memorials that will consecrate that day and site for generations to come. All the while, it could be a place for workers to bring their brown bag lunches and rest as they once did at the World Trade Center Plaza.

By night, the theater would come alive with the sounds of symphonies and well-loved arias, with age-old tragedies and heart-lifting comedies, with rock bands and film festivals, and circus flyers and displays of the imagination, creativity and energy that make this city so vibrant. Flooded in wintertime, the orchestra space would metamorphose into a skating rink, a source of endless smiles for those watching from the bleachers.

Our Memorial Theater would provide a final destination for that most quintessential of New York institutions: the ticker tape parade. Here, the great processions through Wall Street would culminate in ceremonies celebrating our most esteemed sports stars, astronauts, and future heroes against the backdrop of the very last surviving piece of the Trade Towers ruin. And in thus transforming the World Trade Center site into the centerpiece of the recreational and commemorative life of the city, we would be declaring: The terrorists did not win.

The finest memorial for the dead is life itself. Let those who perished communally, a throng of some 3,000 taken from us in a single day, be honored through a never-ending chorus of the living. A theater filled with exhilarated and inspired, entertained and contemplative Americans encircled in one of the oldest architectural forms given to us by those who invented democracy itself.

A Memorial Theater could accommodate the thousands of world visitors who most certainly will make pilgrimages to the site. On its very uppermost level, along the broad arc that encircles the sweeping seating space below, let us fly high the flags of every nation that lost a citizen in the Sept. 11 attack. When the world visits our most devastating national shrine let them know that we have remembered their children, too. And let them know that we have responded to this unspeakable destruction with the most powerful answer of all, life.

Joan Breton Connelly is an associate professor of fine arts at New York University.

EXERCISE

Analyze the argument made by Professor Connelly for an open-air theater as part of the rebuilding scheme for the World Trade Center. Then write two paragraphs, first summarizing her views, and then responding to them. You can agree, disagree, or qualify her argument in your response to her.

Student Essay on Architecture

In the following paper, Emily Sheeler, a student, compares the influence of the Egyptian temples at Luxor and Karnak with that of the Greek Parthenon.

<div style="text-align:center">Influence through Architecture</div>

For centuries temples and statues have been constructed to pay homage to gods of many cultures. Although they vary in size, construction, and technique, they serve as an intertwining thread that links seemingly disconnected time periods and cultures. Through art it is possible to see influence and commingling from other cultures; art proves to be one of the most influential aspects of history that sews together communities that may otherwise have never been connected. The one binding factor that helps lead to a connection through art is that of faith. Gods have always been a prevalent aspect in most, if not all, cultures and have even caused wars, destruction, and untimely downfalls. The influence of the gods can be seen in historical texts but through art in all its forms as well—in Homer's *The Odyssey,* Virgil's *The Aeneid,* and certainly through architecture. Some of the most well known art pieces and structures were created to praise some god or gods. Not only were these pieces painstakingly constructed over many years to please the gods but also, although unknowingly, to influence the cultures and techniques that came after them. The building of the Temples at Luxor and Karnak by the Egyptians are not only to be marveled at but also to be examined and thought of as a piece of history that influenced the construction of other even more well known structures, such as the Parthenon.

The building of the massive structures at Luxor and Karnak are proof themselves of the influence of previous art on culture and new art. These temples replaced smaller ones that were begun during

the Middle Kingdom. The innate urge to display power and triumph can find no better medium than art. The rather thinly veiled idea that these structures were created to praise a god (Amun), although this does hold some truth, is largely outweighed by the fact that their creation was a show of power. "As an expression of pharaonic power, the temples at Luxor and Karnak are without equal" (Janson 47). However, it was not only power over the current civilization that prompted these pharaohs to build such a massive and imposing structure, but the influence that they would have over future cultures. Power is intoxicating and one of the few things that can transcend time; this is an idea that the Egyptians were very well aware of in building these temples. The temples themselves were built on "a principle of exclusion" (Janson 46), which shows that they were meant to stand apart and be noticed as structures to be reckoned with just as was the government.

The temples were made so as to be shown in the best light not from an outside perspective but rather from one who is inside the temple. This speaks highly of the Egyptians' need to control and conquer. The worshippers were almost confined in this temple, afraid even that the weighty structure would cause their death. Fear was a primary motivator in this architectural feat; in fact the architect purposely made the weight of the columns in the structure heavier than needed. This overwhelming sense of power and fear casts the praising of the gods in a shadowed light; portraying power as the most important aspect of culture, rather than worship.

This unbridled urge for power and influence was not lost on the Greeks. In achieving their greatest architectural feat, and possibly the best known historical structure the world, the Parthenon, power played a great role. Much like the Egyptians' temples, the Parthenon was set high on a hill and away from the ordinary. It was constructed for the goddess Athena, ironically the Greek goddess of war and wisdom. The looming structure looks down on those in the city from the Acropolis, almost spiting those below as underlings. However, the structure is far less impending than others and offers a sense of support rather than fear (as the Egyptian structure). The time surely influenced the architects (Iktinos, Kallikrates, and Kaprion) when creating the structure. The money raised to construct the site was taken from funds that had been received in

order to ward off the Persian enemy. This brazen move of taking funds out of money for defense only shows how far rulers will go to glorify not only themselves but their city.

Although the Parthenon is and will always be known as one of the greatest architectural feats in history, it ultimately was a helping factor in the downfall of Athens. It begs the question which is greater: longevity of a city or longevity of influence and power? Cleary, Perikles chose influence. There are few structures that come close to the fame of the Parthenon and this is ultimately what Perikles sacrificed his defense against the Persians for, endless fame and influence. At the time the Parthenon was constructed it was highly debated as whether or not it was worth what it cost them, as if the inhabitants of the city were aware of their untimely doom. Yet the Parthenon was something not suggesting an end, but was rather lively and intimate. Although the Egyptian influence can be seen in some aspects of the Parthenon, it varies in its overall sense.

The Parthenon was far more welcoming and open than the temples at Luxor and Karnak but this merely shows the progression of time. It was as if the rulers of these civilizations found a better way to exude power over their people and prolong their influence. The Egyptians thought it best to strike fear into the people's hearts, thus causing them to remain respectful not only of the current government but of the gods the temples were constructed for as well. This is a much different perspective than what the Greeks did with their Parthenon. The Parthenon was much more inviting and sought to rule through rank, being built on the highest point of the city, and friendship. The Greeks are often seen as a much livelier group of people, who celebrate food and wine when reveling in worship of their gods. The structure proves as a backdrop for the Grecian lifestyle. Regardless of how both civilizations sought to ooze power and influence, their goal was much the same: to be remembered through history as nations that were able to create menacing works of art.

The question of whether or not the two civilizations succeeded in their goal is debatable. If the Egyptians had not created such works of art like these temples, would they have been as well remembered? It is unlikely. Although history may be seen as the

past, this cannot hold true in the world of architecture and art. The Egyptians created something that can never be forgotten. There is a sense of immortality in these temples that will surely never die as the Kingdoms did. The Greeks are the same way, known not only for their glorious history and very well known defeat, but also for the Parthenon.

There are few places in the world that this structure is not echoed in some sense through art. Influence is a tremendous idea, and both civilizations achieved greatly at this. The Egyptians surely influenced the building of the Parthenon and thus must always be remembered. Art, although it is beautiful and holds meanings that may never be fully discovered, is used as a medium for eternal influence. In the structure of the Parthenon can be seen traces of Egyptian influence: dominating the city as did the temples of Luxor and Karnak, showcasing power no matter what the cost, and having the same goal of ascendancy.

Power may be corrupting, but it can also be used for good. Looking at the art from a standpoint of beauty there is nothing lacking in these magnificent structures; they are strong and demanding while still aesthetically pleasing. It is the beauty of these structures that cause their timelessness, which is why their construction cost so much. It cost the Athenians their city, while the Egyptian temple only highlighted their unholy drive for power. It is ironic that the course of history would have the Greeks conquering the Egyptians. The Egyptian temples of Luxor and Karnak surely influenced the Athenian Parthenon, which was a factor in their downfall. The ties of influence never end, and both the Egyptian temples as well as the Parthenon only serve to further enforce this idea.

CRITICAL THINKING: *Monuments*

A perennially debated question for countries during and after wars is how to memorialize their dead. Following the Vietnam War, a debate ensued about how to best remember the Americans who died in Vietnam. A contest was held with over a thousand entries submitted, resulting in the selection of a design by Maya Lin, which has since become the Vietnam Veterans War Memorial, better known as "The Wall."

Lin's design for a monument was unconventional, departing radically from traditional realistic representations of soldiers in combat gear. Instead of depicting soldiers realistically in action, Lin opted for a more symbolic design, with a long, black, shiny granite wall incised with the names of all soldiers who died in the war. Why do you think some people opposed Lin's design for the monument, and preferred something more traditional? Why, after more than twenty years that the Vietnam Memorial has stood, do you think it has retained its popularity, having become the most visited of all memorials?

4

Writing About Music and Dance

This chapter, "Writing About Music and Dance," discusses various types of writing about music and some different ways to write about musical works and musical performances. It includes examples of professional musicians and of non-musicians writing about music, including concerts. It concludes with a sample student research paper on a musical subject.

Music is not the easiest of the arts to write about. Part of the challenge of writing about music involves attempting to describe what the fleeting sounds are like. Confronted with this challenge, writers often resort to metaphor, particularly simile, to explain through the use of comparisons, what the music sounds like.

WRITING ABOUT MUSIC DIRECTLY

Among those who have written about music clearly and engagingly are the American composer Aaron Copland and the American composer, conductor, and teacher Leonard Bernstein.

Here, for example, is Leonard Bernstein describing a theme in the work of the Russian composer Peter Ilych Tchaikovsky:

> Let's just see how Tchaikovsky went about building up that lovely theme of his by simply repeating his ideas in a certain arranged order—what I like to call the 1-2-3 method. In fact so many famous themes are formed by exactly this method that I think you ought to know about it. Here's how it works: first of all there is a short idea, or phrase: (musical quote)—second, the same phrase is repeated, but with a small variation: (musical quote)—and third, the tune takes off in a flight of inspiration: (musical quote). 1, 2, and 3—like a 3-stage rocket, or like the countdown in a race: "On your mark, get set, go!" Or in target practice: "Ready, aim, fire!" Or in a movie studio: "Lights, camera, action!" It's always the same 1, 2, and 3!

Bernstein uses a series of similes, comparisons using "like," to explain how Tchaikovsky's theme contains three parts. The comparisons he makes are with things familiar to his audience—a group of children attending a lecture and concert.

Here is another example of a writer, this time the composer Aaron Copland, describing the musical element of timbre:

> After rhythm, melody, and harmony, comes timbre, or tone color. Just as it is impossible to hear speech without hearing some specific timbre, so can music exist only in terms of some specific color in tone. Timbre in music is analogous to color in painting. . . . Just as most mortals know the difference between white and green, so the recognition of differences in tone color is an innate sense with which most of us are born. It is difficult to imagine a person so "tone-blind" that he cannot tell a bass voice from a soprano, or, to put it instrumentally, a tuba from a cello.

Like Bernstein, Copland makes a comparison with something his audience understands, to help them understand something unfamiliar to them. Where Bernstein used simile, Copland develops an analogy, or extended comparison.

WRITING ABOUT MUSIC INDIRECTLY

In addition to writing about music directly as do Bernstein and Copland, writers sometimes write around the music, talking about music without actually describing what it sounds like. They might write about the life and times of a composer or performer; about the reasons for the rise and decline in popularity of a particular instrument or musical form or style; about a composer's or performer's influence, such as that of Beethoven or the Beatles.

Here, for example, is the American writer Ralph Ellison writing about the gospel singer Mahalia Jackson:

> There are certain women singers who possess, beyond all the boundaries of our admiration for their art, an uncanny power to evoke our love. We warm with pleasure at mere mention of their names; their simplest songs sing in our hearts like the remembered voices of old dear friends, and when we are lost within the listening anonymity of darkened concert halls, they seem to seek us out unerringly. Standing regal within the bright isolation of the stage, their subtlest effects seem meant for us and us alone; privately, as across the intimate space of our own living rooms. And when we encounter the simple dignity of their immediate presence, we suddenly ponder the mystery of human greatness.

Perhaps this power springs from their dedication, their having subjected themselves successfully to the demanding discipline necessary to the mastery of their chosen art. Or, perhaps, it is a quality with which they are born as some are born with bright orange hair. Perhaps, though we think not, it is acquired, a technique of "presence." But whatever its source, it touches us as a rich abundance of human warmth and sympathy. Indeed, we feel that if the idea of aristocracy is more than mere class conceit, then these surely are our natural queens. For they enchant the eye as they caress the ear, and in their presence we sense the full, moony glory of womanhood in all its mystery—maid, matron and matriarch. They are the sincere ones whose humanity dominates the artifices of the art with which they stir us, and when they sing we have some notion of our better selves.

Lotte Lehmann is one of these, and Marian Anderson. Both Madame Ernestine Schumann-Heink and Kathleen Ferrier possessed it. Nor is it limited to these mistresses of high art. Pastoria Pavon, "La Niña de Los Peines," the great flamenco singer, is another and so is Mahalia Jackson, the subject of this piece, who reminds us that while not all great singers possess this quality, those who do, no matter how obscure their origin, are soon claimed by the world as its own.

—from "As the Spirit Moves Mahalia," *Shadow and Act*

Ellison celebrates Jackson as a musician as well as a singer. He glories in how she sings and relishes the memory of hearing her in person. What makes Ellison's own memorializing of Mahalia Jackson memorable is the care he takes with his language, the precision of his vocabulary and the elegance and grace of his sentences. Look, for example, at the shape and listen to the sound of his first two sentences. This kind of concern with the how as well as the what—with style as well as with thought—makes for outstanding writing.

USING QUESTIONS TO WRITE ABOUT MUSIC

One way to approach writing about a musical subject is to frame one or more questions about it. You might ask, for example, "Why do people listen to music"? Or you might ask: "What kinds of effects does music have on people?" You might single out a particular type of music and create a question-topic, such as "How and Where did Rock (or Jazz) Originate?" Or: "What is the future of Rap (or Rock, or Classical) Music?"

In writing a research paper, you might trace the development of a performer's or composer's career. You could explore origins and influences, developments and continuities, changes and shifts of direction.

For such an assignment, you need to identify a composer or performer that interests you (or about whom you would like to learn more) and begin with some questions to guide your reading, listening, and research. Questions such as "Why did the Beatles become a musical phenomenon in the 1960s?" or "What was the Beatles' musical legacy?" or "What makes Chopin's musical career and musical style distinctive?" Once you have a good question, your research paper can become your way of answering it.

EXERCISES

1. Review a Music Concert
 Attend a concert of classical music. Take notes on the concert musical selections, the performers, the composers, the audience, the hall. Write a paper describing your experience of attending such a concert. Include your personal responses to the pieces on the program. You may also wish to do some library research about one or another of the works performed. And you may also use the concert program for information.

2. Interview and write about a city street and/or subway musicians. Find two or three street/subway musicians playing classical music—guitar, violin, cello—whatever you discover. Spend some time listening to each of them. Bring a notebook, and see if you can interview the performers about why they perform where they do, what kind of musical training they may have, what kinds of music they play, and why—and so on. Include your personal responses to the musicians and their music.

Following are additional questions you can use to direct your thinking when writing about music:

- What strikes you most forcibly about the music—and the lyrics, if there are any?
- What instruments are used—and how many of each?
- Who is the composer? When was the work composed?
- Where does it fit in the composer's career?
- Why was it composed—for what kind of occasion?
- What is its musical genre or type?
- What is the structure of the work? How is it organized?
- What style and period is the work written in? What features of the work—its melodies, harmonies, rhythms, structure—reflect the characteristics of the period (such as the classical era)?
- Which features of the work mark it as particularly reflective of the composer who wrote it?

- How would you characterize its musical language—medieval, Renaissance, baroque, romantic?
- What does the work express or convey? What feelings and ideas does it communicate?

Writing About a Musical Performance

One fairly common occasion for writing about music is reviewing a performance. Most major city newspapers review concerts—pop, jazz, and classical, including opera. Music critics for papers like the *Los Angeles Times* and the *Chicago Tribune* write regular review columns, usually with each reviewer specializing in a different type of music.

The following reviews, one of a rock concert and the other an opera performance, appeared in the *New York Times* on the same day. Read each review and answer the questions that follow them.

Voigt's Aida Is Assured
by
Anthony Tommasini

As opera fans everywhere know by now, Deborah Voigt's voice is gloriously suited to the German dramatic soprano repertory, especially Wagner and Strauss. But as she increasingly takes on weightier German roles, like Isolde, which she sings for the first time at the Vienna State Opera in May, she wants to keep the kind of lightness in her sound and smoothness in her legato that singing Italian repertory can provide. Though not an ideal match for Ms. Voigt's voice, the role of Verdi's Aida has been especially important to her.

Ms. Voigt sang her first "Aida" at the Met in 1999, a vocally tentative but honorable effort. In early 2001, she tried again. This time, though her singing was more confident, she seemed understandably rattled by her vocally and physically wobbly Radames, Luciano Pavarotti. Everyone in the cast and James Levine had to prop him up, sometimes literally. These turned out to be Mr. Pavarotti's last Met performances.

Ms. Voigt, strikingly slimmed down and exuding confidence, took over the title role of "Aida" on Thursday night in the Met's revival of its 1988 Sonja Frisell production. And this time, as Professor Higgins might say, "I think she's got it."

Sustained lyrical midrange singing and floated, high-lying Verdian phrases still did not come easily to her. You sensed

Ms. Voigt being careful to rein in her sound. But she never blustered her way through these passages, honored Verdi's dynamic markings and sang with genuine Italianate poignancy. Where impassioned, full-bodied singing was called for, Ms. Voigt filled the phrases with gleaming, dramatic soprano sound that lirico-spinto sopranos more suited to the role would covet. And as usual her musicianship was consistently impressive.

Ms. Voigt will sing two more performances of "Aida" on Tuesday and next Saturday.

Keith Richards Keeps the Stones Rolling
by
Ben Ratliff

Keith Richards is the formula for the Rolling Stones as well as its claim to spontaneity. The best moments of the Stones' show at Madison Square Garden on Thursday were introduced by his riffs, which appeared suddenly, bright, and cutting and emphasizing the weak beats of a rhythm. They sliced through the music's laggardly atmosphere.

When you're nearing 60, you don't cross through New York City four times on a yearlong world tour unless you have astounding amounts of money to make. (In September the band played at Madison Square Garden, Roseland Ballroom, and Giants Stadium; this "Forty Licks" tour will soon continue in Europe through August.)

A few years ago one witty reviewer wrote of one of the band's 1990's albums that it sounded as if the Stones had eliminated the in-between steps and recorded it inside a bank. But at some point in the 1970's, through its music and its publicity, the band really did create a kind of delicate golden mean, balancing rock, money, sloth, and sex; our culture has grown up understanding the proportions, and the context of popular culture prevents the group from seeming like venal laughingstocks.

Really, the Rolling Stones are predicated on good songwriting. The Stones rehearsed about 130 songs for this tour, and also revolved various sequences of songs that are deep-catalog although certainly not obscure. On Thursday at midconcert they played a triptych of songs from "Let It Bleed," flashing a giant image of the album's cover above them before and after the set.

An unsmiling Mick Jagger spent the show on his tiptoes, flopping from the elbows out and the knees down; he's still a great antivirtuosic dancer, if not the electrifying singer he was. The steady-enough rhythm section—the drummer Charlie Watts, the bassist Darryl Jones, and the keyboardist Chuck Leavell—hit some tempos that felt wrong (a too brisk "Angie," a mellow "Monkey Man") but also some that felt beautifully right, particularly a nasty, leisurely "Can't You Hear Me Knocking."

The same song pointed out the difference between the two guitarists, Ron Wood and Mr. Richards. Mr. Wood re-enacted the iconic solos recorded by Mick Taylor, his predecessor in the band; when casually improvising, he was a totally banal musician. Mr. Richards barely soloed, but when he did, each phrase had a spindly power and was based in rhythmic ideas. For long stretches, he parked in front of the drum set and locked into a groove.

The lasting image of the show, which was a run-through before another one to be broadcast live on HBO tonight, wasn't the red confetti during "Jumping Jack Flash." Nor was it the catwalk from a big stage to a small stage in the center of the arena—a device from the last tour—nor the thrashing return to the A section of "Midnight Rambler" after a five-minute slow-blues sojourn. It was Keith Richards, looking like a ragbag sponsored by Van Cleef & Arpels, sweetly smiling for the audience, and embracing his guitar: a startling, cuddly scene.

EXERCISE

Answer the following questions about the two reviews.

1. Which of the reviews engaged you the most? Why?
2. What similarities do you see in the opera and pop reviews?
3. How do each of the reviewers go about the business of actually describing the music?
4. How does each describe the performance?
5. What kinds of background and context does each reviewer provide?
6. What judgments does each reviewer render about the performance he attended?
7. Given the opportunity, would you be inclined to attend a performance by either of the artists reviewed here? Why or why not?

Sample Student Essay About Music

We conclude this chapter with an example of a student writing about music.

The author, Karen DiYanni, considers the significance of Richard Wagner's music, and the kind of influence the man and his music exerted on future generations of composers and musicians.

Notice how the author begins her paper with an epigraph, which suggests in a nutshell, the argument she will make in the paper overall. Notice, too, how she uses a comparison between Wagner's work and influence with that of Beethoven to clarify her ideas. And, notice, finally, how she introduces quotations and references from her sources.

The Importance of Richard Wagner

by

Karen DiYanni

"*Of all the German figures of the nineteenth century, only Marx and Nietzsche had impacts equal to Wagner's on subsequent thought; like them, he could be attacked and parodied, but never ignored.*"

—Rey Longyear

Richard Wagner dominated the musical life of the second half of the nineteenth century as Beethoven dominated the musical world of the first half of the century (Schonberg 274). Both composers left their highly individual imprints on the music that would come after them. Both achieved greatness such that their works continue to serve as artistic monuments against which others' musical compositions are measured. Moreover, one might argue that Richard Wagner's operatic achievement compares with the achievement of Beethoven in symphonic music.

Unlike Beethoven, whose influence on future generations was confined to the realm of music, Richard Wagner's influence extended to art and politics. Also unlike Beethoven, whose works express a resilient optimism, a profound hope in human possibility, Wagner displays a more pessimistic attitude toward life. Influenced by the philosopher Arthur Schopenhauer, Wagner emphasizes the blind force of irrationality and passion that drive human behavior (Levy 251).

His operas portray characters whose lives are made unhappy by circumstances they cannot control, as in his most famous opera, *Tristan and Isolde*, in which the two lovers are kept apart only to be united in death.

Wagner was born in 1813, in the northern German city of Leipzig, home also to Bach and Handel, of Beethoven and Brahms. Unlike these musicians, all of whom were musically precocious, and all of whom received extensive musical instruction in their youth, Wagner, when young, was more interested in literature than in music. Shakespeare, in fact, was his idol (Schonberg 275). Wagner did not begin the serious study of music until age fifteen, and he never mastered a musical instrument as Bach and Handel mastered the organ and Beethoven and Brahms' the piano. Wagner was also largely self-taught, mostly through intense study of the works of Beethoven (Schonberg 275). In fact, later in life, Wagner explained that he had wanted to do for opera what Beethoven had done for symphonic music—to make it express a wide range of experience, and to have it achieve overwhelming emotional effects. Wagner's admiration for Beethoven can be heard in the following comment from his writings:

> The last symphony of Beethoven is the redemption of music from out of her peculiar element into the realm of universal art. . . . for upon it the perfect art work of the future alone can follow (Schonberg 275).

Wagner believed that he and he alone could compose this "perfect art work of the future," and he believed that it could not be an orchestral work since Beethoven's mighty ninth symphony could never be surpassed. Instead, Wagner would create a new kind of opera, which he called "music drama" (Levy 251).

II

Wagnerian music drama attempted to bring together song and instrumental music, dance, drama and poetry in a single unbroken stream of art. Wagner did not like the way any of these arts had developed in his time. He thought that song in opera had been reduced to the operatic aria, that dance had become only ballet, and that music in opera had become reduced to a secondary role of accompanying the singers (Longyear 165). His ambitious goal was to

restore the importance of music in opera, to establish a better balance between orchestra and singers. His goal also included raising the quality of the texts of operas. He attempted this in part by finding his subjects in medieval legend and Nordic mythology and partly by writing his own librettos (Longyear 166).

In honoring his musical forefather, Beethoven, Wagner would use the orchestra to do more than simply provide beautiful accompaniments for operatic arias. Instead Wagner's operatic orchestral writing would arouse intense emotion, "comment" on stage action, and be associated with incidents in the plot and characters' behavior. One important and influential way that Wagner accomplished these goals was by using what were called "leitmotifs" (Levy 252). These musical motives were usually brief fragments of melody or rhythm that, when played, would remind the audience of particular characters and actions, somewhat in the way a movie or television theme triggers associations in the mind of the audience.

III

From all accounts, Wagner was not a very nice human being. He was arrogant, willful, pompous, and rude. He was also a liar, a deadbeat, and a sensualist (Levy 250). He has been further described as "a selfish ingrate, an egotistical profligate, and an obnoxious megalomaniac" (Frost and McClure). And he was nothing if not ambitious. His ambition eventually paid off, for even after producing a number of failed operas, and after living in political exile in Switzerland for eleven years, he secured the patronage of King Ludwig II of Bavaria, who enabled Wagner to acquire wealth, fame, and power. Most important for Wagner was that with Ludwig's support, he could fulfill his dream of establishing an annual festival at which his (and only his) music dramas would be performed. Wagner designed the auditorium and the sets for productions of his monumental operatic works, some of them lasting for as long as six hours.

Wagner's works include the comic *Die Meistersinger*, the popular *Lohengrin* and the sensuous *Tristan and Isolde*, which influenced subsequent European musical style perhaps more than any work of the late nineteenth century. His tetralogy, *The Ring of the Niebelung*, which is generally considered his greatest work, includes four

operas—*The Rhine Gold, The Valkyrie, Siegfried*, and *Twilight of the Gods*.

Because Wagner's music does not break easily into set pieces, it is difficult to illustrate his musical style. Complicating matters is that, like his great predecessor, Beethoven, his style developed and changed during his musical career, so much so that his music of the 1850s differs considerably from that of the 1870s (Schonberg 284). Nonetheless, something of the power Wagner could generate with an orchestra can be suggested with the Prelude to Act III of *Lohengrin*, especially in its opening and closing sections. The middle provides a brief hint of Wagner's lyrical style.

Alternatively, the mysterious quality of Wagner's music along with something of its relentless drive can be heard in his "Ride of the Valkyries" from his music drama *The Valkyrie*. Both of these excerpts provide examples of what might be called "Wagner's Greatest Hits." These popular selections, however, exist within a complex whole—the individual music dramas of which they are a part, and the entire range of Wagner's operatic output. As a result they can reflect only the slightest hint of his musical legacy. This legacy has been described best, perhaps, by the music historian Donald Grout, who sums up Wagner's enormous influence in this manner:

> Wagner's work affected all subsequent opera . . . His ideal of opera as a drama of significant content, with words, stage setting, visible action, and music all working in closest harmony toward the central purpose . . . was profoundly influential (Longyear 171).

IV

If Beethoven was the composer whose works crossed the bridge from the Classical style and outlook to a vision and style that is distinctively Romantic, Wagner is the composer whose greatest works epitomize that style and vision and bring it to its culmination. His music has long made such a powerful impression largely because of its "sheer overwhelming power" it creates in its listeners, "that all-embracing state of ecstasy, at once sensuous and mystical, toward which all Romantic art had been striving" (Grout

and Palisca 752). He also served as the "father of modern music," introducing chromaticism and pointing to atonality with his masterpiece *Tristan and Isolde*.

Wagner's stature as one of music's all-time prominent composers is beyond question, as is his position as one of the nineteenth century's most influential and provocative individuals. His impact extended beyond music into politics and philosophy, and he has done much to shape the world we know today.

Works Cited

Frost, Thomas and John McClure. Liner notes for *The Wagner Album*. New York: Columbia Records, MG 30300, n.d.

Grout, Donald J. and Claude V. Palisca. *A History of Western Music*, 4th ed. New York: Norton, 1988.

Levy, Kenneth. *Music: A Listener's Introduction*. New York: Harper & Row, 1983.

Longyear, Rey M. *Nineteenth-Century Romanticism in Music*, 3rd ed. Englewood Cliffs, NJ: Prentice Hall, 1988.

Schonberg, Harold C. *The Lives of the Great Composers*, rev. ed. New York: Norton, 1981.

CRITICAL THINKING: *The Popularity of the Beatles*

During the 1960s, a rock group from England took that country and then the U.S. by storm. The Beatles began their musical journey in Liverpool, a working-class city, playing locally there before receiving acclaim in London and throughout England. The Beatles included four musicians, drummer Ringo Starr, accomplished guitarist George Harrison, and lead singers and guitarists Paul McCartney and John Lennon, who also wrote most of the group's songs. Each of the four had a distinct personality and an individual musical identity, yet they blended into a cohesive and wonderfully identifiable group identity unlike any before in the realm of pop/rock music.

But what was it that made the Beatles the phenomenon they became? What elements combined to make them the premier pop combo of their generation not only in England and the U.S., but beyond? To what extent was it the personas they created and purveyed?

To what extent was it their musicianship, their originality, and their unique sound? To what extent was their popularity attributable to the musical innovations they introduced, such as the "concept album," in which all the songs on a disk were related to an overarching topical theme? To what extent was their success a function of the times in which they rose to fame—an era when teenage girls went wild over young rock stars? And why is it that the Beatles continue to remain popular today—in Britain, the U.S., and Europe?

WRITING ABOUT DANCE

Dance shares a number of characteristics with the other arts. First, dance is often associated with music, which is, like drama, a performing art. Also like music, dance occurs in time, and, like music, provides sounds and rhythms that dancers move to, and that choreographers, or dance designers, use as the basis for constructing the patterns of dance movement. Second, dance shares with drama costumes, props, and sets, as well as actors moving through space on a stage—though the dance stage is typically far more open than a theater stage, which often contains furniture and more frequent abundant props. Third, dance shares with painting, visual imagery, colors, and visual patterns that are created as dancers move through space on the stage. And fourth, when dancers stop their motion, they can be seen as three-dimensional sculptures, momentarily frozen in time, like inanimate marble or bronze sculpted figures.

Elements of Dance

What makes dance unique among the arts, however, is movement through space in time. The following can be considered the essential elements or building blocks of dance: gesture and motivation, dynamics, rhythm, and form.

Dance involves gestures, some of which are familiar from everyday life and others of which are more stylized motions pertinent to various genres or types of dance. Gestures such as saluting, shaking hands, bowing, pushing and pulling, waving arms and crooking fingers are common. Various kinds of jumps and twists might be more particular to ballet, as various movements involving a couple's entangled arms and legs reflect a popular dance like the tango, and as various movements bringing the arms to the sides and then stretching them out like an airplane's wings resemble movements in tap dancing. Whatever gesture and movement dancers make, however, must be motivated. That is, the movement occurs for a purpose, with an intention—perhaps as part of a story the dance is telling, perhaps as an emotion the dancer is expressing or a

visual pattern dancers create on the stage. Learning to appreciate dance requires, in part, learning to attend to the various gestures dancers make and the varied effects those motivated gestures create.

Dynamics provides variety to dance, as it does to music. In music, dynamics involve loudness and softness; sharp, short staccato sounds; or more languorously sounding, long, lingering legatos. In painting, dynamics involve variety in surface texture, in color and intensity. In sculpture, dynamics comes from the contrast of light and shade, the varieties of convex and concave contours on the surface of a figure.

In dance, dynamics involves varieties in movement—fast and slow, sharp and smooth, tense and relaxed, in some combination. Think, for example, of a traditional Spanish dance, a flamenco, in which the feet move very rapidly in small steps and larger ones, staccato and sharp, while the arms move more smoothly in long, flowing lines. That combination expresses grace and elegance, while simultaneously conveying strength and passion.

All dances employ and embody rhythm, or the steady and driving beat that animates a dance's movement. This is true for all kinds of dance—ballet, modern, popular, ethnic folk dances, and the like. Rhythm provides the energy of the dance and gives it its life pulse, which is affiliated with the natural rhythms of the body, such as the beating of the heart or the steady pattern of arm and leg motion in a person's walk.

Rhythm involves pattern—the pattern of beats you hear or see in someone's speech or walk, for example, or in the motions of a dance. Learning to recognize—to feel—a work's rhythm, its pattern of movement, is essential for learning to appreciate the art of dance.

What we have been suggesting about dance is, essentially, that it is an art of patterned movements that can be appreciated with practice in learning how to look and in knowing what to look for. We should also mention that a dance may develop an overall form, like a sonnet in poetry, for example, or a rondo (a repeating melodic pattern) in music. Among the most familiar dance forms are narrative forms—dances that tell stories with a beginning, middle, and end. Dances that use a narrative form typically employ the common devices of drama, such as character presentation and development, conflict and resolution, and sometimes flashbacks and flash forwards in time, all without the use of words.

In addition to narrative, other forms that dance can assume include musical forms, such as a typical ABA or three-part form, in which the second part provides variety and the third part a return to what began the dance. Dances can also be arranged as a suite, a varied overall composition

that includes changes in each self-contained section—changes of personnel, of costume, of tempo and music—to provide variety within an overall concept. Some American ballets such as *Rodeo* or *Appalachian Spring* are arranged this way.

WRITING ASSIGNMENTS

1. Write a short essay in which you describe your attitude toward and experience with dance and dancing. Explain why you do or do not enjoy dance—either as an observer or as a participant—and provide one or more reasons based on your experience to support your attitude.

2. Do some research on two of the following dancers or dance companies. Write a one-page summary for each of your findings: Doris Humphrey, Martha Graham, Alvin Ailey, George Balanchine, Gregory Hines, Savion Glover, Gene Kelly, Ginger Rogers, Fred Astaire, The New York City Ballet, The San Francisco Ballet, The Kirov Ballet, Mikhail Baryshnikov, Michel Fokine, Bob Fosse, Vaslav Nijinsky, Merce Cunningham, Giselle, Copellia, The Nutcracker, Les Ballets Trockedero de Monte Carlo.

3. Attend a professional dance performance, and write a review that includes some background on the dance(s) performed, a discussion of what you think the dances were conveying or communicating, and a personal response to your experience of attending the dance performance.

5

Writing About Fiction and Poetry

Writing about fiction and poetry is often a common requirement in college courses, and not just in English courses. History instructors may require students to read and write about literature from the standpoint of their discipline. Novels in particular often provide a window on the past and an understanding of social and cultural values of different times and places. Stories and poems may be included for study in psychology courses to illustrate the analysis of human motivation and various psychological complexes and behaviors, such as obsession, compulsion, and personality development. Philosophy courses sometimes include literary works to exemplify particular philosophical issues and movements, such as existentialism. Courses in health and medicine may include literature about doctors and nurses, as well as about aspects of disease. Because literary works reflect the human condition, it makes a prime subject for many kinds of courses besides those specifically designed to teach its special qualities and features. This chapter offers a brief overview of the elements of fiction and poetry with a view toward writing about stories and poems.

Before you can write about literary fiction and poetry with confidence, however, you need to understand something about how to interpret works in these genres. You have already had practice in interpretation, both in your previous study of literature and in Chapter 2. You can apply the approach to analysis and interpretation provided in this book—observing, connecting, inferring, and concluding—to writing about literary works.

READING AND WRITING ABOUT FICTION

Fiction refers to imaginative prose, stories of whatever length in many genres, such as novels and novellas, tales and short stories, myths and

legends, and parables. We may write about fiction to understand it better ourselves and to share that understanding with others. We may write about fiction because a story or novel provides evidence for an argument we are making or a point of view we wish to express. And we write about works of fiction, as well, because such a task is a common assignment in university courses.

One of our focuses in this chapter is writing about short fiction. The advice provided here, however, can be readily adapted and applied to writing about longer works as well. In focusing on short fiction, we have the opportunity to work with short complete stories.

We read fiction to better understand a writer's perspective on the world; we write about fiction to clarify and sharpen that understanding. In the process we may come to a clearer understanding of our own views about people, their relationships, and their and our values and concerns.

As a part of learning to write successfully about works of fiction, you will need to consider some approaches to reading it.

Reading Fiction

In reading fiction it is helpful to understand its basic elements: plot, character, setting, point of view, style, irony, symbol, and theme. Though each of these elements will be described separately, they work together in a story or novel. Thus each fictional element, plot, for example, should be considered in relation to the others and in relation to the work as a whole.

Elements of Fiction

In reading fiction it is helpful to understand its basic elements: plot, character, setting, point of view, style, irony, symbol, and theme. Though each of these elements is described separately, the elements of a story or novel work together; each should be considered in relation to the work as a whole.

Plot is the action element in fiction, the arrangement of events that make up its story. Fictional plots often turn on a conflict between opposing forces which is resolved by the end of the work. Whether you are reading a novel, such as Jane Austen's *Pride and Prejudice*, or a short story by Ernest Hemingway, you typically expect a conflict that complicates the fictional work, pushing it toward a climax and ultimately a resolution.

Structure is related to plot. Plot is the sequence of the unfolding action; structure is the design or form of the completed action. In examining plot we are concerned with how one action leads into or ties

in with another. In examining structure, we look for patterns, the design the work possesses as a whole. A work's structure appears in recurring details of action, gesture, dialogue, and description. It appears in shifts and changes of direction and character relationships.

Character is the heart of fiction. We often read to find out what happens to characters, how the plot works out for them, sometimes identifying with them. Characters allow readers to become caught up in their stories, becoming, for a time at least, intensely real, and perhaps affecting enough to influence readers' lives after their stories have ended.

Fictional characters also represent values that convey an author's attitude and ideas embodying the meaning of the work. Authors use the following techniques to convey such attitudes, ideas, and values about their characters:

- What characters say—their speech
- What characters do—their actions
- What characters think and feel—their consciousness
- How characters look—their dress and physical appearance
- What others think about them—judgments

Setting is the place or location of a fictional work's action, along with the time in which it occurs. For some writers, setting is essential to meaning. More than a simple backdrop for action, setting can provide a historical and cultural context that enhances readers' understanding of a writer's plots and characters.

Point of view concerns an author's choice of who tells the fictional story and how it is to be told. In an objective point of view, the writer shows what happens without directly stating more than its action and dialogue imply. Stories with narrators who do not participate in the action are typically presented from a third-person point of view as compared with a first-person point of view, which characterizes stories with participant narrators.

Whether they use a first- or a third-person narrator, writers must decide how much to let the narrator know about the characters. Narrators who know everything about a work's characters are "omniscient" or all-knowing; narrators who know only some things about the characters possess "limited omniscience."

A writer's choice of point of view affects our response to the characters. That response is affected by the fictional narrator, especially by the degree of the narrator's knowledge, the objectivity of the narrator's responses, and the degree of the narrator's participation in the action. It is also affected by the extent to which we find the narrator a trustworthy guide to a work's characters and action. It is our responsibility as readers

to determine a narrator's reliability and to estimate the truth of the narrator's disclosures.

Style refers to a writer's choice of words, and to his or her arrangement of them in sentences and longer units of discourse. Style is the writer's verbal identity, as unmistakable as his or her face or voice. Reflecting their individuality, writers' styles convey their unique ways of seeing the world.

Aspects of style to consider when analyzing a fictional work include diction (the writer's choice of words), syntax (the order of words in sentences), imagery, figurative language, selection of detail, pacing of action, and the amount, nature, and purpose of description. Recognizing the particular qualities of a writer's style is one way to appreciate his or her unique literary achievement.

Irony is not as much an element of fiction as a pervasive quality in it. Irony may appear in fiction in three ways: in the work's language (or style), in its incidents (or plot), or in its point of view. Writers employ verbal irony to convey a character's limited understanding. They employ irony of circumstance or situation to reveal discrepancies between what seems to be and what is, or between what is expected and what actually happens. Writers also use dramatic irony to reveal the difference between what characters know and what readers know, sometimes directing our responses by letting us see things their characters do not.

Some writers exploit the discrepancy between what readers and characters know to establish an ironic vision in a work. An ironic vision is an overall tone that results from the multiple examples of irony that a work includes. Jane Austen's *Pride and Prejudice* reveals an ironic quality right from its opening sentence: "It is a truth universally acknowledged, that a single man in possession of a good fortune, must be in want of a wife." Jane Austen's sentence actually says the opposite of what it means. Single men of means, more often than not, in her time and in ours, are not often in search of wives. In fact, the reverse is usually the case: single men of means are sought out as prospective husbands, largely because of their money.

We can feel more confident about the ironic quality of Austen's first sentence when we examine it in relation to the sentence that follows it: "However little known the feelings or views of such a man may be on his first entering a neighborhood, this truth is so well fixed in the minds of the surrounding families, that he is considered as the rightful property of some one or other of their daughters." The ironic quality of this sentence involves its reversal of the conventional image of a woman being the "property" of a man. Its humor resides partly in this reversal and partly in its assertion of families' and their daughters'

"rights" to such an eligible man. Taken together, these opening sentences establish the ironic tone for the novel.

Symbols in fiction are objects, actions, or events that convey meaning. The meaning of a symbolic object, action, or event extends beyond its literal significance. Yet how do we know if a particular detail is symbolic? How do we decide whether we should look beyond the literal meaning of a dialogue or the literal value of an object or an action? Although we cannot always be certain about the significance of any detail, we can be alert to its possible symbolic overtones.

The following questions can serve as guidelines for thinking about symbols in literary works:

- How important is the object, action, gesture, or dialogue? Does it appear more than once? Does it occur at a climactic moment? Is it described in detail?
- Does a symbolic interpretation make sense? Does it fit in with a literal or common-sense explanation?
- What objections might be raised against a symbolic interpretation?

Theme refers to a story's idea formulated as a generalization. The theme of a fable is its moral; the theme of a parable is its teaching; the theme of a novel or story is its implied view of life and conduct. Fictional themes in novels and stories are most often obliquely presented rather than directly stated. More often than not, theme is less presented than implied; it is abstracted by readers from details of character and action that constitute the fictional story.

Writing About Fiction

Why write about fiction? Besides fulfilling a requirement, one reason is to find out what you think about a story or novel. Another is to read it more carefully. You may write about a work of fiction because it engages you. You may wish to praise its characters or style; you may want to argue with its implied ideas and values. You may find its action compelling.

Whatever your reasons for writing about a fictional work, a number of things happen when you do. First, you read it more attentively, noticing things you might overlook in a more casual reading. Second, you think more about what a particular work means and why you respond to it as you do. You also begin to acquire power over the works you write about, making them more meaningful to you.

When you write about a novel or short story, you may write for yourself, or you may write for others. In writing for yourself, you write to discover what you think. This type of writing takes casual forms,

such as annotation and freewriting, which you practiced in Chapter 1. These less formal kinds of writing are useful for helping you focus on your reading of fiction. They can also serve as preliminary forms of writing for more formal essays and papers about fiction.

Annotation

When you annotate a text, you make notes about it, usually in the margins or at the top and bottom of pages—or both. You can make annotations within the text, as underlined words, circled phrases, bracketed sentences, or paragraphs. Your annotations may assume the form of arrows, question marks, and various other shorthand marks and symbols that you devise.

Annotating a literary work offers a convenient and relatively painless way to begin writing about it. Annotating helps you to zero in on what you find interesting or believe to be important. You can also annotate to signal details that puzzle or disconcert you.

Your markings help focus your attention and clarify your understanding. Your annotations can also save you time in rereading or studying a work. And they can also be used when you write a more extended essay about it.

EXERCISE

Select a short story or a novel to read, interpret, and write about. Begin the process by making some marginal annotations.

Freewriting

In freewriting, you explore a text to find out what you think about it and how you respond to it. When you freewrite, you may have only a preliminary notion or idea for your initial response to the work. You write about the work to see where your thinking takes you.

Freewriting leads you to explore your memories and experience as well as aspects of the text. When you freewrite, you may wander from the details of the story or novel you are writing about. In the process you may discover thoughts and feelings you didn't know you had or were only dimly aware of. You can use freewriting to explore these responses. You can also use freewriting to see where it leads you in thinking about the work itself.

EXERCISE

Reflect on the story you read and annotated for the previous exercise. Do ten minutes of freewriting about the work.

Analysis

Analysis is one of the most common ways of writing about fiction, often required in college courses. In writing an analytical essay about a short story or a novel, your goal is to explain how one or more particular aspects or issues in the work contribute to its overall meaning. You might analyze a work's dialogue by explaining how the verbal exchanges between characters contribute to the story's meaning. You might analyze the characters in a story or novel to explain how their relationships reveal the story's theme or general idea.

One way to begin doing these kinds of analyses is by using the approach to interpretation explained in Chapter 2. You may wish to review the process described there: making observations, establishing connections, drawing inferences, and formulating a provisional, or tentative, conclusion.

EXERCISES

1. Make a list of observations and connections about the story you annotated and freewrote about for the previous exercises.
2. Make a list of inferences based on those observations and connections.

Steps to Writing a Literary Analysis

1. Annotate the work.
2. Freewrite about the work—its characters, language, subjects, issues, perspective.
3. Outline its structure; identify its parts and their functions.
4. Identify its speaker, narrator, characters, voices. Briefly explain the role or function of each, and identify their key relationships.
5. Describe the setting of the work and how the time and place of its action contribute to its meaning.
6. Consider its point of view (fiction), sound play (poetry), staging (drama), perspective (nonfiction).
7. Discuss your observations and impressions of the work with a few classmates.
8. Select two key passages from different parts of the work and explain why each is important. Relate the passages to each other.
9. Write a draft of an essay in which you use your detailed observations, developed in the previous steps, as the basis for developing an interpretation of the work. See the guidelines for drafting an essay in Chapter 1.
10. After receiving feedback from your instructor and your classmates on your draft, revise your essay. See the guidelines for revision, editing, and proofreading in Chapter 1.

Sample Student Essay on Fiction

The following sample essay is a brief discussion of Mark Twain's *The Adventures of Huckleberry Finn*. The focus the student, Karen DiYanni, takes is Twain's use of satire. As you read Ms. DiYanni's paper, consider the extent to which you are persuaded by her argument. Consider, also, what question you might ask her about her paper, should you have a chance to speak with her about it.

Karen DiYanni

Professor Hogan

English 102

October 10, 2002

Mark Twain's Satire in

The Adventures of Huckleberry Finn

The Adventures of Huckleberry Finn, one of the great American novels, tells a story of a young boy's journey down the Mississippi River. The author, Mark Twain, uses many literary techniques to enhance the mood and alert the reader to various themes. One major literary technique he commonly uses in his novel is satire. Satire is a method of taking a serious subject and presenting it in a humorous way. The object of satire is to ridicule the subject satirized. By using satire, Twain can dramatize the weaknesses and failings of people and society. In the novel, Twain's satire enables the reader to view the flaws in American society while enjoying the exciting adventures of Huckleberry Finn.

While Huck journeys down the Mississippi River, he meets the notorious "rapscallions" the king and the duke. They board Huck's raft, hoping the river will be a channel to promote their work. The king and duke represent people who honor money and success above all things. Since they are both humorous characters who are nothing "but just low down humbugs and frauds," the reader laughs at their ridiculous behavior. But they are more than just silly and harmless old men. They are dangerous and destructive, causing many individuals to suffer. What motivates them is greed. Through them Twain shows how greed can lead to trouble and unhappiness.

A second social fault Twain satirizes in *Huckleberry Finn* is conformity. Twain demonstrates the psychological need of an individual to conform to the ideas of a group rather than to follow his own mind. The most important example of this dangerous habit of conformity is the ridiculous feud between the Grangerfords and the Shepherdsons. In his portrayal of the feuding families, Twain creates a satire on the irrationality of love and hate. Perhaps the best example of the irrationality occurs during Huck's conversation with Buck Grangerford. When Huck asks the young man what a feud is, he replies:

> a feud is this way. A man has a quarrel with another man, and kills him; then that other man's brother kills *him;* then the other brothers, on both sides, goes for one another, then the *cousins* chip in—and by-and-by everybody's killed off, and there ain't no more feud. But it's kind of slow, and takes a long time.

As the conversation continues Twain shows that the two feuding families kill each other's members without even knowing why. Nobody seems to remember what started the feud or why the two families hate each other.

Throughout the chapters that describe the feud, Twain uses satire to show how nonsensical and irrational people can be. For example the Grangerfords and the Shepherdsons go to church on Sundays and listen to the minister preach "all about brotherly love and such like tiresomeness." Meanwhile their guns are lined up against the wall ready for use. The members of neither family ever stop to think about what they are doing and why they do it.

Finally and most importantly, the novel satirizes slavery, which Twain attacks as the greatest flaw in American society. Jim, the runaway slave, is a warm-hearted individual seeking freedom by escaping down the river with Huck. Twain shows how society's treatment of Jim is cruel, heartless, and irrational. Twain shows that Jim deserves a better fate than to be separated from the wife and children he loves and be forced to work for people who humiliate him.

Perhaps the most important way Twain reveals the absolute evil of slavery is to show how difficult it is for Huck not to turn Jim in even though Jim loves Huck dearly and has only done things to help him. Through his portrayal of Huck's crisis of conscience over what to do about Jim, Twain shows how society's values during that time were the opposite of what they should be.

Because Huck was taught at home and in school that slavery was right, it is difficult for him to go against that belief. Deep in his heart, however, he knows that Jim should be free, that he is a good man, and that to enslave and humiliate him is wrong. Society's values, however, affect Huck so strongly that he goes along with Tom Sawyer's ridiculous plans for Jim that result in Jim's further humiliation. Huck does, however, realize that Jim is not inferior to him, even though as he describes the time he apologized for his unkind treatment of Jim, he reveals that "it was fifteen minutes before I could work myself up to go and humble myself to a nigger." The important thing for Huck is that he does ask Jim's forgiveness. The important thing for Twain's readers is that they realize that in doing what society has told Huck is wrong, he ends up doing what is right and good.

Throughout the *Adventures of Huckleberry Finn*, Mark Twain treats serious matters in a humorous way. By ridiculing the weakness and faults in society, he entertains his readers while at the same time instructing them in how they should live. Through his use of satire, Twain illustrates the major themes of the novel. He gives his readers a clear perspective on the dangers of greed, the destructive consequences of conformity, and the evils of slavery.

CRITICAL THINKING: *The Popularity of the Novel*

The novel became a popular literary genre in the eighteenth century with the serial publication of books such as *Tom Jones* in England and *Les Liaisons Dangereux (Dangerous Liaisons)* in France. These novels told the stories of fictional characters whose adventures their authors chronicled as if the characters were real and their stories biography rather than fiction. In the case of Defoe's *Robinson Crusoe* and *A Journal of the Plague Year*, as well as with the case of his novel, *Moll Flanders*, the characters and

events seem as real as any actual person's life story or any actual historical chronicle of events.

To what extent do you think that the novel's popularity in the eighteenth century can be attributed to authors' attempts to make their books appear factual—either as biography or as history? What other factors contributed to the appeal of novels for readers then? To what extent do you think those appealing aspects of novels continue today to make the novel popular in the twenty-first century? And, finally, as with the eighteenth century, so today, the majority of novel readers are women. Why do you think this genre has always been more popular with women than with men?

READING AND WRITING ABOUT POETRY

You write about poems for the same reasons you write about stories, with many of the same results. In writing about a poem, you tend to read it more attentively and think harder about its meaning. In writing about a poem for yourself, to discover what you think, you can use the same strategies as for writing about fiction, including annotation and freewriting. As with writing about fiction, these less formal kinds of writing are useful for helping you focus on your reading of poems, in studying for tests about poetry, and as preliminary forms of writing when you write more formal essays and papers about poetry.

Analysis

In writing an analytical essay about a poem, your goal is to explain how one or more particular aspects or issues in the work contribute to its overall meaning. You might analyze, for example, a poem's speaker and situation, its diction or imagery, its syntax, structure, sound, and/or sense. In the process, your goal would be to see what any or all of the poetic elements contribute to the meaning of the poem as a whole.

In addition to analyzing these and other poetic elements in a single poem, you might also write to compare two poems, perhaps by focusing on their symbolism, sound effects, rhythm and meter, structure, or figures of speech. Or, instead of focusing on literary elements, you might write to see how a particular critical perspective, such as a feminist or reader-response perspective, illuminates a poem.

Elements of Poetry

In some ways, reading poetry is much like reading fiction. Readers observe details of action and language, make connections and inferences based on the details they observe, and draw conclusions about

the work's meaning or theme. Yet there is something different about reading poems. The difference, although one more of degree than of kind, involves being more attentive to the connotations of words, more receptive to the expressive qualities of sound and rhythm in line and stanza, more discerning about details of syntax and punctuation. Poetry is typically denser and more concentrated, more compressed than fiction. This is almost always true of lyric poetry, and it is often the case with epic, narrative, and dramatic poetry as well.

Diction refers to a poet's choice of words. In reading any poem, it is necessary to know what the words mean, but it is equally important to understand what the words imply or suggest. Knowing the words' denotations or dictionary meanings is necessary but not sufficient. Attention to the **connotations**, or associations and suggestions, of a poem's language is equally important for understanding. Consider the opening stanza of the following poem by the British Romantic poet William Wordsworth:

> I wandered lonely as a cloud
> That floats on high o'er vales and hills,
> When all at once I saw a crowd,
> A host of golden daffodils;
> Beside the lake, beneath the trees,
> Fluttering and dancing in the breeze.

The "I" of this poem describes himself as "lonely," which suggests not only that he is literally alone but also that he experiences that single state unhappily. When a person is lonely, he or she typically does not want to be alone. That is one of the connotations of the word *lonely*.

Wordsworth uses the word *crowd* to describe the daffodils, an unusual word in this context because *crowd* refers more often to people than to flowers. The connotations of *crowd* suggest more than a large number of people. They also carry the sense of not being alone and of not being lonely. The word *crowd* thus connotes, or suggests, the opposite of *lonely*. A third word in these lines is also rich with connotation: *golden*, which describes the color of the daffodils. If the poet had described the daffodils as "yellow" rather than as "golden," he would have lost the connotations of wealth and value that the word *golden* conveys. Considering the connotations of these and other words enables you to better understand the poem's theme and the resources of language the poet employs in expressing it.

Imagery

Poems are grounded in the concrete and the specific—in details that stimulate our senses—for it is through our senses that we perceive the world. When specific details appear in poems, they are called

"images." An **image** is a concrete representation of a sense impression, feeling, or idea. Images may appeal to the senses of sight, hearing, touch, taste, or smell.

Poetry describes specific things, for example, daffodils, fires, and finches' wings. Typically, poets describe such things in specific terms: the color of the daffodils, the glare of the fire, the beating of the finches' wings. From these and other specific details readers derive an understanding of the meaning of poems and the feelings they convey.

Consider the images in the second and third stanzas of Wordsworth's poem:

> Continuous as the stars that shine
> And twinkle on the milky way,
> They stretched in never-ending line
> Along the margin of a bay:
> Ten thousand saw I at a glance,
> Tossing their heads in sprightly dance.

> The waves beside them danced; but they
> Outdid the sparkling waves in glee;
> A poet could not but be gay,
> In such a jocund company:
> I gazed—and gazed—but little thought
> What wealth the show to me had brought.

Wordsworth emphasizes the imagery of light in describing how the stars "shine" and "twinkle." He continues this image in the next stanza's image of the "sparkling waves." The water reflects the light of the sun, by which the poet connects the two stanzas' images, linking the sky's milky way of "continuous" stars and the bay's water with its glittering waves.

Figurative Language

Language can be classified as literal or figurative. Literal language conveys the meaning of the words themselves; figurative language conveys meaning that differs from the actual meanings of the words. Of the more than 250 types of figures of speech, among the most important for poetry are metaphor and simile. The heart of both these figures of speech is a comparison between normally unrelated things.

Simile establishes its comparison by the use of the words *like, as,* or *as though*. Metaphor uses no such verbal clue. When Wordsworth writes, "I wandered lonely as a cloud," he uses a simile to emphasize the speaker's isolation. The simile limits the comparison between speaker and cloud to this one aspect. When Wordsworth writes in the poem's final stanza that the daffodils he once saw "flash" upon the "inward

eye," he uses "flash" as a metaphor for remembering—recollecting the flowers in his "inward eye," a metaphor for memory. When the speaker "sees" the daffodils in his "inward eye," he realizes the great "wealth" they have brought him. This "wealth" is figurative; Wordsworth uses "wealth" as a metaphor for joy:

> For oft, when on my couch I lie
> In vacant or in pensive mood,
> They flash upon that inward eye
> Which is the bliss of solitude;
> And then my heart with pleasure fills,
> And dances with the daffodils.

Symbols in poems are objects that stand for something beyond themselves—feelings, experiences, or abstract ideas. A rose can represent beauty or love or mortality; a lily can stand for purity or innocence. Ashes can represent death; birds can symbolize freedom. Light and darkness can stand for life and death, knowledge and ignorance, joy and sorrow.

The meaning of a poetic symbol is controlled by its context. Whether fire symbolizes lust, rage, destruction, or purification (or nothing beyond itself) can only be determined within the context of a particular poem. Nor is there any limit to how many symbolic meanings an object, character, or gesture may possess.

Deciding on the symbolic significance of a poetic detail is not an easy matter. Even when we are fairly confident that something is symbolic, it is not often a simple task to determine just what it represents. Like any inferential connection made while interpreting poetry, the decision to view something as symbolic depends in large part on whether the poetic context invites and rewards a symbolic interpretation. In Wordsworth's poem, we might say that the daffodils symbolize the power of nature to restore a person's good feeling. For it is the memory of seeing the daffodils that lifts the spirits of the poem's speaker.

Syntax, which comes from a Greek word meaning "to arrange together," refers to the grammatical structure of words in sentences and their deployment in longer units. Syntax is the order or sequence of words in a sentence. Poets occasionally alter the normal syntactic order, as does Emily Dickinson in the following stanza from "Tell all the Truth but tell it slant":

> Tell all the Truth but tell it slant—
> Success in Circuit lies
> Too bright for our infirm Delight
> The Truth's superb surprise.

Dickinson inverts normal syntax in the second line after establishing it in line 1. She then alters the word order more dramatically by reversing the grammatical sentence order of lines 3–4. The difference is apparent in the following reconstruction of Dickinson's lines in a more conventional syntactic arrangement:

Tell all the Truth but tell it slant
[For] Success lies in Circuit
The superb surprise [of] Truth's [is]
Too bright for our infirm Delight.

What the more conventional syntactic arrangement loses most dramatically is the steady rhythm that beats in Dickinson's original lines, which are arranged in alternating units of eight and six syllables.

The most familiar element of poetry is **rhyme**, the matching of final vowel and consonant sounds in two or more words, usually at the ends of poetic lines. For the poet, rhyme is a challenge; for the reader, rhyme is a pleasure. Part of its pleasure for the reader is in anticipating and hearing a poem's echoing song. Part of its challenge for the poet is in rhyming naturally, without forcing the rhythm, the syntax, or the sense. When the challenge is met successfully, the poem is a pleasure to listen to; it sounds natural to the ear, and its rhyme aids those who would remember it.

Robert Frost's "Stopping by Woods on a Snowy Evening" is one such rhyming success. Its music is best heard when read aloud.

Here is the opening stanza:

Whose woods these are I think I know.
His house is in the village, though;
He will not see me stopping here
To watch his woods fill up with snow.

Three of the stanza's four lines rhyme—1, 2, and 4, with line 3 the lone unrhymed line. But Frost does something special with this line. He makes its unrhymed sound the rhyming sound of the next stanza, thereby creating a link between the first and second stanzas.

Structure

Basically, poetic structure can be described as open or closed. Poems written in **open structures** or open forms do not follow a prescribed pattern of rhyme or stanzaic patterning. They are freer, looser, and less constrained than poems written in closed or fixed forms. Poems in closed forms adhere more closely to prescribed requirements concerning line length, rhyme, and stanzaic structure.

An example of a **closed form** is the sonnet, which is typically written according to one of two common patterns: the Shakespearean sonnet and the Petrarchan sonnet. Both kinds of sonnets are fourteen lines long with ten syllables per line arranged in alternating stressed syllables. The Shakespearean, or English, sonnet divides into three four-line quatrains and a concluding couplet. Its rhyme scheme is abab cdcd efef gg. The Petrarchan or Italian sonnet consists of an eight-line octave and a six-line sestet, often rhyming abba abba cde cde.

Not every poem in closed form, however, follows as strict a set of formal requirements as the sonnet, as the following poem by the modern American poet Langston Hughes indicates:

My People

The night is beautiful,
So the faces of my people.
The stars are beautiful,
So the eyes of my people.
Beautiful, also, is the sun.
Beautiful, also, are the souls of my people.

Hughes's poem uses parallel structure throughout. Lines 1 and 3 echo each other structurally. Lines 2 and 4 do the same, as do lines 5 and 6. Although parallelism is the primary structural device of the poem, there is another structure that accompanies it. The odd-numbered lines identify aspects of nature: night, stars, and sun. The corresponding even-numbered lines focus on the human dimension, specifically on how African Americans are considered "beautiful," a word that appears in each couplet or two-line stanza. In addition, the poem describes a kind of progression from dark to light to greater light—from the darkness of night, to the stars with their reflected light, to the sun with its self-generated light. This progression is paralleled by that describing Hughes's people—first their faces, then their eyes, and finally their souls. The progression moves from outside to inside, external to internal, surface to depth. Seeing the structural design of Hughes's poem helps readers appreciate his poetic accomplishment while also enhancing their understanding of the poem's meaning.

Theme

As with fiction, theme in poetry involves an abstraction or generalization drawn from the details of a work. **Theme** refers to the idea of a poem, its meaning and significance. One of the dangers of deciding on the theme of a poem is in oversimplifying its meaning, perhaps reducing a complex idea to a cliché. Like other forms of literature,

poems can contain multiple themes. Considering a poem's themes leads us toward understanding what it signifies—what it says and suggests about life.

Sample Student Essay on Poetry

In the following sample student essay, Loren Spigelman provides an interpretation of May Swenson's poem "The Universe." Mr. Spigelman is interested in the questions posed by Swenson's speaker. His attention to the form of the poem, to its arrangement on the page should spur you to look as closely at that form as he does. Notice how he links the poem's form to the meaning as he understands it. When you finish reading Mr. Spigelman's paper and rereading Swenson's poem, consider the extent to which you agree with his interpretation, and why.

```
Loren Spigelman
Humanities 101
Professor Johnson
November 23, 2002
                     What's the Big Picture?
                  May Swenson's "The Universe"

                  The Universe
                      What
                       is it about,
                  the universe,
                  the universe about us stretching out?
             We, within our brains,
                within it,
                              think
             we must unspin
        the laws that spin it.
                         We think why
                  because we think
                  because.
                  Because we think,
                       we think
                       the universe about us.
```

But does it think,

the universe?

Then what about?

About us?

If not,

must there be cause

in the universe?

Must it have laws?

And what

if the universe

is not about us?

Then what?

What

is it about?

And what

about *us?*

MAY SWENSON
[*b.* 1919]

May Swenson, in "The Universe," offers her readers a deep
analysis, as well as a reason not to be so analytical, of the uni-
verse. Her messages are expressed in her syntax and configuration,
which makes them effective enough to make you stop and think, stop
thinking, and then think about not thinking.

First, Swenson brings up a question and provides an answer.
What is it about the universe that makes us try so hard to figure
it out? What makes us think we can? All of us, in varying degrees,
think we have an understanding, or at least the ability to *have* an
understanding of everything. "We think 'why' because we think
'because.'" We ask questions because we believe we have the
answers, or the capacity to comprehend the answers. And since our
minds are so able, we try to conquer even the most complex ques-
tions, such as the meaning behind the universe. We can unspin the
laws that spin it. Swenson's wordplay with her description of
thinking, and trying to answer these questions, makes this poem
seem ambiguous, almost senseless—just like the universe we are
trying to analyze.

Next, the poet points out the futility of trying to figure out the universe. We think about the universe because it is vital to our existence. Swenson suggests, however, the possibility, (or probability) that we are not vital to the universe's existence. The universe is not required to answer to us; therefore, it does not have to make sense to us. It seems to have no laws, but then, it does not need any. Therefore, it is silly to try to figure it out because it has no rhyme or reason. This opinion is expressed in the configuration of the poem. The words do not seem to be arranged neatly, in order, line by line, as we think they should. They seem to be arranged haphazardly, without sequence. Such is the arrangement, or apparent lack thereof, of the universe.

But when we look closely at the poem we see lines are arranged so that repeated words fall under one another. These words are the ones that describe our role. Lines three and four repeat the word "universe." This is the first instance where we see some kind of pattern. The first thing one needs to do in order to solve a problem is to define it. This is what Swenson does by lining up the word "universe." This is her subject and ours.

Lines five and six show where this problem solving will take place—within our brains, which are within the universe. Here is another example of how futile it is to try to understand the universe. How can we begin to understand something we exist within? One cannot explain something accurately unless he or she sees the whole picture. It is impossible for us to see the whole picture because we are inside it.

Knowing what the problem is and where it will be solved, the poet then shows the reader how to go about solving it, beginning with line seven. We will think. By thinking, we will unspin the laws that spin the universe (as shown by the repetition of the word "spin" in lines eight and nine. Thinking is our main tool, so the poet does exactly that down the middle column of the entire poem until line 17: Universe, universe, think, think, think, think, universe, think, universe. This central column identifies the central idea. The lines eleven to thirteen (right in the middle of our thinking) reveal an attempt to come up with some answers, all beginning with "because." But of course, this is a worthless plan, which is why the column also shows our failure to understand. From

line 18 to 30, we go back to asking what, universe, what, universe, what, what, what. Our questions remain unanswered.

Swenson raises one more question—this one also without an answer. If the universe does not "think about us," then what about us? Where do we fit in? The poet illustrates this in the right-hand column. Beginning with line two, and intermittently until line 31, we go back to wondering what the universe is about. What part do we play? If we cannot understand the meaning behind the universe, can we understand the meaning behind us? After instructing us not to think, we must then think. The poet leaves this question unanswered because it is for us to think about, and come up with our own understanding—if we can. Although we think we can understand every-thing, we are left wondering whether we even understand ourselves.

CRITICAL THINKING: *Does Poetry Matter?*

The poet W. H. Auden once wrote in one of his poems that "poetry makes nothing happen," which might be read to mean that poetry has little, if any, effect on the world and on people's everyday lives. A recent book by the poet and critic Dana Gioia was entitled *Can Poetry Matter?* Gioia believes that it does matter, that poetry is important in people's lives, and that it might even influence events beyond the lives of individuals.

What possibilities for poetry do you see as a part of people's lives? Do you, for example, think that poetry might be useful on particular occasions? Do you think that it might be of value for particular kinds of life situations? If so, for what kinds of occasions and situations do you think poetry can make a difference—can actually matter?

6

Writing About Drama and Theater

This chapter, "Writing About Drama and Theater," explains some differences between the literary and theatrical dimensions of plays. The chief aspects or elements of drama are presented in pairs: plot and structure, character and conflict, dialogue and monologue, setting and staging, thought and theme. Forms of writing about drama described and illustrated include annotation, the double-column notebook, analysis, and the review.

Unlike the other literary genres, drama is a staged art. Plays are written to be performed by actors before a live audience. When we are unable to view a play in the theater, a reasonable alternative is to read their scripts with attention to both their literary and theatrical elements.

DRAMA AS LITERATURE

As a literary genre, drama has affinities with fiction and poetry. Like fiction, drama possesses a narrative dimension: A play's action often embodies a story conveyed by its plot. Like fiction, too, drama relies on dialogue between and among characters. Unlike fiction, however, in which a narrator may mediate between us and the story, there is no such authorial presence in drama. Instead we hear the voices of the characters directly in the dialogue the dramatist has created for them.

Drama shares features with poetry as well. Plays may, in fact, be written in verse. Shakespeare, for example, wrote in blank verse (unrhymed iambic pentameter), the French playwright Moliere in rhymed couplets. Plays share with lyric poems the quality of being overheard: We listen to characters or to speakers expressing their concerns as if there were no audience present.

Plays may also serve a rhetorical function as vehicles of persuasion, and thus share elements with prose nonfiction. Henrik Ibsen and Bernard Shaw frequently used the stage to dramatize ideas and issues and to advance arguments on their behalf. For most of his plays Shaw wrote prose prefaces in which he discussed the plays' dominant ideas. In drama, ideas typically possess more primacy and immediacy than in poetry and fiction, to which critics of the genre testify. Aristotle, for example, made *thought* one of his six elements of drama; Eric Bentley, a modern theater critic, entitled one of his books *The Playwright as Thinker*.

However, if we look exclusively to the literary aspects of drama, or to its poetic, fictional, and rhetorical elements, we may fail to appreciate its uniquely theatrical idiom. To gain this more theatrical appreciation of drama, we should read plays with special attention to their performance elements. We can try, for example, to hear the voices of characters, imagining their tones and inflections. We can try to see mentally how characters look, where they stand in relation to one another, how they move and gesture. We can read, in short, as armchair directors and as aspiring actors considering the physical and practical realities of dramatic performance.

DRAMA AS THEATER

Much of the pleasure drama brings us arises from the way the language of the play's script comes alive in the speech of living actors. Part of our pleasure involves watching (or imagining) actors dramatically enact the "lives" of the characters they portray. We enjoy the way they walk and talk, the way they interact with other characters, even their facial expressions and bodily gestures. For even the smallest gesture, such as the lowering of a hand, or the slightest facial movement, such as the raising of an eyebrow, can contribute to our sense of a play's human experience.

Drama is a *mimetic* art, one that imitates or represents human life and experience. A large part of the pleasure drama brings us, in fact, reflects its ability to show us aspects of human life meaningfully dramatized. Drama is also an *active* art in which actors portraying characters serve as agents, doers, who make things happen through speech and bodily action. In addition, drama is an *immediate* art, one that represents action that occurs in the play's present. Our experience of drama is of watching events as they occur. We are firsthand witnesses of present-tense actions rather than auditors who simply hear about events later from a narrator secondhand.

An additional critically important feature of drama derives from its mimetic, active, and immediate qualities: its interactive nature. The action of plays is interaction. Dramatic characters respond and relate to one another through dialogue and action, through speech and visual displays. Such character interaction is the heart of drama: It is the spring of plot, the source of meaning, and the central reason for our pleasure in dramatic experience.

Drama, however, is interactive in still another way. Drama is a *composite* art—one that makes use of many other arts. Painting and architecture are used in the design and creation of stage sets and in the way stage and actors are lighted or kept in shadow. Music and other sound effects may be used to suggest feelings, build tension, and create mood and atmosphere. Sculpture and dance are suggested by the way characters are positioned on stage and by their movements around it. Drama, thus, is a complex art that involves a dynamic interaction of many visual and aural elements. In viewing drama and in reading it with emphasis on its theatrical aspects, we need to be as alert as possible, keeping our eyes and ears, as well as our minds open.

Our pleasure in drama then arises from the cumulative impact of a multitude of impressions both visual and aural. Makeup and costume, lighting and sound, speech and action, posture and gesture, movement and expression—all work together to bring plays to life and to create a distinctive theatrical experience for the audience. It is this experience we attempt to capture when we read drama, knowing all the while that reading a play is not the same as sitting in an audience and watching it enacted on a stage. To compensate we try to read plays imaginatively as if we were actually watching them being performed. We attempt to read drama theatrically.

ELEMENTS OF DRAMA

A play is a complex network of action, dialogue, and reference that embodies feeling and conveys meaning. As viewers of plays in the theater and as readers of play scripts on the page, we come to understand dramatic works through an understanding of their elements. We consider the following elements of drama: plot and structure, character and conflict, dialogue and monologue, setting and staging, and, finally, thought and theme. We also apply what is said about these elements of drama to the following one act play, *Andre's Mother*, by Terrence McNally.

Andre's Mother
by
Terrence McNally

CHARACTERS

CAL

ARTHUR

PENNY

ANDRE'S MOTHER

Four people enter. They are nicely dressed and carry white helium-filled balloons on a string. They are CAL, a young man; ARTHUR, his father; PENNY, his sister; and ANDRE'S MOTHER.

CAL: You know what's really terrible? I can't think of anything terrific to say. Goodbye. I love you. I'll miss you. And I'm supposed to be so great with words!

PENNY: What's that over there?

ARTHUR: Ask your brother.

CAL: It's a theatre. An outdoor theatre. They do plays there in the summer. Shakespeare's plays. (*To* ANDRE'S MOTHER.) God, how much he wanted to play Hamlet. It was his greatest dream. I think he would have sold his soul to play it. He would have gone to Timbuktu to have another go at that part. The summer he did it in Boston, he was so happy!

PENNY: Cal, I don't think she . . . ! It's not the time. Later.

ARTHUR: Your son was a . . . the Jews have a word for it . . .

PENNY: (*Quietly appalled.*) Oh my God!

ARTHUR: Mensch, I believe it is and I think I'm using it right. It means warm, solid, the real thing. Correct me if I'm wrong.

PENNY: Fine, dad, fine. Just quit while you're ahead.

ARTHUR: I won't say he was like a son to me. Even my son isn't always like a son to me. I mean . . . ! In my clumsy way, I'm trying to say how much I liked Andre. And how much he helped me to know my own boy. Cal was always my two hands full but Andre and I could talk about anything under the sun. My wife was very fond of him, too.

PENNY: Cal, I don't understand about the balloons.

CAL: They represent the soul. When you let go, it means you're letting his soul ascend to Heaven. That you're willing to let go. Breaking the last earthly ties.

PENNY: Does the Pope know about this?

ARTHUR: Penny!

PENNY: Andre loved my sense of humor. Listen, you can hear him laughing. (*She lets go of her white balloon.*) So long, you glorious, wonderful, I-know-what-Cal-means-about-words . . . *man!* God forgive me for wishing you were straight every time I laid eyes on you. But if any man was going to have you, I'm glad it was my brother! Look how fast it went up. I bet that means something. Something terrific.

ARTHUR: (ARTHUR *lets his balloon go.*) Goodbye. God speed.

PENNY: Cal?

CAL: I'm not ready yet.

PENNY: Okay. We'll be over there. Come on, pop, you can buy your little girl a Good Humor.

ARTHUR: They still make Good Humor?

PENNY: Only now they're called Dove Bars and they cost 12 dollars.

(PENNY *takes* ARTHUR *off.* CAL *and* ANDRE'S MOTHER *stand with their balloons.*)

CAL: I wish I knew what you were thinking. I think it would help me. You know almost nothing about me and I only know what Andre told me about you. I'd always had it in my mind that one day we would be friends, you and me. But if you didn't know about Andre and me . . . If this hadn't happened, I wonder if he would have ever told you. When he was so sick, if I asked him once I asked him a thousand times, tell her. She's your mother. She won't mind. But he was so afraid of hurting you and of your disapproval. I don't know which was worse. (*No response. He sighs.*) God, how many of us live in this city because we don't want to hurt our mothers and live in mortal terror of their disapproval. We lose ourselves here. Our lives aren't furtive, just our feelings toward people like you are! A city of fugitives from our parent's scorn or heartbreak. Sometimes he'd seem a little down and I'd say, "What's the matter, babe?" and this funny sweet, sad smile would cross his face and he'd say, "Just a little homesick, Cal, just a little bit." I always accused him of being a country boy just playing at being a hot shot, sophisticated New Yorker. (*He sighs.*) It's bullshit. It's all bullshit. (*Still no response.*) Do you remember the comic strip Little Lulu? Her mother had no name, she was so remote, so formidable to all the children. She was just Lulu's mother. "Hello, Lulu's Mother," Lulu's friends would say. She was almost anonymous in her remoteness. You remind me of her. Andre's Mother. Let me answer the questions you can't ask and then I'll leave you alone and you won't ever have to see me again. Andre died of AIDS. I don't know how he got it. I tested negative. He died bravely. You would have been proud of him. The only thing that frightened him was you. I'll have everything that was his sent to you. I'll pay for it. There isn't much. You should have come up the summer he played Hamlet. He was magnificent. Yes, I'm bitter. I'm bitter I've lost him. I'm bitter what's happening. I'm bitter even now, after all this, I can't reach you. I'm beginning to feel your disapproval and it's making me ill. (*He looks at his balloon.*) Sorry, old friend. I blew it. (*He lets go of the balloon.*) Good night, sweet prince, and flights of angels sing thee to thy rest! (*Beat.*) Goodbye, Andre's Mother. (*He goes.* ANDRE'S MOTHER *stands alone holding her white balloon. Her lip trembles. She looks on the verge of breaking down. She is about to let go of the balloon when she pulls it down to her. She looks at it a while before she gently kisses it. She lets go of the balloon. She follows it with her eyes as it rises and rises. The lights are beginning to fade.* ANDRE'S MOTHER'S *eyes are still on the balloon. Blackout.*)

Plot and Structure

One of the reasons we read plays is to discover what happens, to see how particular consequences result from specific observable actions. We become engaged by a play's story line and remain held by its twists and turns, until the playwright resolves its complications. The details of action, or incidents, in a well-organized play form a unified structure. This unified structure of a play's incidents is called its *plot*.

It is important to realize that a dramatic plot is not merely a series of haphazardly occurring incidents. It is, rather, a carefully arranged series of causally related incidents. The incidents of the plot, that is, must be connected in such a way that one gives rise to another or directly results from another. And of course the playwright shapes and arranges the incidents of the plot to do precisely these things.

Besides being unified, a good plot will also be economical. This means that all the play's incidents contribute to its overall meaning and effect. No actions included in the play are extraneous or unnecessary. The economy of a play's plot distinguishes it from everyday life, in which a multitude of minor actions mingle indiscriminately with significant related incidents. Dramatists, however, fit together the actions of their plays in meaningful ways.

The *exposition* of a play presents background necessary for the development of the plot. The *rising action* includes the separate incidents that "complicate" the plot and build toward its most dramatic moment. These incidents often involve conflicts either between characters or within them, conflicts that lead to a crisis. The point of crisis toward which the play's action builds is called its *climax*. Following this high point of intensity in the play is the *falling action*, in which there is a relaxation of emotional intensity and a gradual resolution of the various strands of the plot in the play's *denouement*. This last is a French word that refers to the untying of a knot.

The plot of *Andre's Mother*, for example, involves a few simple actions—conversation about a dead man, the release of the helium-filled balloons in an unusual memorial ceremony, and a lecture critical of the dead man's mother, given by his gay lover. The crisis, climax, and denouement all occur during this speech, which occupies half the length of the brief play and immediately after, as the mother kisses her balloon and then releases it.

Whether playwrights use a traditional plot or vary the formula, they control our expectations about what is happening through their arrangement and structure of incidents. They decide when to present information and when to withhold it, when to arouse our curiosity and when to satisfy it. By arranging incidents, a dramatist may create suspense, evoke laughter, cause anxiety, or elicit surprise. One of our

main sources of pleasure in plot, in fact, is surprise, whether we are shown something we didn't expect or whether we see *how* something will happen even when we may know *what* will happen. Surprise often follows suspense, thus fulfilling our need to find out what happens as we await the resolution of a play's action.

In considering our expectations and response to the developing action of a play, we approach the concept of plot less as a schematic diagram of a play's completed action and more as an evolving series of experiences we undergo as we read or view it. For our emotional experience in reading a play is an important aspect of the play's meaning for us.

Another dimension of a play's structure is the way it satisfies our need for order and form. Besides considering how a play is structured to affect us emotionally, we can also consider ways it exhibits formal or artistic design. In the first instance we attend to the theatrical and psychological aspect of structure; in the second, to its aesthetic dimension. Both contribute to our experience of drama. Both aspects of structure contribute to the meanings of plays.

We can be alert for a play's structure even as we read it for the first time, primarily by paying attention to repeated elements and recurring details—of action and gesture, of dialogue and description—and to shifts in direction and changes of focus. Repetition signals important connections and relationships in the play, relationships between characters, connections among ideas. Shifts in direction are often signaled by such visual or aural clues as a change of scene or the appearance of additional characters. They may also be indicated by changes in the time or place of the action and by alterations in the play's language or tempo.

In *Andre's Mother*, for example, we notice a shift from brief exchanges of dialogue among the characters to a single long speech that Cal gives to Andre's mother. We notice, too, that all the characters speak except for Andre's mother. There is a shift as well in her reaction—as she is about to break down in tears—and in the way she pulls her balloon down and kisses it before releasing it.

Character and Conflict

If we read plays for their plots—to find out what happens—we also read them to discover the fates of their characters. We become interested in dramatic characters for varying, even contradictory, reasons. They may remind us in some ways of ourselves; they may appeal to us because they differ from us. They may represent alternative directions we might have taken, alternative decisions we might have made. And although fictional characters cannot be directly equated with actual

people, they are usually recognizably human, and as such, subject to the changing conditions of circumstance.

Characters bring plays to life. First and last we attend to characters— to how they look and what their appearance tells us about them; to what they say and what their manner of saying expresses; to what they do and how their actions reveal who they are and what they stand for. We may come to know dramatic characters and respond to them in ways we come to know and respond to actual people, all the while real- izing that characters are imaginative constructions, literary imitations of human beings. Yet even though characters in plays are not real people, their human dimension is impossible to ignore, because actors portray them, and their human qualities typically engage us. Nonethe- less, it is helpful to remain mindful of the distinction between dramatic characters and actual people, so that we do not expect them always to behave realistically and so that we do not expect playwrights to tell us more about them than we need to know for the meaning of the play.

Character is the companion of plot; the plot of a play involves the actions of its characters. Another way of defining plot, in fact, is sim- ply as characters in action (or interaction). And in the same way that a play's plot must be unified, so must a character be coherent. This means that all aspects of the character—speech, dress, gesture, movement— must work together to suggest a focused and unified whole. Our sense of a character's coherence, however, derives mainly from his or speech and actions. From these we gain a sense of who the characters are and what they are like. But even though speech and action are the primary indicators of character, our sense of characters' identity and personal- ity are derived essentially from four things: (1) their actions—what they do; (2) their words—what they say and how they say it; (3) their phys- ical attributes—what they look like; and (4) the responses of other char- acters to them—what others say or do about them.

Even a play as short as *Andre's Mother* gives us an opportunity to assess the characters and understand their relationships via their words and actions. We acquire hints of understanding about Andre and his relationship with each of the other characters—his lover, his sister, his father, and his mother, who is otherwise unnamed, to suggest, as Cal intimates, her remoteness.

Dialogue and Monologue

This discussion of character and conflict brings us to a critical aspect of dramatic characters—their speech or dialogue. Although generally we use the word *dialogue* to refer to all the speech of a play, strictly speaking, "dialogue" involves two speakers and "monologue," one. An

important dramatic convention of dialogue in the broader sense is the use of a soliloquy to express a character's state of mind. A *soliloquy* is a speech given by a character as if alone, even though other characters may be on stage. A soliloquy represents a character's thoughts so the audience can know what he or she is thinking at a given moment. Soliloquies should be distinguished from *asides*, which are comments made directly to the audience in the presence of other characters, but without those other characters' hearing what is said. A soliloquy, moreover, is typically a speech and is thus longer than an aside, which is usually a brief utterance.

Dialogue is more than simply the words characters utter. It is also itself action, since characters' words have the power to affect each other and the audience. Words in drama initiate events and effect change. Dialogue, moreover, is an important index of character, not only in what characters say about themselves and each other, but in their manner or way of expressing what they say. This concern with characters' language is crucial, whether we attend plays in the theater or imagine them performed in the theaters of our minds.

Aspects of dialogue are admittedly much harder to discern in a silent reading of the play. Some would contend that they are impossible to hear. But with an imaginative effort and a willingness to read aloud on occasion, we can begin to hear how much meaning and feeling the dialogue conveys. Better yet, we can go to the theater and hear the drama for ourselves.

In imagining how the lines in *Andre's Mother* might be spoken, we try to hear the tones of voice each of the actors uses to portray his or her character. For such a brief play there are a variety of voice tones and inflections the characters employ in their snatches of conversation with one another. In the long speech Cal makes before Andre's mother, we would listen for both the predominant tone of accusation and for shifts in tone that convey his changing feelings as he speaks.

Setting and Staging

The action of a play, like that of any fictional work, occurs in a particular place and time. We call this spatial and temporal location its *setting*. Although some plays are set approximately in the times and places of their composition, more often than not a play's setting departs significantly from the time and place of its composition. The immediate world of a playwright is not often directly represented in the environment and milieu in which he or she sets a particular play. This does not mean, however, that there cannot be important connections between the playwright's immediate milieu and the possibly

very different time and place of the play's action. Sometimes, in fact, particularly in political plays (and often in Shakespeare), historical events of earlier times reflect social and political situations of the playwright's own time. Shakespeare's London is clearly not the world depicted in *Hamlet*, yet the importance of monarchy, central to the play, was important in sixteenth-century England. The critical thing, though, is not the literal identity of a playwright's milieu with that of a given play, but rather the impression the setting makes on us, what it contributes to our understanding and experience of the play.

When we attend a play (and when we read one) the first thing we see is the stage set, the physical objects that suggest the world of the play. The stage set is usually indicated by the playwright, though the degree of detail and specificity of this rendering vary from one playwright to another, and from one literary period to another.

The setting for *Andre's Mother* is not specifically indicated, except that it is outdoors. The stage directions are sparse until the very end, when the mother's actions are described in detail. The set for this play leaves room for directors and stage managers to decide just how to represent its world. Some plays, however, include very explicit directions for stage sets—Anton Chekhov's *The Cherry Orchard* or Arthur Miller's *Death of a Salesman*, for example—and so, leave less room for decisions by the director or stage manager.

The setting of a play is one element of its *staging*, or the spectacle a play presents in performance. Staging in general refers to all the visual detail of a play. It includes the positions of actors onstage (sometimes referred to as *blocking*); their postures, gestures, movements, and expressions *(stage business)*; the scenic background; the props and costumes; the lighting and sound effects.

A playwright's stage directions will sometimes help us imagine such things as we read. However, while an increased imaginative alertness to the sights and sounds of a play can help us approximate the experience of a dramatic performance—enhancing our understanding of the play and our appreciation of the dramatist's craftsmanship—it still is no substitute for a direct theatrical experience.

Thought and Theme

From examining the various elements of a play we derive a sense of its significance and meaning. One of the dangers of reading drama without attending sufficiently to its theatrical dimension is that we may reduce its meaning to an overly simplified and generalized statement of idea. We use the word *theme* to designate the main idea or point of a play stated as a generalization. Because formulating the theme of a play

involves abstracting from it a generalizable idea, theme inevitably moves away from the very details of character and action that give the play its life. This is not to suggest that we should not attempt to identify a central idea or set of ideas from plays, but only that we should be aware of the limitations in doing so.

First, we should distinguish the ideas that may appear *in* a play from the idea *of* a play. The meaning of a play—its central, governing, or animating idea—is rarely identifiable as an explicit social, political, or philosophical idea manifest in the dialogue. Rather, a play's idea or meaning is almost always implicit, bound up with and derivable from the play's structure, character interactions, dialogue, and staging. Because the theme of a play grows out of the relationships among its concrete details, any statement of it that omits significant aspects of a play's dramatic elements will inevitably represent a limitation and a distortion of the play's meaning. Any statement of theme, in fact, inevitably only approximates a play's meaning rather than fully characterizing or embodying it.

As readers of drama, we tend to reach for theme as a way of organizing our responses to a play, as a way of coming to terms with what it implies about how human beings live. At times we emphasize our personal responses, our emotional reactions to what the play dramatizes. At times we seize on an intellectual response based on observations of its action and on inferences drawn from connections we establish from among its details. At times we look at what the play is; at times we feel what the play does. For the meaning of any play is ultimately more than any statement of theme, any series of words and sentences that we employ to describe it. Our experience, our moment-by-moment engagement with the play on stage or page, constitutes its meaning for us.

The theme of *Andre's Mother* concerns the tensions that exist in families whose children fear their parents' disapproval of their sexual identities. Or we might say that the play portrays the sense of loss and grief that exists in families when they realize too late that they shut their homosexual children out of their lives. An additional theme concerns the inability of language to express the full extent of people's feelings about these things and about one another. This is suggested forcefully by the silence of Andre's mother but is indicated in earlier remarks about the inadequacy of words to capture feelings.

WRITING ABOUT DRAMA

You may write about a play for some of the same reasons you write about poetry and fiction, art, and music. You may wish to understand it better, and writing can aid your thinking. You may need to review a

play for the school newspaper, or you may be required to write a paper about a play as a course assignment.

When you write about a play, you may write for yourself or you may write for others. Frequently these are intertwined. You write informally first for yourself as a way to spur thinking and discovery. Then you write something more formal—that paper or review—to share with others.

What follows are two strategies for using informal writing about a play as a way to begin thinking about its issues, aspects, and elements. The two techniques, annotation and the double column notebook, are illustrated and focus on a scene from Sophocles' play *Antigonê*. A sample student paper on *Antigonê* is also included.

Annotation

When you annotate a text, you make notes about it, usually in the margins or at the top and bottom of the pages—or both. Annotations can also be made within the text, as underlined words, circled phrases, or bracketed sentences or paragraphs. Annotations may also assume the form of arrows, question marks, and various other marks.

Annotating a literary work offers a convenient and relatively painless way to begin writing about it. Annotating can help you to focus in on what you think is interesting or important. You can also annotate to signal details that puzzle or disconcert you.

Your markings serve to focus your attention and clarify your understanding of a story or novel. Your annotations can save you time in rereading or studying a work. And they can also be used when you write a more formal paper.

Double-Column Notebook

Another way of writing for yourself, informally, is to use the double-column notebook. To create a double-column notebook, divide a page in half vertically (or open a notebook so that you face two blank pages side by side). On one side *take* notes, summarizing the scene's situation, action, and ideas. On the other side, the responding side, *make* notes, recording your thinking about what you summarized on the opposite side. On the responding side, ask questions, speculate, and make connections.

Here is an example of a double-column notebook, for the excerpt from the Greek drama *Antigonê*. Notice how the entries in the double-column notebook are more detailed, and written in a more formal style, than the annotations shown with the excerpt.

CHORAGOS: Like father, like daughter:

 both headstrong, deaf to reason!

 She has never learned to yield:

CREON: She has much to learn.

 The inflexible heart breaks first, the toughest iron

 Cracks first, and the wildest horses bend their necks

 At the pull of the smallest curb.

 Pride? In a slave?

 This girl is guilty of a double insolence.

 Breaking the given laws and boasting of it.

 Who is the man here,

 She or I, if this crime goes unpunished?

 Sister's child, or more than sister's child,

 Or closer yet in blood—she and her sister

 Win bitter death for this!

Margin notes:
- How important is this choral comment?
- Images: iron, horses
- conflict: man/woman age/youth

 (To servants)

 Go, some of you.

 Arrest Ismenê. I accuse her equally.

 Bring her: you will find her sniffling in the house there.

 Her mind's a traitor: crimes kept in the dark

 Cry for light, and the guardian brain shudders;

 But how much worse than this

 Is brazen boasting of barefaced anarchy!

ANTIGONÊ: Creon, what more do you want than my death?

CREON: Nothing.

 That gives me everything.

ANTIGONÊ: Then I beg you: kill me.

 This talking is a great weariness: your words

 Are distasteful to me, and I am sure that mine

 Seem so to you. And yet they should not seem so:

 I should have praise and honor for what I have done.

 All these men here would praise me

 Were their lips not frozen shut with fear of you.

 (Bitterly) Ah the good fortune of kings.

 Licensed to say and do whatever they please!

CREON: You are alone here in that opinion.

ANTIGONÊ: No, they are with me. But they

 keep their tongues in leash.

CREON: Maybe. But you are guilty, and they are not.

ANTIGONÊ: There is no guilt in reverence for the dead.

CREON: But Eteoclês—was he not your brother too?

ANTIGONÊ: My brother too.

CREON: And you insult his memory?

ANTIGONÊ (SOFTLY): The dead man would not say that I insult it.

CREON: He would: for you honor a traitor as much as him.

ANTIGONÊ: His own brother, traitor or not, and equal in blood.

CREON: He made war on his country. Eteoclês defended it.

ANTIGONÊ: Nevertheless, there are honors due all the dead.

CREON: But not the same for the wicked as for the just.

Margin notes:
- Why does Creon accuse Ismenê?
- Anarchy? Is Creon a bit paranoid?
- She knows how to fight back.
- image: dogs on a leash held. in check by fear
- a complication: the other brother, Eteoclês
- tempo: pace picks up here with rapid-fire dialogue exchange
- buildup of interest

Summary and Observations

Creon's language is formal, even self-important. He sounds like, or tries to sound like, a king.

Part of Creon's anger stems from Antigonê's rebellion against *him*, against *his* law. Part derives from her seeming disregard for the law of the land more generally.

Antigonê's view seems to be that since Creon's law was a bad one, she shouldn't obey it. And even further, that she has a responsibility to disobey it since the gods require that family members honor their dead. She points out that her burial of her brother was necessary for her own peace of mind.

Antigonê at one point angers Creon by reminding him that he is not almighty. She attempts to put him in his place, to remind him that his rule has limits. He doesn't like that. Nor does he like her suggestion that it is better to die than to obey an unjust law or live in a corrupt society.

Creon, of course, sees her act of rebellion and her disrespectful attitude toward him as king as the cause of societal corruption.

During the course of their dialogue (more a confrontation or debate than a conversation), they insult each other. Creon calls Antigonê stubborn; Antigonê calls Creon a fool.

Creon's long speech parallels and answers Antigonê's. Once the two positions have been established, we watch and listen as the dialogue speeds up as Antigonê and Creon trade arguments and insults.

Throughout this taut scene both characters seem tense and angry. They neither like nor respect each other.

Responses and Reactions

Creon is unpalatable here. He's pompous and arrogant. Yet to some extent he seems justified in being angry. What's interesting here is why Creon reacts so strongly to the violation of his edict. It probably has something to do with his recent acquisition of power. He is very likely more than a little insecure in his new position. He must feel the need to assert himself and establish his authority. Suppose he ignores Antigonê's action. What will people think of him? Won't they see him as weak?

Antigonê's point has merit. She has to do what she has to do.

Antigonê seems the more likeable of the two.

Antigonê enjoys pulling Creon down a peg. Her tone does sound insulting. She almost seems to enjoy thinking of herself as a martyr for a cause. Isn't she a bit theatrical here, relishing her role and the image she projects as much as, or even more than, the idea and point of view she stands up for?

Doesn't Creon overreact here in seeing Antigonê's action as an example of "anarchy"? And doesn't he also overreact in assuming that Ismenê is also guilty? He assumes things without testing them.

As in any good fight, the antagonists really do try to hurt each other.

It's an enjoyable verbal battle—for us readers.

Even though the dialogue is somewhat stylized and conventional, it is beautifully arranged for maximum punch and counter-punch.

The effect overall is of tension building to the point of explosion.

Analysis

In writing an analytical essay about a play or a scene from a play, your goal is to explain how one or more particular aspects or issues in the work or the scene contribute to its overall meaning. In analyzing the dialogue in a scene from a play, your goal would be to explain what the verbal exchanges between characters contribute to the play's meaning and to its effect on the audience. You might analyze the imagery of a play to see what it suggests about a character's perspective, or the author's attitude toward the characters or the action. Or you might analyze its plot or staging to see how the playwright's manipulation of action creates tension and conflict, humor and irony.

Sample Student Essay About Drama

The following sample student paper focuses on the imagery of dust in *Antigonê*.

Melissa Gerstel

ENG 102

Dr. DiYanni

December 13, 1999

Antigonê Undusted

For centuries, literary works have used nature in connection with various human characters. The natural elements often enhance human traits by complementing them. The same human/nature interaction theme is laced throughout Sophocles' famous tragedy, *Antigonê*. In the play, the burial scenes witnessed by the Sentry reveal aspects of Antigonê's character because they are filled with images that represent Antigonê's inherent link with nature.

The Sentry first appears in the play as the unfortunate messenger who is forced to tell Creon that someone has buried Polyneices' corpse. The burial of the body violates Creon's decree that no citizen of Thebes shall honor Polyneices with a proper burial because Polyneices died a traitor to his country. Although the burial, in the traditional sense, requires covering the corpse deep beneath the soil or building a "funeral mound," the burial the Sentry describes is still considered a proper one, for the earth is sprinkled over the corpse (Jacobs 7). The Sentry tells Creon:

> Look:
>
> The body, just mounted over with light dust: you see?
>
> Not buried really; but as if they'd covered it
>
> Just enough for the ghost's peace (I, 80-83)

Unbeknownst to them, Antigonê is the perpetrator of this illegal act. Unfortunately, though she attempts to bury her dead brother, his spirit remains in an undetermined state. Nonetheless, through her actions, she reveals her affinity with nature, for her intended burial of Polyneices does not disturb the earth (Jacobs 8). Her gentle and almost ethereal connection with the environment allows her to leave the burial site without a remaining trace of her exploits. The Sentry describes the unmarked area with an incredulous air:

> The ground was dry, not a sign of digging, no,
>
> Not a wheeltrack in the dust, no trace of anyone.
> (I, 76-77)

Antigonê does not plunder the earth with shovels, picks, or other tools of human invention; she gathers the dust with her bare hands. The heroine then becomes part of nature, as nature becomes part of her. However, because the Sentry's speech contains implications of otherworldly elements, the chorus believes it is not a work of a mortal or an animal; rather it is the will of a heavenly deity (Oudemans 176).

The dust plays an even greater role in Antigonê's connection with nature during the second burial, which results in Antigonê's capture. Interestingly enough, the Sentry evokes different images when he informs Creon of the second burial. He describes the first burial as a product of a mysterious, even spiritual force. In contrast, he describes the second burial as a wild but natural occurrence. Although the Sentry overlooks Antigonê's role as a driving force in the surroundings, he unconsciously realizes the spiritual and natural elements behind Antigonê's burial actions (Oudemans 176). The body is "soft . . . and stinking" (II, 23). The toxic odor of the corpse, then, is the result of Creon's unyielding authority. By forbidding the burial of Polyneices, Creon ensures that his "enemy" is punished by physical contamination (Oudemans 177).

At the burial site, however, nature repels against Creon's decree. While the Sentry and the other guards look out for trespassers near the body, the sun suddenly beams down on them with its intensity. Then a "dust storm" occurs and they are momentarily blinded, although from their point of view it lasts an eternity (Steiner 224). The Sentry describes the storm's violent attack on his senses:

> A storm roared up from the earth, and the sky
> Went out, the plain vanished with all its trees
> In the stinging dark. We closed our eyes and endured
> it. (II, 30-32)

The dust storm is significant because it shows the violent fusion of natural elements. The dust, which emerges from the ground, converges with the wind, which is a product of the sky (Steiner 224). The result, then, is one of natural contamination.

The dust storm is also significant because it reflects Antigonê's relationship with nature. Antigonê highly values the dust since it serves to honorably bury her brother Polyneices. It is important to note that the dust storm occurs *after* the guards eliminate dust from the corpse. The storm then sweeps sprinkles of dust over the body, as Antigonê had done before. The storm is depicted as Nature and enters the scene simultaneously with Antigonê. Together they demonstrate the practice of burying Polyneices' corpse, but they never fully succeed in burying it (Jacobs 9).

After the dust storm subsides, the guard becomes aware of Antigonê's presence and witnesses her deep wrought sorrow. He observes her, weeping angrily over the dust removed from her brother, and compares her painful cries to those of a bird's:

> I
> I have seen
> A mother bird come back to a stripped nest, heard
> Her crying bitterly a broken note or two
> For the young ones stolen (II, 35-38)

Antigonê's sorrow stems from her awareness that she has "failed" her brother. Although she originally places dust on his corpse to rid him of external pollution, the guards' removal of the

dust causes the body to be merely an infringement on the environ-
ment, rather than a part of it (Oudemans 177). The dust storm's
occurrence fixes the problem by spilling more earth onto the land-
scape, and therefore on the body, but its overwhelming force is one
of aggression whereas Antigonê's display of her ritual is one of
tenderness.

In addition, the dust that the storm strews about is devoid of
any personal trappings. Nature's dust just exists without regard to
tradition, heritage, or family identity. However, when Antigonê
buries Polyneices by hand, she buries a part of herself with him.
Though Antigonê affiliates herself with the natural world, she
understands that there is a distinct difference between Polyneices'
burial by the wild (nature) and by the domestic (Antigonê). As Seth
Benardete says in "A Reading of Sophocles' *Antigonê*," "Antigonê's
recognition . . . that the storm's dust is not her dust perfectly
agrees with the law's prescription that man must bury man" (Steiner
225).

Works Cited

Jacobs, Carol. "Dusting Antigonê." *MLN* 111.5 (1996): 890–917.
 Project Muse. http://muse.jhu.edu/journals/mln/v111/111.
 5jacobs.html (10 Dec. 1999).
Oudemans, Th. C. W., and A. P. M. H. Lardinois. "Tragic Ambiguity:
 Anthropology, Philosophy, and Sophocles' Antigonê." *Brill's
 Studies in Intellectual History*. Vol. 4. New York: E.J. Brill,
 1987.
Sophocles. "Antigonê." Trans. Dudley Fitts and Robert Fitzgerald.
 Literature: Reading Fiction, Poetry, and Drama. Compact Edi-
 tion. Ed. Robert DiYanni. New York: McGraw-Hill, 2000. 811–841.
Steiner, George. *Antigonês*. New York: Oxford University Press,
 1984.

Writing a Review of a Play

Besides a formal class paper—an essay about a play—such as the one
Melissa Gerstel wrote on the imagery of *Antigonê*, you may be required
to review a play in performance. In such an assignment, the emphasis
is typically less on analyzing the play's elements or aspects to arrive at

an interpretation of its meaning than to assess the particular performance you attend. Your emphasis in the review, thus, should be on how well the actors bring the play to life, and how its stage setting and costumes, its lighting and sound effects contribute to the overall quality of the production and performance.

Even with this emphasis on evaluating the play in performance, however, you need to have a sense of the play's central issues and themes. For it is those qualities and aspects that the director and actors will strive to realize in their production and performance.

The following review of the musical play, *Vincent*, based on the life of the painter Vincent van Gogh, appeared in the *New York Times*. As you read it, note how the reviewer, Lawrence Van Gelder, presents information about the performance, how he introduces allusions to van Gogh's life, and how he renders mixed judgments about the play.

A Musical Life of van Gogh, Evoking the Art and the Anguish

"Vincent" Wings Theater
by Lawrence Van Gelder

The severed ear. The suicidal gunshot. The sunflowers.

All are present in "Vincent," an operatic new musical retracing the tortured life of Vincent van Gogh, playing through Feb. 1 at the Wings Theater, 154 Christopher Street, in Greenwich Village.

With a book, music, and lyrics by Robert Mitchell (the songs are based on van Gogh's letters to his brother, Theo, and to friends), "Vincent" proves ultimately touching though not consistently satisfying. Its effectiveness owes much to the persevering performance of Paul Woodson in the demanding title role of the lonely, loveless artist, and to the sympathetic portrayal by Mark Campbell of the often vexed but caring Theo.

As biography, "Vincent," directed by Judith Fredricks, wavers between a dutiful recounting of the artist's travails and, more successfully, dramatic depiction of his emotions and the evolution of his artistic tenets.

The show's lyrics are blunt and understandably unpoetic, its music suitably spiky, dark, and dissonant. No one is likely to leave humming a tune. The single brief dance number, set in a Parisian cafe where the leading artists of the day—among them Cezanne, Signac, Gauguin and Toulouse-Lautrec—air their theories, falls flat, though the 19-member cast displays commendable talents.

The scenes in the cafe leading to van Gogh's fierce espousal of art that is not a race to see who is first in innovation but to portray what is real, are powerful, as is an earlier scene in the van Gogh home. There, in the presence of his disapproving parents, the grubby, penniless van Gogh, who has lived with a prostitute and her illegitimate child and who favors the contemporary literature of Hugo and Zola, likens himself to a "gruff, scruffy dog," but one with a soul and a human heart.

In the end this soul and this heart infuse "Vincent," like the artist himself, with a stubborn nobility.

EXERCISES

1. Answer the following questions about Van Gelder's review.
 - Why does he begin with the references he does?
 - How does he include information about the dates and place of performances? Where else might he have positioned this information?
 - What does Van Gelder like and dislike about the musical?
 - On the basis of this review and given the opportunity, would you attend a performance of *Vincent*? Why or why not?
2. Write a review of a play or other dramatic performance. Use the following guidelines to ensure that you include the necessary aspects in your review.

 Guidelines for Writing a Review of a Play
 - Title of the play
 - Time and place of performances
 - Name of the playwright
 - Its focus, topic, and major themes
 - Relevant background and contextual information
 - Relation to previous works by the playwright or similar works by others
 - Your final judgment about its value and quality

CRITICAL THINKING: *Who Wrote Shakespeare's Plays?*

Among issues in literary studies that have reappeared over the centuries is that of whether William Shakespeare is the actual author of plays such as *Hamlet, Julius Caesar,* and *Romeo and Juliet.* Those arguing

against Shakespeare's authorship claim that he was not sufficiently well educated to have written such masterpieces, with their wide range of knowledge and their brilliant language. These critics of Shakespearean authorship offer alternative authors, including, among others, Sir Francis Bacon and Edward De Vere, the Seventh Earl of Oxford, and the Renaissance playwright Christopher Marlowe, all of whom were extremely well educated and themselves very good writers.

Defenders of Shakespeare claim that the preponderance of evidence is in favor of his authorship of the plays. These defenders offer as evidence that Shakespeare's name is on the first printed editions and that he was an actor and part owner of an acting company that needed new material, which he wrote as a normal part of his theatrical work. They refer to contemporary paintings of Shakespeare and to his extensive knowledge of Italy, classics, and the law, which run throughout his plays.

How would you go about deciding whether Shakespeare wrote the plays attributed to him? What questions would you have in pursuing your investigation of the matter? What kinds of evidence would you look for? What types of sources would you consult, and what kinds of credentials for the writers of those sources would you find credible?

7

Writing About Film

Writing about film shares a number of characteristics with writing about other arts, particularly writing about drama, fiction, and music. We will take up some of the similarities and differences between film and these other arts as part of our introductory discussion of the nature of film.

But just what is film, anyway? What do we mean when we refer to film? In common speech we refer to films as "movies," though we sometimes use the word "films" as well. The singular word "film" as distinguished from the plural terms "films" and "movies" (in the context of this discussion) refers to the general features and overall capacity of the medium. A third term, "cinema," is more formal and academic. It connotes the serious side of film, in which technical, theoretical, and aesthetic issues are paramount.

James Monaco* distinguishes among these terms in the following way: According to Monaco, who follows French film theorists, film concerns the relationship of film artworks with the world around them; cinema, on the other hand, refers to the aesthetic and internal structure of their art and artistry. In this schema, movies are seen as more commercial enterprises and represent their economic aspect.

Whatever terms we use to designate these varying aspects of film (and we will use this term to refer to the genre in general), it should be noted that a variety of films can be described according to function and intent. One kind of spectrum would put documentary films on one end, mass-market entertainment films in the middle, and "art" films on the other end. Another way to distinguish among films is according to film genres with categories such as historical films, westerns, horror movies, gangster

*This chapter is indebted to James Monaco's *How to Read a Film*, 3rd ed., New York: Oxford University Press, 2000.

films, war films, action films, fantasy and science-fiction films, romantic comedies, films based on novels, and so on.

In this chapter our concern is to consider how we might view a film, whatever its type, carefully enough to be able to write about it. Our goal is to consider some of the special qualities of films, though without entering into detailed technical questions.

FILM AND THE OTHER ARTS

Viewing a film in a movie theater shares some similarities with viewing a play in a theater designed for the enactment of drama. In both instances, we are usually seeing human actors portraying various roles of the story being dramatized. In viewing both films and plays, the audience enters their worlds with a temporary suspension of disbelief that what we are watching are real events experienced in real time by actual people. We suspend our disbelief in the artifice and in the fictional world we are viewing until the performance is over, and we applaud (or not) what we have seen.

But there are some significant differences between theater and film, between plays and movies. In most plays, there is no clearly defined point of view, as there is in film. Although playwrights can keep the focus on their characters through speech and action, filmmakers control the way we see their films through decisions about what images and scenes to film, through controlling exactly what the audience is permitted to see. A playwright cannot control where the audience looks or what it focuses on as it watches a play. On the other hand, an audience of a film sees only what the filmmaker decides to let it see.

Other differences between films and plays include the constant per-spective or distance maintained between an audience and the actors dramatizing a scene in a play and the varying degrees of close-up and long-shot views a filmmaker can provide in a film. That's why stage actors work so hard to develop their voices, both to project and to con-vey nuances of feeling. Stage actors also need to develop bodily gesture, whereas film actors have to use facial expression more carefully and diligently, allowing for the possibilities of the camera close-up shot.

Still other differences are attributable to the technical limitations and possibilities allowed on stage and screen. Although stage and set designers have exercised great ingenuity in creating stage sets for plays, film set designers have greater latitude because of the technology avail-able to them, particularly since the advent of digitalization.

Films also have close connections with fiction, particularly with novels. Unlike drama, films and novels are driven by their narrative impulse—their impulse to tell a story. Although films are less limited

in what they can do visually than are plays, they are more limited than novels in their handling of time. While it is certainly true that plays and films can suggest shifts in time from present to past and back again, the novelist has a considerably easier task in adjusting not only such time shifts, but also the ways that time can be speeded up or stretched out, giving a few words to many years or many pages, even an entire volume, to a single day, as James Joyce does in *Ulysses*.

Like plays, too, films are subject to the attention span of their audiences, while readers can pick up and put down novels, since they are not limited by the duration of a film or a theatrical performance. The biggest difference, of course, between novels and films and theatrical productions is the verbal/visual distinction. An audience sees actors portraying characters, on the one hand, as they are presented by filmmakers, dramatists, and directors of movies and plays. Readers, on the other hand, must imagine characters and scenes as they are created by and suggested through the medium of writing, of words on a page. Readers, in a sense, must conspire with writers to bring characters, actions, and scenes to life in ways they do not when watching a play or a film.

Like theater, film has both a pictorial and a musical dimension. Images in films are momentarily pictorial, like paintings. Of course the images move, which differentiates them from paintings. Films also include soundtracks, which typically include significant amounts of music. And just as in concert music, film music affects audiences emotionally, though concert music exists in and takes its meaning from itself, whereas film music exists as part of a larger and predominantly visual and narrative art.

We might identify still other ways in which film is similar to and different from the other arts, but these comparative and contrastive elements can help us consider the special nature and quality of film en route to reading and writing about films.

READING A FILM

In "reading" a film, we interpret it, attempting to understand its implications, to make sense of it. When reading a film, we ask ourselves what its producer and director intended its audience to experience and understand through viewing it.

In learning to read films, we can consider some of the same elements that we considered in discussing reading fiction and drama—plot and structure, character and conflict, point of view, staging and setting—as well as aspects such as irony and symbolism. In writing about films, you may wish to focus on such elements or aspects; you can consult the

discussion of those elements in Chapters 5 and 6. Here, however, we briefly discuss a few elements special to film, although some of them have counterparts in the other arts.

ELEMENTS OF FILM

Just as we refer to the elements of literature, drama, and the other arts, we can also approach film through a consideration of its special features. Among those we consider here are photography, acting, *mise en scene* and movement, editing, sound and music.

Photography (Shots)

Although the smallest element of film is the single image, film-makers work with shots and sequences of shots to create a scene or a sequence of scenes. The film shots are typically taken at different times—often involving repeated takes to create a scene. Scenes themselves are usually edited later with shots from the different takes, so that what an audience sees has been constructed from many takes of individual shots and scenes to construct the finished sequences that constitute the completed film.

Films may be shot primarily in close-ups, which tend to be disorienting because we don't see background and context. On the other hand, films may be made primarily with long shots, which tend to emphasize context and action and to downplay character and personality. Most films, of course, combine these two very different shot styles and incorporate a variety of approaches to them.

One key aspect of a film shot is focus. Deep focus shots, which keep foreground, middle ground, and background all in reasonably sharp focus. Shallow focus shots allow the director to emphasize one of these, foreground, for example, over the others. The focus of a shot can also be made sharp or soft, with a sharp focus often emphasizing a realistic edge, a life-like verisimilitude, and a soft focus emphasizing a more attenuated, sometimes romanticized image.

Additional factors affecting the way film shots look to an audience are its angle of approach, lighting, and composition. Shots made from a high angle make the subject look smaller and less important, whereas shots from a low angle emphasize the size and significance, even the power of the subject. Lighting can create all sorts of effects, with characters appearing in full or partial light, backlit, and also partially lit and partially shadowed, with one character or one feature of a single character highlighted.

The sequence of shots on page 131 includes both mid-range and close-up shots.

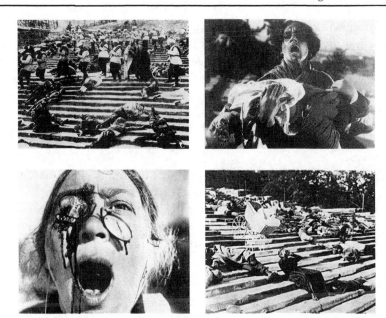

These stills from Eisenstein's *Battleship Potemkin* reveal the director's dramatic use of close-ups and his use of contrasting mid-range shots in starkly realistic style.

Sergei Eisenstein, "Battleship Potemkin," 1925. Goskino, Courtesy of The Kobal Collection

Acting

One of the first questions we often ask about a new film is who is in it, what actors are starring in the film. We may also want to know who produced and directed it, but mostly our interest centers on the actors and the roles they play in films. From the beginning, the film industry centered on its stars, a small number of actors (and actresses, when that term was in use) who had major drawing power, appealing to large audiences of viewers. Today we have Matt Damon, Tom Cruise, Jennifer Lopez, and others; in the past there were Clark Gable, Rock Hudson, Marlene Dietrich, Ava Gardner, Katherine Hepburn, Humphrey Bogart, and numerous others through the years.

Actors, however, are not all stars. Many actors serve in type-cast, familiar secondary roles; these character actors, as they are known, can become familiar screen (or television) faces, though they don't assume the role or possess the drawing power and name recognition of stars. In addition, some directors will cast nonprofessionals in acting roles in films, as did Vittoria de Sica, in his classic film *The Bicycle Thief*. Also appearing in films are "extras," the people used to fill out crowd scenes and background scenes for the stars of a film.

In viewing a film, we should attend to an actor's performance in his or her given role. We should ask ourselves how well the actor carries the role. Is the actor's performance convincing? Does the actor make you believe in the character's situation and circumstances and behavior? Some criteria you can use to analyze and evaluate an actor's performance when writing include the following:

- Is the actor well suited to the role for which he or she has been cast?
- How well did the actor's voice, gestures, and facial expressions convey the character being portrayed?
- Is the actor believable in the role? Why or why not?
- In which scenes does the actor excel—or not excel? Why?
- How well does the actor relate to the other actors and their roles in the film?

Mise en Scene and Movement

The term *mise en scene* is a French phrase that refers to theater, meaning "placing on stage." It involves the arrangement of all the visual elements on the stage of a theatrical production. With respect to film, *mise en scene* refers to the visual elements of a film, from its still shots to the patterns of changing images we see as the film's action moves in a constant flux. Just as in viewing any single image from a film, a still such as a close-up or long-distance camera shot, in viewing the moving film images, you should be alert for the visual patterns created and their effects on viewers.

We can be alert for how the director arranges the actors in a given scene and how the scenes are sequenced to create a particular design or pattern of designs. One of the most common principles for sequencing shots and scenes is contrast. Consider, for example, the way the *Star Wars* films or the *Lord of the Rings* trilogy of films handles battle scenes, alternating between long shots of vast armies with close-ups of the effect of the devastation on particular individuals. Just as we examine the composition of a painting by analyzing the orderly arrangement of its parts, so too do we with film shots. And just as we can analyze the way a play's scenes flow visually from one to another and its sets change, so too can we consider the flow and changing scenes in a film from a similar perspective—though in a film, of course, the changes are much more rapid.

Another aspect of the moving images of films is the physical movement of the actors, their kinetic dimension, and then, in addition, the ways in which actors' movements combine and commingle in shifting scenes. Think, for example, of slapstick comedy routines of characters

such as Laurel and Hardy or the Three Stooges. Or think of the way physical movement plays out in films such as *Crouching Tiger, Hidden Dragon,* or the aerial acrobatics of films involving plane fights, such as those in the Tom Cruise film *Top Gun.*

Some questions to consider when analyzing and writing about the visual effects of *mise en scene* and movement are the following:

- How does the film's setting contribute to its overall emotional atmosphere?
- How is the setting related to the plot and the characters of the film?
- To what extent is the setting realistic, symbolic, fantastic?
- What kinds of repetition and contrast do you notice in the flow of scenes? What effects do the repetitions and contrasts create?
- To what extent is the film's action presented as occurring in a realistic, recognizable temporal manner, and to what extent is the action slowed down or speeded up—and with what effects?
- What is the overall impression created by the film's visual details and their arrangement?

Editing

Film editing is a highly complex and extremely important art and film element. Editing affects the look and feel as well as the rhythm and pacing of a film. The extent to which the camera lingers on a shot and scene, and the extent to which it moves slowly across a wide shot, affect the emotional as well as visual implications of a film. Lingering shots tend toward languor; fast, quick shots that jump from one to another create a kind of edginess.

Film shots are edited to create continuity in the action—or to create discontinuity and disrupted action. It depends on what effects the director is aiming for. Editing also allows films to present action realistically without having to do so in "real time." For example, in shooting a scene in which a pair of lovers walk across a bridge under lamplight, stop halfway to talk, resume their walk, and then stop again to kiss, might take a few minutes of real time to film. In the edited version, three or four shots strung together can depict that action in a matter of seconds.

One important aspect of editing is montage, sequences of rapidly edited images, often transitional, to suggest the lapse of time or the passing of events. Montage editing was a specialty of the great Russian filmmaker Sergei Eisenstein, best known for his silent film, *Battleship Potemkin,* which includes a famous montage referred to as the Odessa steps sequence or montage. Four images of that montage appear on page 131.

Some questions to keep in mind when you analyze and write about a film's editing are:

- How fast or slow are the shot sequences? How consistent are they throughout the film? With what effects?
- Does the film employ much cutting between and among scenes, or is it relatively fluid and continuous? With what effects?
- How are changes of time and place—transitions—indicated?
- What kinds of juxtapositions of scene, perhaps extending to montage, do you notice, and with what effects?

Sound and Music

Although film is primarily a visual medium, it also includes an aural component—sound, which includes, but is not limited, to the use of music. Films incorporate many kinds of sounds in many ways and for a variety of purposes. The most notable but perhaps taken for granted is the sound of speech, the film's dialogue. There may also be a narrative voice-over of an unseen speaker, who comments on the film's characters and action, and who fills in plot details, and more. Of course, there are also on- and off-screen sounds—of cars starting, glass shattering, sirens sounding, bombs exploding, for some examples of loud sounds—and for softer ones, of people breathing, lights being clicked on, matches struck, and the like. Directors—and actors—use sound effects to establish tone, enhance character revelation, and create and enhance setting, as well as to advance the film's action.

Music, the score for a film, is an important sound element. Music can be used as a background hardly noticeable; it can be used to heighten suspense, to reveal character, to intensify emotion. Much of the time when we watch a film, we hardly notice the music. But if you switch off the sound and watch in silence, you detect a difference in the character and the quality of the viewing experience, since music contributes heavily to a film's effects.

Here are a few questions to consider when analyzing and writing about a film's sound and music:

Guidelines for Analyzing Film Sound and Music

- What kinds of sounds, on or off screen, does the film include? For what purposes?
- What sound effects seem most important in the film? Why?
- To what extent does the film use sound to convey a character's state of mind? How? With what effects?

- To what extent is sound used for transitions or scene shifts in the film? With what effects?
- Does the musical score of the film remain in the background (background music), or does it assume greater prominence? Where? With what effects?
- To what extent does the music convey or create emotion? To what extent does it convey a character's thoughts and feelings?
- How would the viewing experience differ if the music, the film score, were omitted?

DOCUMENTARY FILMS

Among the many film genres is the documentary. A documentary film presents factual information about life in the world. Unlike typical feature films, which are fictional, documentary films attempt to describe the world as it is. It is important to note, however, that regardless of how factual a documentary film may be, it always expresses a particular point of view—a stance or perspective on reality. Classic documentaries such as *Nanook of the North*, about Eskimo life, approach their topic as objectively as possible, providing information. A recent example is the Academy Award winner in the documentary category, *March of the Penguins*. But this recent film, and a documentary such as *Hearts and Minds*, about the Vietnam War, attempt to do more than just provide information. These films, like many documentaries, attempt to move an audience emotionally and perhaps, as in the case of the Vietnam film, to present a political argument. Other recent documentaries expressing strong political viewpoints include those of the director, Michael Moore, especially *Sicko*, about the healthcare industry.

A documentary, then, will very likely take a stand on an issue, and perhaps offer a solution to a problem, as well as provide information. Documentary films remain based on fact, on things that have actually occurred or are really happening. However, through selection of certain details, omission of other details, selection and sequencing of scenes, documentary filmmakers convey their ideas about the world as they see it.

Some of the elements used in documentary films are newsreels, pictures from archives, interviews, and prerecorded music (sometimes archival period recordings). All these elements can be found in the highly successful documentary films—actually series of films—produced by Ken Burns, which were shown to great acclaim on public television, and which are now available on DVD. These documentary film series include *The Civil War*, *Jazz*, and *Baseball*.

Here are some questions to consider when viewing and writing about a documentary film:

- What are the purpose and point of the documentary?
- To what extent is the director's point of view about the topic evident?
- To what extent is the documentary an attempt to persuade viewers toward a specific point of view? To what degree is the documentary informational?
- What documentary elements does the film include? With what degree of success?

EXERCISES

1. Think back to a documentary film you have seen. Perhaps it was a segment of a television documentary, such as *60 Minutes*, *Prime Time*, or *Dateline NBC*. Write a couple of paragraphs about the film in which you consider the following questions: What was the subject of the documentary? What was its purpose and its point? What kinds of documentary elements were included, and how effectively were they presented? To what extent did you find the documentary engaging and/or persuasive? Explain.

2. If you haven't seen a feature-length documentary, such as *Sicko*, *Hearts and Minds*, *Nanook of the North*, or the *March of the Penguins*, rent or borrow a DVD copy and watch one of them. Write a one-page summary of the film.

ANIMATED FILMS

Animated films, which bring cartoon characters to life, have long been popular with children, though adults have frequently enjoyed them as well. The first and most important full-length animated films are those produced by Walt Disney, including *Cinderella*, *Snow White*, and *Fantasia*, among many others. The earliest animated films, however, were short cartoons, which have been perennially popular since their inception.

For decades, Disney studios had a virtual monopoly on feature-length animated films. In 2006, Disney purchased competitor Pixar Studios, which has produced, among other animated films, the award-winning *Toy Story*. Disney studios, however, hasn't been idle, having continued to make animated films, including the highly popular *The Lion King*.

Here are a few questions to consider when viewing or writing about an animated film:

Questions for Analyzing Animated Films

- How interesting are the characters? How well do the characters relate to one another?
- How believable are the characters within the context of the film's world? To what extent have the characters been given human, or anthropomorphic, traits? With what effects?
- What kind of voices do the animated characters have? What kinds of physical characteristics have they been given? How convincing do you find these?
- What are the purpose and point of the film? What is its story and what does that story contribute to the film's meaning?

EXERCISES

1. Think back to an animated film you have seen. Perhaps it was a classic Disney film, such as *Bambi, Cinderalla*, or *Snow White and the Seven Dwarfs*. Write a couple of paragraphs about the film in which you consider the following questions: What was the subject of the animation? What was its purpose and its point? How enjoyable did you find the film? Why? Explain.

2. Write a short paper in which you compare one of the classic Disney animated films, or a more recent Disney animated film, such as *The Lion King*, with a film made by Pixar Studios, such as *Toy Story*. Consider the bulleted questions listed above as you compare and contrast the films.

CRITICAL THINKING: *Ancient Rome in Film*

Many films have been made in which Rome has been depicted at different historical stages. Among the most popular is the 2000 movie *Gladiator*, starring Russell Crowe, a film that won a number of major film awards, including Oscars for Best Actor and Best Film.

Why do you think *Gladiator* became a hit? What accounts for its popularity?

To what extent is the film historically accurate? And how would you go about evaluating its historical accuracy?

Would it matter greatly if the plot were fiction while the general spirit of the times was accurately depicted? Explain.

How would you characterize the film's treatment of Commodus, Marcus Aurelius, Maximus, and Lucilla? To what extent have they been portrayed with reasonable historical accuracy?

WRITING ABOUT FILM—THE FILM REVIEW

There are a number of kinds of writing about film. One of the most common is the movie review, which can be found in the newspapers of most cities, as well as in the student newspapers on many college campuses.

Besides the movie review, there are longer articles that discuss the films of a particular director, such as the films of Woody Allen, Federico Fellini, or Steven Spielberg, to suggest a few prominent figures. Another type of film writing describes and analyzes the career of a particular actor, tracing the trajectory of roles he or she plays across a spectrum of films. The more elaborate and detailed reviews of new films by major actors and directors often include analysis of their previous work, as the reviewer situates their current film performance in the larger context of earlier roles and previously directed films.

Theorists of film, like theorists of other arts, philosophize and speculate about the nature of film as a medium, analyzing its technical dimensions, its technological aspects, and its social, economic, and cultural values and contexts.

For our purposes, the movie review provides an occasion to consider films from a number of aspects, without having to introduce specialized terminology about its technology.

In writing a review of a film, you need to watch it carefully, usually more than once. In the process you tend to observe elements and details of the film you might overlook under normal circumstances—situations when you viewed a film simply for pleasure and without the ulterior motive of writing about it.

An Example of a Film Review

The following review is of the 2002 film, *Catch Me If You Can.*

Catch Me If You Can is brisk fun.
by
Peter Rainer

LEONARDO DICAPRIO SHOWS UP AGAIN AS THE chief protagonist of Steven Spielberg's breezily enjoyable but thin *Catch Me If You Can*. It's based on the autobiographical book by Frank Abagnale Jr. about

his four-year career in the mid-sixties as a master check forger who, beginning at age 16, also pretended to be a Pan Am co-pilot, a Harvard-trained physician, and a New Orleans attorney. The movie has a bright and colorful look appropriate to sixties pop and an amusing Road Runner-versus-Wile E. Coyote plot that pits Abagnale against dogged, dark-suited FBI agent Carl Hanratty, played with bureaucratic brio by Tom Hanks. We are lulled into believing that this pre-counterculture, pre-Vietnam America was a place where the innocent could more easily be bilked than in our own time. (More likely, the innocence remains; the bilking is just more sophisticated.) The real Abagnale was able to fool people because he was older-looking and prematurely gray, while DiCaprio, although he was 27 when he made the film, looks like a precocious teen. It's difficult to buy the fact that so many people could be taken in by such a stripling, but in every other respect, DiCaprio is a shrewd casting choice: There's an inscrutability to his boyish glamour that makes him something of a cipher; he may look like an open book, but he's not at all easy to read.

Early on, in films like *This Boy's Life* and *Marvin's Room*, DiCaprio had a seething undercurrent that separated him from most fresh-faced juvenile actors. Spielberg doesn't call upon DiCaprio to tap into that undercurrent and go beyond the blithe escapades of a kid con man, and the movie suffers for it. We are, after all, watching a movie about someone who relishes cheating people and treating them as dupes, and although Spielberg and his screenwriter, Jeff Nathanson, are careful to frame most of Frank's victims unsympathetically, we're still left feeling rather queasy. What's missing in Frank is any trace of cruelty or dark guile. Spielberg explains him away as a misguided but well-meaning product of a suburban broken home—Frank's down-on-his-luck-father is hauntingly well played by Christopher Walken—whose scams are meant to reconcile his divorced parents. This is well-tilled Spielbergian turf.

Despite Spielberg's periodic forays into darker realms, he may not have the comprehension of character required to do justice to someone like Frank Abagnale, who, after serving some prison time, was ultimately recruited as a fraud expert by the FBI and today is a highly successful entrepreneur in the security-systems field. (It's as if his ultimate scam was to go straight.) To a lesser degree, and with much more at stake, Spielberg revealed a similar lack of comprehension of the

dark side in his presentation of Oskar Schindler in *Schindler's List*, who was also a species of con artist and who was made to seem right-eously idealistic. I wish Spielberg hadn't shelved his oft-announced movie project about his boyhood hero Charles Lindbergh; the avia-tor's pro-Nazi sympathies would have challenged the director's com-placencies and stretched him as an artist. For his latest movie, Spielberg can't be faulted for wanting to confect a simple entertain-ment after the heavy-going *A.I.* and *Minority Report.* The problem is, he's chosen a hero who is far from simple.

EXERCISE

Select a film you would like to review. It might be a film you have not yet seen; it might be a film you have already viewed but which you think is worth seeing again. If possible, rent the video or DVD of the film so you can replay scenes you would like to analyze and which you might include to illustrate and support the ideas about the film you develop in your review.

Be sure to include the following considerations in your review:

- The type of film
- The main characters and the actors who portray them
- The setting of the film's action
- The name of the director
- An evaluation of the acting performances
- An interpretation of the film's meaning and significance

8

Writing with Sources

Research writing is one of the most challenging kinds of writing you can do. It requires not only development of an idea, claim, or thesis, as in your other kinds of essay writing, but also use of primary or secondary sources, which you must integrate smoothly and naturally into your own writing. In addition, research writing adheres to strict rules of documentation and citation by which you indicate what sources of information you are using and precisely what you have taken from them.

In spite of, or perhaps because of, its complexity, research writing can be extremely rewarding. Doing research—gathering information from libraries, people, the Internet—can be exciting, as you learn about a subject through reading intensively about it. The challenge of putting together your findings in a research essay or report that reflects your perspective or point of view on what you have learned can bring great intellectual enjoyment.

One reason to do research about works of art is to understand them better. Another is to see how they have been interpreted in the past. Scholars who have devoted their lives to the study of particular artists, writers, architects, or composers can provide insights that can enrich your understanding and deepen your appreciation of the artworks you study.

THE RESEARCH ASSIGNMENT

Your instructor may assign you a specific research topic, a general topic that you have to narrow down in an acceptable way, or an open topic, which gives you the liberty to choose your own topic. Whatever kind of research assignment you are given, be sure that you understand its nature and requirements. Ask your instructor to clarify the purpose of the assignment.

Does your instructor expect you to write a three-page paper or one of a dozen pages—or something in between? Are you expected to type your paper, to use primary sources, secondary sources, or both? Are you being asked to focus on a single work using only one or two sources, on a single work using multiple sources, on multiple works and multiple sources? Are you expected to document your sources by providing footnotes or parenthetical citations and a bibliography or list of works cited? Be sure to clarify the specific requirements of the research writing assignment.

Because so much is often at stake in a research assignment—a heavy investment of time and work and perhaps a significant portion of a course grade—it is critical that you understand what you are supposed to do for the assignment. Asking questions early on can save you from wasting large amounts of time later. It can also prevent misunderstanding, reduce frustration, and generally improve your chances of producing a piece of researched writing that meets your instructor's expectations.

Selecting a Topic

Let's suppose you are asked to write a paper—say, five to seven typed pages, double-spaced, approximately 1,250 to 1,750 words. You need to cite a minimum of six sources, at least three of which must be from periodicals or the Internet and three from books. You also are required to prepare a bibliography or works cited list.

Instructors sometimes provide topics, either by assigning everyone the same topic (or some variation of it) or by giving individual students assigned topics of their own. If that is your situation, you can skip down to the next section on finding and using sources. Most often, however, you will need to choose your own topic for a research essay, paper, or report.

You can do a number of things to simplify the task of finding a topic. First, ask your instructor for suggestions. Second, look over your class notes and your reading notes for key points of emphasis, for repeating issues and concerns, and for provocative questions and complex ideas.

Third, talk with other students, with both your classmates and with students who have already written papers for the course you are now taking. Fourth, consult other sources with information about the artist, composer, author, and work (or works) you will be writing about. A general reference work on artists, composers, or authors will provide you with an overview of his or her life, works, and influence.

Your aim in using these human and library resources is to develop a viable topic, one you can explore in the allotted number of pages

required for the research assignment. It should be a topic you can say something thoughtful about, with some degree of detail and specificity. It's a good idea to clear your topic with your instructor. Your instructor can help you shape the topic, perhaps by narrowing or broadening it in ways that might make it more manageable, more sharply focused, and potentially more engaging.

Working with an Assigned Topic

If you are given a topic by your instructor, you may still have room to focus or narrow it. Suppose, for example, that for an English course, you are required to write a research essay on one of the writers you are studying. You have selected or been assigned to write on the American fiction writer Ernest Hemingway. But the assignment is no more specific than to "write a research essay on some facet of the author's work." Let's say that the paper is to be approximately 2,500 words—about ten typed pages, double-spaced. It must include at least eight sources, to which you refer with in-text parenthetical citations at some point in your essay. And it must include a "Works Cited" list, which you present in proper format.

Your task is to read some work or works by Hemingway and some secondary sources about his writing. In the process, you are to come up with a narrowed topic, along with an idea, thesis, or claim about it. You are to write an essay that presents your idea, thesis, or claim along with the evidence to support it. This evidence will come from the text of the writer's work and from the secondary sources of information you consult. You can find these secondary sources in your library's books and journal articles. You can also find information on Hemingway through the Internet, and you can access the holdings of your school and other public and private university libraries through the Internet.

Let's consider first how to use a typical library to find information needed for a research project. We will follow with information on using the Internet and the World Wide Web.

USING A LIBRARY TO CONDUCT RESEARCH

Knowing that information is accumulated and stored in the library, however, is not enough. You need to know how to access that information efficiently and effectively. Because a typical college or university library stores so much information, it may prove daunting for a new student to know where to begin to acquire the information he or she needs. Be aware, first of all, that the resources of your college or university library extend even beyond its holdings, however vast they may be. In this age of spectacular communications, libraries are able to

communicate with one another and to share their resources to the ultimate benefit of all users.

One way to make the transition to acquaintance with your library is through its staff. Take the opportunity to speak with one or more members of your library staff. Ask them for their help in gaining familiarity with their (and your) library's resources. They will be happy to assist you. Another way to gain access to a large university library is to speak with more experienced students who have used the library's resources.

Finding Books

To find books in your college library, you need to know two things. First, you have to find out how to access the books. Second, you need to locate the books themselves.

Your books will be catalogued in a computerized catalog accessed through an online database system. You can access books in these ways: by *title* (should you know it); by *author* (should you know the author's name); and by *subject* (should you be searching to see what books your library has on a particular subject).

Accessing Books Using the Library Catalog

The first thing you should know in using an online catalog is whether or not it is integrated. An *integrated catalog* combines the author, title, and subject cards in a single catalog system arranged alphabetically. The alternative filing system typically separates the index into two or three parts: one part for subjects, a second for authors and titles, and sometimes a third just for titles. The most common system, however, and the most efficient is the integrated catalog.

Here are sample listings from an integrated catalog:

Author Listing

```
PS 3515 Lawrence, Frank M. Hemingway and the Movies.
E37 Z689 Jackson: University Press of Mississippi.
c 1981. xix, 329 p.: ill; 24 cm.
```

Title Listing

```
PS 3515 Hemingway and the Movies. Frank M. Lawrence.
E37 Z689 Jackson: University Press of Mississippi.
c. 1981. xix, 329 p.: ill; 24 cm.
```

Subject Listing

```
PS 3515 Hemingway, Ernest. Hemingway and the Movies.
E37 Z689 Frank M. Lawrence. Jackson: University Press
of Mississippi. c 1981. xix, 329 p. ill; 24 cm.
```

Notice that all are listings for the same book: *Hemingway and the Movies* by Frank M. Lawrence. The first listing, an author reference, will be found alphabetized according to the first letters of the author's last name. The second listing, by title, can be found alphabetized according to the words and letters of the book's title. And the third listing, by subject, is found similarly alphabetized in a section of the online catalog devoted to Ernest Hemingway as a subject. This and other subject listings for Hemingway (or any other writer, artist, or composer) will be found alphabetized according to the author's *last* name.

It is important, however, to distinguish Hemingway as a subject from Hemingway as an author. When you pop up "Hemingway" in the online catalog, you will find first listings for books that Ernest Hemingway wrote. His works will be listed alphabetically beginning with *Across the River and into the Trees* and ending with *Winner Take Nothing* (if your library has those books). Following the computer listings for books Hemingway wrote will be listings for books written *about* Hemingway. In this group of subject listings, also alphabetically arranged, you will find books such as *Hemingway and the Movies, The Hemingway Hero*, and *The Hemingway Women*.

Searching for Ernest Hemingway

Let's say you want to look up Ernest Hemingway. You will need to indicate by a specific system command (punching the S key on your computer keyboard, for example) if you want to search for titles about Hemingway as a subject, including books in which the word *Hemingway* appears as part of the title. To search for Hemingway's works, you would punch another key (the A key perhaps) to tell the system you want to conduct a search for an author. Once you tell the system how to search, it will present you with a list of categories. Here, for example, is what part of one university library online catalog lists for Hemingway as author. The first eight and the last eight entries of the seventy-nine books included among the university's holdings are listed.

```
Hemingway, Ernest:

1. 88 Poems
2. Across the River and into the Trees
3. Across the River and into the Trees
```

```
 4.By-line
 5.The Collected Stories
 6.Complete Short Stories
 7.Correspondence
 8.The Dangerous Summer
 .  .  .  .  .  .  .
72.The Sun Also Rises
73.Three Novels
74.To Have and Have Not
75.To Have and Have Not
76.To Have and Have Not
77.Winner Take Nothing
78.Winner Take Nothing
79.Winner Take Nothing
```

The repeated titles at numbers 2–3 and 77–79 reflect holdings among the university's different campus libraries.

Notice that, if the library has numerous books on a subject or by an author, it organizes these books into categories. So to begin to see actual titles on the screen, you need to perform one additional step. You need to look over the list of numbered categories, and then tell the computer which category to display. Suppose you wish to look up Hemingway as subject to see what has been written about him. Here is what could appear for Hemingway as subject in an online catalog:

```
1.Hemingway, Ernest 1898                         1 entry
2.Hemingway, Ernest 1899-1961                   52 entries
3.Hemingway, Ernest 1899-1961 Appreciation   1 entry
4.Hemingway, Ernest 1899-1961 Appreciation–  1 entry
                              Germany
5.Hemingway, Ernest  1899-1961 Bibliography  10 entries
6.Hemingway, Ernest  1899-1961 Biography     12 entries
7.Hemingway, Ernest  1899-1961 Juvenile       1 entry
                               letters
8.Hemingway, Ernest  1899-1961 Biography–     3 entries
                               Marriage
```

Notice that category 2 includes 52 entries. Because the category has no heading, to find out the kinds of books included within it, you would have to press 2 and scan through the listings. We will look at a shorter list, that for 8, Biography—Marriage. Here are the books that appear on the screen when you press 8:

1. <u>Along with Youth: Hemingway: The Early Years,</u>
 Griffin, Peter
2. <u>Hadley,</u> Diliberto, Gioia
3. <u>The Hemingway Women,</u> Dert, Bernise
4. <u>How It Was,</u> Hemingway, Mary Welsh

To view the information, including call numbers of these books, location, and other information, you would simply press the appropriate number. You will be given information about the length and size of the book, its publication data, and location. Most systems also provide information about the book's availability.

In browsing in one of these books about Hemingway's marriages, you might get an idea for a research paper that focuses on the marriages depicted in one or more of Hemingway's novels or short stories. Reading the works in the context of biographical sources can be supplemented by reading other secondary sources that are less biographical than interpretive or analytical. And of course you should reread the primary sources—in this case, Hemingway's own writing.

Finding Periodical Articles

You can locate articles in popular magazines and scholarly journals in any number of ways. First, you can find current issues of periodicals displayed in a special section, where you can peruse them in the library. Usually a handful of back issues of each periodical to which your library subscribes is available for casual reading and browsing.

If you need issues of magazines or journals that are more than a few months old, you will probably need to access those periodicals either by means of a computerized database or by using one or more of the periodical indexes. The basic procedure is the same.

Periodical indexes are organized by subject rather than by author or title. Periodical indexes cover a specific group of periodicals, which are identified with their abbreviations at the front of the index or volume. The *Social Sciences Index* provides references to articles published in periodicals pertaining to sociology, psychology, political science, economics, and other social science subject categories. The *Humanities Index* refers you to articles about literature and history; music, art, and film; religion and philosophy; and other related subjects.

Because the vast majority of information in periodicals is not reprinted in books, it is important to learn how to use indexes to different subjects. Here are some important ones:

The *Art Index* is an index of articles and reviews about the arts, including not only painting, drawing, sculpture, and architecture,

but also photography, decorative arts, city planning, and interior design—for non-Western as well as for Western civilizations.

The *Bibliography of the History of Art* covers the visual arts in all media but covers only Western art from late antiquity to the present.

Architectural Periodicals Index indexes about 500 journals. It is available online as *The Architecture Database* (DIALOG), with files since 1973.

The Modern Language Association International Bibliography of Books and Articles in Modern Language and Literature is a comprehensive index to literature and language arranged by national literatures and subdivided by literary periods.

The *Annual Bibliography of English Language and Literature* is a subject index of articles chronologically arranged.

The *Humanities Index*, formerly the *Social Sciences and Humanities Index*, covers a wide range of subjects, from archaeology to religion.

Historical Abstracts includes abstracts of scholarly articles on world history exclusive of the United States and Canada.

The Philosopher's Index includes scholarly articles published in books and periodicals indexed by subject and author.

Religion Index One: Periodicals provides a subject and author index of scholarly articles on topics of religion published in Protestant, Catholic, and Jewish periodicals.

Using Interlibrary Loan

You can request to borrow books and journal articles from other libraries via interlibrary loan. In order to do so, however, you must provide your librarian with precise information concerning the book or periodical. Titles and authors of books with call numbers will usually suffice. For periodical articles, provide the exact name of the periodical, its publication date and/or volume number, and the pages you need. This information, by the way, is critical at every stage of your access of periodical material. When you first copy the information from the periodical index, you must be careful to identify the periodical correctly, as well as to take down volume, date, and page numbers. Your librarian may need this to pick the right issue from closed stacks. Or you may need it to find the correct microfilm or bound volume and then the appropriate pages

for reading. And finally, later, when it comes time to write your report or research paper, you will need this information for proper documentation.

USING THE INTERNET FOR RESEARCH

The vast computer network, the Internet, includes the World Wide Web (WWW or simply, "the Web"), a system of linked documents. Information is stored at sites on the Web, which are linked to other sites and which can be located by accessing the sites' Web pages.

Gaining Access to the Internet

To gain access to the Internet your computer needs either a modem that connects to a telephone line, or an ethernet card that links your computer to the Internet through a DSL/cable modem or through a mainframe computer that has a pathway to the Internet. You (or your university) also need an account with an Internet service provider so that you can use the system. If you haven't already done so, check with the computer services department or the library staff at your university (if you do not own your own computer).

Browsing the Web

To navigate your way around the Web, you point and click on underlined words and phrases on a given Web site. Doing so enables you to move among electronic pathways, or hypertext links, among Web pages and sites. When you move from link to link you are browsing the Web.

The very first screen you see at any Web site is typically its home page. In fact, you may see the home page of the Web browser software program that you use to navigate or browse the Web (often either Netscape Navigator or Internet Explorer). These browsers employ search engines, another kind of software device, used to find information organized by categories. Among the most frequently used search engines are Alta Vista, Google, and Yahoo!.

Search engines use the key words you enter on the home page (the topic for your search) and provide a list of sites that relate to the key words you selected. If after visiting the sites you haven't found the kind of useful information you need, you can change search engines, either by clicking a button for a particular search engine or by typing in its Internet address.

Some Dangers of Web-Based Research

Once you learn your way around the Web and can move about among sites, you will need some guidelines for selecting from the information you locate. You will need to decide which information is truly useful and which is not. And you will also need to evaluate the reliability of that information. Even more than with print sources, Web sources often contain information that has not been carefully reviewed for accuracy. Because anyone can post information on the Web, you need to be especially careful that the sources provide current and accurate information. You can use the following guidelines to help you evaluate Web sources:

Guidelines for Evaluating Web Sources

- Identify the individual or organization who established the source site.
- Consider how the source compares in care, thoroughness, accuracy, and currency with the print sources you have seen.
- Consider what special interest groups might think about the information from the source.
- Consider whether you think the source is good enough to cite in your research essay, paper, or report.

But how do you know if a source is reliable? One test is whether it has gone through a process of review, the way articles in scholarly journals and books published by reputable presses do. This is problematic for Web sites, because they do not undergo a rigorous selection process. Among the most potentially untrustworthy sites are anonymous Web sites, those whose origin and source you do not know.

Another question to ask yourself is whether the poster of the Web site has a vested or special interest in the information the site includes. Check the information presented against other information gleaned from other Web sites and from print sources.

And finally, consider how your audience might respond to the information on the Web site should you use it as evidence or fact in your research essay, paper, or report.

USING SECONDARY SOURCES WISELY

For most topics you research you will find a multitude of sources—far more than you can read and use for your research assignment. From the start you will need to select from among them those most useful and relevant for your topic. In addition, you will need to evaluate the sources for credibility, reliability, and currency.

Avoid the temptation to begin reading thoroughly and taking notes from the first sources you find. Instead, compile a list of many sources—a dozen books and articles at least—before reading any of them carefully and before taking notes. Select your list of sources by looking carefully at titles and subtitles of books and articles. Look also at their dates of publication. Up-to-date information in journal articles may correct, supplement, or otherwise provide an advance on material published earlier in both journals and books.

Browse through your books and articles, skimming their tables of contents, indexes, and headings. Look to see how many pages are devoted to your topic. More often than not, you will find that in-depth treatment will be more useful for your research and writing than brief superficial coverage of your topic. Read the preface and introduction to books and the abstract or summary of articles, if available. These will give you a clearer sense of their relevance for your work than titles and tables of contents.

Once you begin reading your potential sources, read quickly at first, skimming through chapters and articles to gain a sense of their depth, degree of detail, level of difficulty, and general point of view. If you are researching a controversial subject, you should look for books and articles representing different points of view. You can determine an author's point of view by identifying his or her claims, kinds of evidence brought in their support, types of sources and authorities cited, and whether the author is affiliated with or represents a special interest group.

Regardless of your own point of view on an issue or topic, try to read with an open mind. Be careful to distinguish facts from emotional appeals. Try also to question what you read; avoid simply accepting as truth every assertion you find.

You can use the following questions to analyze your sources:

- Does the title of the source provide a clue to its point of view? Does the title reveal bias?
- What is the author's professional affiliation and perspective on the topic?
- Does the evidence in the source seem persuasive?
- Does the author include opposing points of view?
- How well does the author support his or her argument and refute opposing views?
- What is the author's tone? How engaging are the author's ideas and arguments?

How can you use secondary sources without allowing them to dominate your research paper? The most important thing you can do is to read the literary work, look carefully at the work of art or architecture,

listen repeatedly to the musical composition. In each encounter with the artwork, you should make and take notes, using the techniques described in Chapter 1. Through listing, annotating, freewriting, and reflecting on what you read, see, or hear, you can begin to form your own sense of the work.

Do the same thing when you read secondary sources. Photocopy them, if you can, so you can annotate them. Summarize the key claims made by the author of each source. Look for connections between the sources; identify contradictions and contrasting perspectives. Record in your notebook your own thinking about what the authors of the secondary sources say.

In addition, go back to the primary sources to read, look, or listen again. Jot down in your notebook new insights you have gained as a result of your reading in the secondary sources. Consider the extent to which you agree with what you have read in the secondary sources. You can use secondary sources you agree with to bolster an argument you wish to make about an artwork or to provide factual information about it. You can use a source you disagree with as a point of departure for your own views. If you agree in part with a source, you can make distinctions and express qualified agreement or approval in expressing your reservations as you develop your own perspective.

NOTE TAKING

When you are ready to take notes on your sources, be sure to list the complete bibliographical information from the source on an index card or on a list of sources you compile. List the author's name, the work's title and subtitle, and place and date of publication. As you take notes, mark the exact pages you refer to for each of your notes. You will need accurate notes when you draft and document your paper. Taking care at this stage will save you time and aggravation later. Careful and accurate notes will also help you avoid plagiarism.

The notes you take will help you better understand the topic you are researching. They will also become evidence in support of the idea, thesis, or claim you develop in your research essay.

Try to make your notes more than a simple matter of copying from your sources or summarizing and paraphrasing their ideas and arguments. Use the note-taking stage of the research process to think and develop your ideas. Try to make connections among the ideas and evidence you find in your sources. Draw inferences and conclusions based on information they provide. Evaluate the inferences and conclusions they present.

You will also have to decide whether to write your notes on index cards or in a notebook or to use a computer. Whatever method you use, be sure to distinguish carefully between your words and ideas and those of your sources. If you think you may use a source extensively in your paper, you may wish to photocopy it.

Taking Efficient Notes

Among the problems a beginning researcher confronts is when to begin taking notes, how many notes to take, and what kind of notes to take. The solution to these note-taking problems is to consider the purpose of your research—your research question or topic and the thesis or claim you wish to make about it.

You should begin taking notes at the beginning of your research rather than reading through many sources before beginning your note taking. You may be tempted, however, as you begin doing research, to take down too much. It is more useful, however, and more efficient, to write down less rather than more at the early stages.

To be selective, you should try to imagine how a given source might be used in your paper. Will the information and ideas be used to provide background information? Will they be used as part of an analysis of a problem or issue? Will they be used to illustrate different approaches or points of view? Will they be used to provide evidence in support of your position or claim? Will they be used as part of a counterview, which you will argue against?

Considering such questions about the information, ideas, and views presented in a source can help you in deciding not only what you need to extract from it, but also how your own thinking can enrich, support, qualify, or refute it. Introducing your own reflections into your note taking is extremely important for at least two reasons: (1) It helps you avoid being swayed by every different source you read and (2) it helps you develop and refine your thinking about your research topic so that the final product becomes "yours" and not just a compilation of the views of others.

In general, your purposes in note taking will be to gather data and information or to understand varying perspectives or points of view. If the purpose of your research project is to inform or explain, you should create notes that gather, select, and organize the information that appears germane and interesting to your prospective audience. If your purpose is to analyze and interpret, you should look for patterns and connections in the sources' information and ideas, so that you can provide an interesting way to understand the issue, text, or problem. If your purpose is to persuade, then you should look at the information

and ideas in your sources as potential evidence to support your claim about the topic. Along the way, whichever your purpose, you will need to accurately summarize and paraphrase the ideas and perspectives you find, whether you agree with them initially or not.

Summarizing and Paraphrasing Secondary Sources

Note taking requires summarizing and paraphrasing sources. When you summarize, you condense the material in your source and put it into your own words and sentences. A summary is always shorter than the original—sometimes considerably shorter. It captures the author's main idea so that other readers can readily understand it.

In summarizing, try to represent an author's point of view fairly and to present his or her ideas accurately. When you paraphrase, you recast an author's words into your own language, translating pretty much sentence for sentence the author's idea and supporting evidence. A paraphrase, which is approximately the same length as the original source, follows its structure and includes more details than a summary. When summarizing and paraphrasing, be especially careful to use your own language—your own words. If you find yourself using the words and sentences of your source, you will have to use quotation marks to indicate that. (For more on summarizing and paraphrasing, see Chapter 1.)

Quoting

You should quote from a source only when the language of the source is especially striking or memorable, or when the quotation will strengthen your argument because the source is an important authority on the topic. You might also decide to quote a source if you wish to argue against the author or when you want an author's exact words to express the outrageousness of a claim or the weakness of an argument.

When you quote, be sure to quote the writer's words exactly and to put quotation marks around them. To indicacte that the source contains an error, add the Latin word *sic* (meaning "thus") in brackets immediately following the error. For example, "Franklin Delano Roosevelt [*sic*] created the memorable phrase 'The New Deal.'"

When you want to emphasize a few words of a quotation, underline or italicize them, but be sure to indicate that the emphasis is yours by adding the words "my emphasis." For example, in an article in the *New York Times*, the German government was reported to have "revalued its gold reserves in an effort to comply with the economic conditions necessary for ensuring readiness for the establishment of a common European currency. The German revaluation, however, is an

accounting trick the German government has *hypocritically condemned* for other countries," such as Italy and Spain (my emphasis).

To indicate that something has been omitted from an occasion, use *ellipses*—three spaced periods (. . .). Writers shorten long quotations with ellipses; they also use ellipses when only certain parts of the quotation are relevant to their discussion. You could shorten the previous example about Germany's revaluation of its gold reserves by using ellipses: Germany "revalued its gold reserves . . . an accounting trick" that many have seen as hypocritical after Germany condemned the same practice by other countries.

Integrating Quotations

Depending on length, you might integrate a quotation into your text by embedding it in quotation marks or setting it off from your text without quotation marks. Incorporate brief quotations (fewer than four typed lines [MLA] or 40 words [APA] for prose, and three lines for poetry), directly into the text of your paper.

```
Johnson claims "The judiciary, not the executive
branch of government, is most seriously in need of
reform today" (156).

"The judiciary," Johnson claims, "not the
executive branch of government, is most seriously
in need of reform today" (156).
```

If you wish to weave a sentence—or a part of it—into your own sentence, you might do it like this:

```
It is not the executive branch of government,
Johnson claims, but the judiciary that "is most
seriously in need of reform today" (156).

Johnson claims that it is not the executive
branch of government that needs reform. He
suggests, rather, that it is the judiciary that
"is most seriously in need of reform today" (156).
```

For longer quotations, indent the passage ten spaces or one inch rather than five spaces or one-half inch. Double-space and do not use quotation marks. Depending on the context, you may use a colon (:) to introduce a block quotation:

```
Johnson's argument differs from Whelan's. Here is
how Johnson sees the issue:

    It is not the executive branch of government but
    the judiciary that is most seriously in need of
```

```
reform today. Moreover, if judicial abuses are
not stopped and immediately corrected, both
business investment and the general quality of
life in the country will plummet. (156)
```

Occasionally you may need to modify a quotation slightly by altering one of its words or by adding a word so that the quotation fits the grammatical structure of your sentence.

```
Without adequate judicial reform, Johnson
envisions "both business and the general quality
of life in the country ... plummet[ing]" (156).
```

The ellipsis (. . .) indicates that one or more words have been omitted from the sentence (in this case, "will"). Notice that the changed word contains brackets [] around the part not included in the original quotation.

Plagiarism

Avoid *plagiarism*—that is, using someone else's words, ideas, or organizational patterns in writing without crediting the source. Writers sometimes fail to acknowledge their sources properly, resulting in plagiarism, a kind of verbal kidnapping or theft. Some writers—especially student writers—believe that plagiarism occurs only when an author's exact words are used without acknowledgment. But this is only one type of plagiarism.

Plagiarism also involves borrowing or using the ideas or structure of an author's argument without acknowledging your source. Even when you use your own words to summarize or paraphrase the words and ideas of a source, you must acknowledge your source. If you do not, you have plagiarized another's work and presented it as your own.

Some students plagiarize out of ignorance; others, out of fear. Some believe that they must only record references to exact and direct quotations, but this, as we have indicated, is not true. Others think that if they document all the ideas they have borrowed from others, there will be nothing left of "them" in their research writing. So they plagiarize out of fear that they have nothing to say of their own.

Still others plagiarize because when they read sources—of art or literary criticism, of cultural analysis, of historical description—they find the writing so clear and the arguments so cogent that they cannot think of ways to convert their source's information and style of writing into their own. So they copy without quoting.

Although it is normal to experience some anxiety when writing a research paper, essay, or report, do not give in to the temptation to plagiarize. Instead, spend more time reading, writing, and thinking. Become more and more familiar with the ideas and issues you are writing about.

Talk about them with classmates, friends, and instructors. Then plunge in, for better or worse, with your own ideas presented in your own words.

Here is an example of how a passage from a source can be plagiarized and also paraphrased without plagiarism:

Original Source

> Two genetically identical twins inside a womb
> will unfold in slightly different ways. The shape
> of the kidneys or the curve of the skull won't be
> quite the same. The differences are small enough
> that an organ from one twin can probably be
> transplanted into the other. But with the organ
> called the brain, the differences become profound.
> George Johnson, "Don't Worry. A Brain Still Can't
> Be Cloned," *New York Times*, 2 March 1997.

Plagiarism

> In a recent article George Johnson notes that
> two genetically identical twins inside a womb will
> unfold in slightly different ways.

Comment: This is plagiarism because the words "two genetically identical twins inside a womb will unfold in slightly different ways." should be placed in quotation marks, as they are George Johnson's words.

Plagiarism

> Cloning is not as sure a thing as some people
> believe largely because the development of the
> human brain differs in profound ways from the way
> other bodily organs develop.

Comment: This is plagiarism because there is no acknowledgment that the idea here came from George Johnson's article.

Plagiarism

> Genetically identical twins unfold in the womb
> in similar but slightly different ways. And
> although the differences are small enough so that
> organs from one twin can be transplanted into the
> other, the shape of a kidney or curve of the head
> won't be exactly the same.

Comment: Here the writer is mixing his own words with phrases of the source. It's as if the plagiarizing writer is trying to hide the fact of his near-copying of the source by changing a word or phrase here and there.

Acceptable Paraphrase

```
    George Johnson suggests that human cloning is
not as close to becoming a reality as some might
think. This is so, according to Johnson, primarily
because of the development of the human brain,
which differs in its very complexity of
development from the simpler, more predictable
development of other bodily organs (15).
```

You can use the following guidelines for help in avoiding plagiarism:

Guidelines for Avoiding Plagiarism

- Allow ample time for writing papers, essays, and reports.
- Take notes on sources after you have read and understood a chapter or section, even a few paragraphs.
- Take notes in your own words as much as you can. Close the book or look away from your source so you can compose sentences and paragraphs that capture its gist or essence.
- Always distinguish clearly between your own words and those of a source, by putting quotation marks around what you copy from the source.
- Copy the author's name and page number beside each note you take; that is, alongside each idea or phrase you borrow from the source.
- Think when you take notes; that is, consider the persuasiveness or value of the source's comments and ideas. One way to do this is to draw a line under or next to the source's language or idea, so that you can then write out a couple of sentences about your reaction to the source.
- Avoid borrowing other students' papers or notes. Work only from your own notes on the sources you have read.
- Be sure to back up on a diskette not only your final draft, but earlier drafts and any notes you took on a computer. Save handwritten notes.

WRITING THE PAPER

In writing your research essay, paper, or report, follow the guidelines for drafting and revising provided in Chapter 1. Set aside sufficient time to work out the basic argument of your paper. This will involve the time necessary for tracking down sources, taking notes, and reflecting on their significance. Try, in your preliminary draft, to articulate your ideas without using your sources—or only using them slightly. Get your ideas down as clearly and fully as you can. Provide the evidence you need to sustain your argument or support your views by analyzing, interpreting, or evaluating the artwork that you are writing about. Then write a second draft in which you incorporate the relevant secondary sources.

Leave time for a third draft in which you further refine your thinking, taking into consideration additional evidence you find in the work itself or among the secondary sources. Use this third draft also to provide precise documentation for your sources.

In general, approach the drafting and revising of a research essay, paper, or report just as you would any other nonresearched assignment. Be careful to avoid letting your sources take over your paper.

Sample Student Research Papers

The following research papers provide samples of writing about a single work of art using sources, and writing about multiple works by one author. In the first research paper, Michael DiYanni analyzes Thomas Eakins's painting *John Biglin in a Single Scull* in the context of Eakins's other rowing pictures. Michael used eleven sources for his research, although five of those sources were articles collected in a single volume, *Thomas Eakins: The Rowing Pictures*. Michael cites his sources with endnotes.

In the second research paper, Karen DiYanni describes the importance of the father-son relationship in the work of the Czech writer Franz Kafka. Karen's well-organized paper explores this theme in three major works, which she takes up one after the other. Karen cites her sources with parenthetical citations.

Michael DiYanni

Humanities 112

Professor Permut

December 1, 1998

Thomas Eakins's *John Biglin in a Single Scull*

*"Rowing—the noblest, manliest, and approaching to the
scientific, of any game, or sport, or play, in any
nation, clime or country."*

Robert B. Johnson

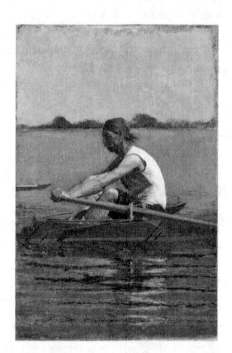

Thomas Eakins, *John Biglin in a Single
Scull*. 1874. Oil on canvas. 61.9 × 40.6
(24-3/8″ × 16″).
Yale University Art Gallery. Whitney Collections of
Sporting Art, given in memory of Harry Payne
Whitney, B.A. 1894, and Payne Whitney, B.A. 1898,
by Francis P. Garvan, B.A. 1897, M.A. (Hon.) 1922

By the time Thomas Eakins began the serious study of art at the
Pennsylvania Academy of Fine Arts in 1862, portraiture was no longer
en vogue with American artists, as landscape and genre paintings had
surpassed them in popularity. Photographs had also begun to supplant
painting in the arena of portraiture. Despite its unpopularity,
Eakins quickly decided that depicting through portraits the people
around him was his true vocation, and he did so with directness and

psychological penetration. Of the more than two hundred sitters and subjects Eakins depicted during his career, no more than twenty-five of his portraits were commissioned.[1] The artist himself sought out subjects, often friends, and looked for intimacy in his work.

Eakins's work was marked with a sense of "brutal realism,"[2] which did not seek to beautify or gloss over his subjects, but rather to arrive at their essential truth by depicting them realistically, in natural settings. Eakins was of a scientific mind, and his work shows a painstaking approach to exactness in lighting and perspective, along with an uncommon knowledge of anatomy and physiology.

Upon his return from study in Paris in 1870, the twenty-six-year-old Eakins entered an intense period of creativity. Now a professional painter, Eakins chose rowers as his primary subject for more than three years. Rowing was a natural choice of subject for Eakins, who was an accomplished oarsman, and who lived only a few short blocks from the Schuylkill River. The artist saw in rowing a sense of discipline and a combination of mental and physical virtue. Eakins was also a careful student of the human body, and paintings of rowers allowed him an opportunity to depict the body in action and motion. This gave him a chance to showcase his substantial physiological knowledge.

John Biglin in a Single Scull

Eakins found inspiration in John and Bernard (Barney) Biglin, two celebrated professional oarsmen from New York. The Biglin brothers had achieved a mastery of both types of rowing, "sweeps" (where each rower pulls one long oar that extends out to one side of the boat, or shell), and "sculls" (in which each oarsman pulls two oars, one in each hand). They were well matched: John at twenty-eight stood 5 9 and 3/4 and weighed 161 pounds; Barney, thirty-one, stood 5 9 and 1/2 and weighed 151 pounds. Both were universally respected for their skill and strength.[3]

John was considered a model of ideal rowing physique, "as besides being skillful and experienced in the art, he [was] endowed with great strength, presenting in appearance the perfect picture of an athlete."[4] He had developed his physique, working variously as a mechanic, laborer, foreman, fireman, and boatman. Barney was involved in predominantly mental work, having won in 1872 the first of several terms in the New York State Assembly.[5]

Thomas Eakins carved out for himself a unique place in the history of American art as a painter who could portray the individual as never before. His 1873 oil on canvas, *John Biglin in a Single Scull*, is a fine example of what set Eakins apart. It demonstrates his attention to lighting, perspective, and detail, coupled with a sense of forthrightness and intimacy that draws viewers into the world of the solitary sculler.

Perhaps Eakins's favorite subjects were members of the Biglin Crew. Anchored by brothers John and Barney Biglin, it was the best rowing outfit in the world. After numerous sketches, studies, and paintings of the Biglins in action, in which the young artist explored many facets of rowing, the mature artist Eakins painted a startling portrait of John racing in his single scull.

Eakin's oil on canvas, *John Biglin in a Single Scull*, was in fact a study made in preparation for a watercolor that Eakins had sent to his former mentor Gerome in 1874. The oil stands alone, however, with its photographlike cropping and the intimacy brought to the subject, giving it a sense of monumentality and an iconic power. Watercolor had become the artist's medium of choice for a short period in the mid-1870s. It was a difficult medium to work with, and Eakins first painted the oil (a much more forgiving medium, thanks to the slower drying time for the paint, and the ability to retouch and layer). The fact that Eakins put so much effort into this oil study is indicative of his methodical and painstaking approach to painting and his respect for and desire to please Gerome. Even before preparing the oil, Eakins drew a perspective sketch as a study almost twice the size of the finished watercolor. In his perspective studies for the work, Eakins noted the measured dimensions and coordinates for the reflections. He was aware of the exact measurements of his subjects, "a practice considered unnecessary by most American teachers of artistic perspective, who trained the eye to judge distances proportionally."[6] However, the precision that Eakins achieved was so great as to present scrupulous viewers with the ability to ascertain the time of day, and even the viewing position of Eakins himself from the paintings.

Once Eakins had completed the perspective sketches, he painted the oil on canvas. The image of Biglin is substantially larger than that of the watercolor, so that Eakins could prepare every detail before

scaling the images down. It is seemingly a study for the figure of John Biglin himself, as less attention is paid to the background. Sailboats and an eight-oared shell seen near the horizon in both the perspective study and the watercolor are omitted in the oil painting. Eakins still concentrates on the reflection in the foreground, yet he gives less attention to the water in the background, which is glimmering with the summer sun in the watercolor. Instead, in the oil painting, Eakins leaves it an almost solid and cool blue. The cloudless sky, the shoreline, and the horizon all seem perfunctory.

It is the form of Biglin himself, poised near the start of his stroke that Eakins, instead, concentrates on. The champion oarsman is in perfect position, his body relaxed yet prepared to attack his next stroke. Biglin's wrists are firmly locked, and his left arm meets the oar at an acute angle, redirecting the oar's diagonal thrust toward his chest. These angles appear everywhere in the painting: the sharp angular meeting of the oar and the arm, the acute angle at which the rower's calf meets his thigh, and the meeting of the shell's rigger and oarlock. "Visually, Biglin seems but one part of the machine that he propels."[7]

The precision with which Eakins prepared his canvases can be illuminated thanks to x-ray and microscopic analysis. These technologies evidence careful etching and inking of certain outlines and perspective lines. The analysis also reveals much about Eakins's layering of paint. There is evidence that the sky of the oil painting was reworked. Eakins may have "regarded a bright blue sky as distraction,"[8] as has been suggested. This reworking probably accounts for the later date, 1874, on a study for a watercolor completed in 1873. Close analysis reveals that Eakins composed the sky out of three distinct layers of blue paint, from bottom to top: "an intense medium blue, a light blue, and a muddy color applied with a palette knife."[9] This calmer, cooler blue contrasts the reds of Biglin's bandanna and crew top, which allow the oarsman to stand out.

It is the simplicity of this study, however, that allows the viewer to concentrate on Biglin. Here we see a portraitist focusing almost exclusively on his subject. Eakins paints John Biglin in the same manner that he is depicted in other of his works, staring stoically forward in perfect concentration. In many ways Eakins's oil study is a more powerful work than the watercolor it preceded.

Cropping the spanning landscape gives the painting a sense of intimacy and mentality. Although it may lack the shimmering and airy qualities of the watercolor, the oil painting seems much more substantial in comparison. The consistent colors and the larger size of Biglin convey a sense of solidity.

With his focus solely on the oarsman, Eakins imparts to his viewer a sense of the solitude of the single sculler. All that is visible in the background is the bow of a boat, indicating that a race is in progress. The legendary Biglin is in full command of the race, with almost a full boat-length lead. Despite the undoubtedly heated action, the painting has a static and immobile feel to it. This emphasizes the relaxation and control of the oarsman. The work has a concentrated power, a sense of honesty that make it an iconic painting of its subject.

John Biglin in a Single Scull shows Thomas Eakins at his best. In it we see the artist's love for portraiture, his precision and attention to detail, and his power to inhabit and convey his subjects. The painting stands as one of Eakins's greatest works; it is a precursor to The Gross Clinic and other Eakins portraits that have become classics of realism. It reveals not only much about John Biglin, but much also about Eakins himself—what he valued, how he painted, and where he was heading, artistically, at this point in his career. It is truly a portrait of an artist.

Notes

1. Elizabeth Johns, Thomas Eakins (Princeton: Princeton UP, 1983), p. xix.

2. Louise Gardner, Art Through the Ages, 10th ed. (Fort Worth: Harcourt Brace, 1996), p. 969.

3. Helen A. Cooper, ed., Thomas Eakins: The Rowing Pictures, (New Haven: Yale UP, 1996), p. 39.

4. Ibid.

5. Martin A. Berger, "Painting Victorian Manhood," in Thomas Eakins: The Rowing Pictures (New Haven: Yale UP, 1996), p. 116.

6. Amy B. Werbel, "Perspective in Thomas Eakins' Rowing Pictures," in Helen A. Cooper, ed., Thomas Eakins: The Rowing Pictures (New Haven: Yale UP, 1996), p. 85.

7. Berger, p. 116.

8. Christina Currie, "Thomas Eakins Under the Microscope: A Technical Study of the Rowing Paintings," in Helen A. Cooper, ed. <u>Thomas Eakins: The Rowing Pictures</u> (New Haven: Yale UP, 1996), p. 100.

9. Ibid.

Karen DiYanni

Literature and Humanities 101

Mrs. Fehrs

March 30, 1997

Franz Kafka and the Fear of the Father

Franz Kafka is generally considered to be one of the greatest writers of the twentieth century. His fictional works have been read and interpreted, analyzed, and debated from the time of their publication early in the twentieth century. Some interpreters have emphasized the religious aspect of Kafka's novels and stories (Spann 59). Others have claimed that his fiction should be interpreted from the standpoint of Freudian psychoanalysis (Greenberg 47). While these approaches are certainly interesting, it seems more natural to consider Kafka's fiction as reflecting his life, especially his relations with his father. Many of Kafka's fictional works, in fact, describe a conflict between an authoritative father (or father-figure) and a weak son, a conflict so powerful as to make the son feel tremendous guilt under the father's authoritative accusations. Among Kafka's fiction, "The Judgment," "The Metamorphosis," and <u>The Trial</u> illustrate how an all-powerful father or father-figure nearly destroys a weak and helpless dependent son.

Although Franz Kafka never married, he nonetheless carried on an intensive correspondence with a number of different women with whom he was engaged. These letters along with a long and complex letter to his father (a letter he never sent) reveal Kafka's fears and anxieties. They also indicate how intensely devoted he was to the craft of writing fiction.

One of Kafka's earliest stories, "The Judgment," was written in a single sitting. Kafka began the story at ten o'clock on the night of September 22, 1912 and finished it at six o'clock the next morning (Hayman 1). "The Judgment" recounts the story of Georg Bendemann, who has written to a friend in Russia about his impending engagement to be married. Before sending the letter, however, he feels the need to secure his father's approval, and thus enters his room to tell him about the letter. The father's reaction is very strange. He accuses his son of not telling him the whole truth about his friend. At one point, in fact, he even suggests that his son does not really have this friend in Russia at all. Later, he indicates that he does believe Georg has such a friend, but he is not in Russia. More importantly, however, in both cases, Georg's father believes that his son has lied to him.

Following these surprising and confusing (for Georg) accusations come two other criticisms. First, Georg's father accuses him of not being a very good businessman. (Georg works with his father in their family business.) The father accuses Georg of closing deals and getting credit that he doesn't really deserve, since his father arranges everything except the final details. Even more disturbing to Georg is his father's suggestion that he has not been a very good son, that his friend would have been a much better son to him than Georg. The father follows this cruel comment with words and actions that attempt to put the son in his place—subordinate to him. He tells Georg that he is not ready to be replaced in the business by his son, that he is indeed stronger than his son, that in attempting to deceive his father and overcome his authority, Georg deserves punishment. He then sentences him to death by drowning, and in the strangest of this story's series of bizarre occurrances, Georg leaves the house and jumps off a bridge to do exactly what his father orders (Heller 54-66).

"The Judgment" can be explained as a reflection of Franz Kafka's life at the time it was written. It is important for describing the "deeply disturbed father-son relation ... in Kafka's life" (Spann 55). Kafka himself described this relationship thoroughly in his "Letter to His Father," in which he explains and defends himself against all his father's accusations while criticizing and blaming his father for terrifying him as a child

and a young man (Heller 186-236). In this letter Kafka writes to
his father that he would like "a diminution of your unceasing
reproaches." He describes these reproaches as "a judgment of me."
He comments that "as a father you have been too strong for me"
("Letter" 186-187). And he sums up by explaining that what was
"incomprehensible" to him was "the suffering and shame you could
inflict ... with your words and judgments" ("Letter" 194).

<div align="center">II</div>

The struggle of father with son, the powerful authority that
the father exercises over his son, and the death of the son in "The
Judgment" are central features of "The Metamorphosis" as well. As
Martin Greenberg points out, the "story is about death. ... The
first sentence ... announces Gregor Samsa's death and the rest of
the story is his slow dying" (Greenberg 70).

Why Gregor dies is one of the important questions of the story.
One answer is that he dies of neglect and loneliness. In the same
way that Gregor's father had mistreated and humiliated him,
Gregor's mother and sister eventually come to abandon him. Although
they had initially sympathized with his metamorphosis, before long
they tire of it. They no longer think of the giant insect as their
son and brother, and they leave him alone to die. Gregor Samsa,
like Georg Bendemann of "The Judgment" and like Kafka himself, is a
lonely person. Many details of "The Metamorphosis," from Gregor's
being locked in his room to his inability to communicate with his
family, to his being misunderstood by his boss, to his memories of
his days before the metamorphosis, all indicate how alone he was.

Kafka himself was lonely and alienated from the society he lived
in. He was a German-speaking Jew living in Prague, Czechoslovakia,
where anti-German and anti-Semitic feelings were strong (Spann 17-20).
And as he himself indicates repeatedly in "Letter to His Father,"
Kafka felt alienated from his family, especially from his father. This
loneliness, however, was a consequence of his sense of inferiority, of
being insignificant and unimportant. Perhaps that is one reason that
when Kafka wrote "The Metamorphosis," he transformed Gregor Samsa into
an insect, something normally regarded as insignificant.

Some of the most compelling and memorable scenes of "The
Metamorphosis" are those in which Gregor's father interacts with

him. In the first part of the story, when Gregor's father first realizes his son's metamorphosis, he "knotted his fist with a fierce expression on his face as if he meant to knock Gregor back into his room" (Heller 13). A bit later, his father "pitilessly" drives him back into the room, "hissing and crying 'Shoo,' like a savage" ("Metamorphosis" 16). And finally, at the end of the first part of the story, when Gregor gets stuck trying to get back into his room, his father gives him a hard shove.

These actions, however, are only preliminaries. In the second and third parts of the story, Gregor's father behaves in an even more menacing fashion. Gregor is afraid at one point that his father will try to step on him as Kafka describes how "Gregor was dumbfounded at the enormous size of his [father's] shoe soles. Gregor, as Kafka writes, "could not risk standing up to him, aware . . . that his father believed only the severest measures suitable for dealing with him" (33). One of these severe measures is taken when Gregor's father bombards him with apples, lodging one in Gregor's back. Later, the wound from this apple begins to fester, and very likely contributes to Gregor's eventual death.

Kafka's real-life relations with his father, especially his feelings of inferiority, explain much of what happens in the fictional "The Metamorphosis." Gregor Samsa's inability to speak understandably, for example, may be related to Kafka's complaint that his father hardly ever let him talk. In his letter, Kafka blames his father for his temporarily losing the "capacity to talk." "At a very early age," he writes in the letter, "you forbade me to speak, silencing the oppositional forces that were disagreeable to you" (Heller 195).

But even more powerful and frightening was the feeling of guilt that Kafka's father made him experience. Something of this guilt is shown in "The Judgment." Perhaps that is why Georg Bendemann really kills himself. He believes the accusation that his father makes against him. Something of this guilt is also apparent in "The Metamorphosis." Perhaps that is one of the reasons Gregor remains a lonely bachelor taking care of his aging parents before his metamorphosis. He may have felt guilty about leaving them alone. And so, like Franz Kafka himself, Gregor Samsa does not marry.

III

The most impressive and sustained expression of the guilt Kafka felt is reflected in his novel, *The Trial*. That work describes how Joseph K., the central character, one day receives an Inspector and two guards who announce that he has been accused of a crime and is to be arrested. What's interesting is that the crime is never identified. The first sentence of the book indicates that he has done nothing wrong. All through the book the reader never discovers what Joseph K. is accused of. Neither does Joseph K. Even stranger, however, than this lack of an identifiable offense, Joseph K. comes to believe that he is guilty of whatever it is he stands accused of. His problem is that he allows the allegations to damage him because he comes to accept them. The entire novel is based on K.'s gradual realization that it does not matter whether or not he committed the offense he is charged with. He is guilty anyway. This he believes and comes to accept as right and just.

The feeling that "one was already punished before one even knew that one had done something bad" was something Kafka had experienced repeatedly in his relations with his father ("Letter" 199). Throughout the "Letter to His Father" Kafka recounts instances of why he so often experienced "an increase in the sense of guilt" ("Letter" 203). In fact, at one point Kafka describes his relationship with his father as one of being on trial, sometimes for things he had not known he had done. He describes the experience in fact as "this fearful trial ... in which you still go on claiming to be judge" ("Letter" 224).

The human relationships of *The Trial* are complicated further by references Kafka makes to the work regarding his love life. Kafka was engaged to be married on more than one occasion. In each instance, Kafka broke off the engagement, partly because he felt that he should be married to his writing only, that he should devote himself completely to his work (Hayman 183-188). When Kafka's engagements "made him realize that marriage threatened his dream world, he was horrified and overcome with feelings of guilt" (Spann 90). But he also seemed to feel that he was not prepared for marriage. He felt, as he expressed it, "mentally incapable of marrying" ("Letter" 230). In addition, however, Kafka felt that marriage was barred to him because it was the domain of his father

and thus was prohibited to him ("Letter" 230). Nonetheless, according to a number of critics, Kafka felt guilty about not marrying and raising a family, which he described as "the utmost a human being can succeed in doing" (Spann 106). At least one critic interprets Joseph K.'s punishment in *The Trial* as a fair punishment for the ineffectual and unworthy life K. has led up till the time of his arrest (Greenberg 114). Joseph K. is punished then because he has misused his life, because he has wasted time and opportunities. This is what Kafka himself meant as he often considered both his marriageless life and his writing.

Franz Kafka's works are interesting for how they reveal the complicated workings of the mind. It is not always clear what is happening to the characters or why it is happening. The action of these fictional works seems often like a bad dream. Things are happening that the main character has no ability to control. But as the critics suggest, this is because Kafka's works reveal the psychological state of mind of the central characters. They reveal their fear, their anxiety, and their guilt. We can understand these works because, like the author and the characters he creates, we too experience our own fears and anxieties. We too sometimes question ourselves, condemn ourselves, and put ourselves on trial.

Works Cited

Greenberg, Martin. *Kafka: The Terror of Art*. New York: Horizon Press, 1965.

Hayman, Ronald. *Kafka: A Biography*. New York: Oxford University Press, 1982.

Heller, Erich, ed. *The Basic Kafka*. New York: Simon and Schuster, 1979.

Kafka, Franz, "The Metamorphosis." *Classics of Modern Fiction*. 4th Ed. Irving Howe. New York: Harcourt, 1985.

Kafka, Franz. "The Judgment" and "Letter to His Father." *The Basic Kafka*. Ed. Erich Heller. New York: Simon and Schuster, 1979.

Kafka, Franz. *The Trial*. New York: Schocken Books, 1937.

Spann, Meno. *Franz Kafka*. Boston: G.K. Hall, 1976.

9

Documenting Sources

In research essays and papers it is necessary to document sources—that is, to indicate where you obtain information, data, and ideas included in your work. Documenting your sources provides readers with a trail to follow should they wish to find additional information or should they wish to check the accuracy or justness of your use of your sources. Indicating what you have borrowed from sources also enables your readers to see what your own contribution to the discussion is. And, finally, documenting your sources lets your readers see the amount and quality of research you have used in developing your essay or paper.

IN-TEXT CITATIONS

When you cite or indicate a source used in your paper, you do so in the text just after the material requiring documentation. To simplify what was once a cumbersome system of footnotes, endnotes, and superscripts, the Modern Language Association (MLA) and the American Psychological Association (APA) have developed their own systems of in-text citations. We explain here the MLA system.

To cite sources using the MLA system, place the author's name and the page references in parentheses immediately following the material being documented. If the author's name has been given in the text of your writing, provide only the page number in parentheses following the cited material. Here is an example of each:

Author not named The evolution of the human species
 has been a hotly debated issue since
 the time of Charles Darwin (Hugo 12).

Author named
```
As Michael Hugo has pointed out, the
evolution of the human species has
been a hotly debated issue since the
time of Charles Darwin (12).
```

Notice that, in both examples, the period comes after the parenthetical page citations.

In the event that you wish or need to cite a quotation from a source quoted in the source you are actually using, use the following model as an example. Suppose, for example, that you found the Hugo quotation shown earlier, not in the original source, but in another source you were reading, let's say in a book entitled *The Origins of Humankind* by Sheryl Fulton. Here is what you would do to indicate that kind of borrowing:

```
"The debate over humanity's origins has been
going on ever since Darwin's The Descent of
Man" (qtd. in Fulton 21).
```

LISTING SOURCES AT THE END

In addition to the in-text citations for documenting sources within a research essay or paper, you must also provide, at the end of your paper, a list of the sources you cite within it. That list of sources is a Bibliography or Works Cited, which includes more detailed bibliographical information than the brief in-text parenthetical citations described earlier.

Works are listed alphabetically by authors' last names. The first line of each entry is placed flush against the left margin, with subsequent lines indented five spaces.

```
Author. Title. City of Publication: Publisher,
     year of publication.
Karnow, Stanley. In Our Image: America's Empire in
     the Philippines. New York: Random, 1989.
```

Before providing examples of the various formats for books—with multiple, anonymous, and corporate authors, with editors, in multiple volumes, translations, special series, and editions—and formats for articles in a similarly dizzying array of variations, we explain briefly how to cite sources using the footnote/endnote format.

Sometimes referred to as CMS style (for its source, the *Chicago Manual of Style*), footnote/endnote format features in-text numbered note references linked to endnotes describing works cited, plus a bibliography for full reference details.

Notes

Endnotes are placed together at the end of a paper; footnotes are placed at the bottom (or foot) of individual pages of a paper. Like the MLA in-text parenthetical citations, footnotes and endnotes provide publication information about sources you quote, paraphrase, summarize, or otherwise reference in the text of your paper. Place superscript numbers slightly above the line in your paper. Place the number at the end of a sentence, clause, or phrase containing material you wish to document. Number the citations sequentially throughout your paper. (Do not, that is, begin a new set of numbers on each page on which you have notes.) Each number will correspond to an entry in your footnotes or endnotes. The following is an example:

Text

As Janetta Benton has noted, gargoyles are usually located in "visually inaccessible locations,"[1] peripheral to the medieval cathedral. Benton also speculates that gargoyle sculptors can be compared with medieval manuscript illuminators in their artistic freedom and imaginativeness.[2]

Notes

[1] Janetta Rebold Benton, *The Medieval Menagerie: Animals in the Art of the Middle Ages* (New York: Abbeville, 1992) 57.

[2] Benton 58-59.

Guidelines for Footnotes and Endnotes

- Place endnotes at the end of the paper on a separate page headed "Notes." Double space to the first note entry and between entries. Single space within individual entries.
- Remember to key each superscript number in the text of your paper to a numbered note in your list of endnotes—or to the corresponding footnote at the bottom of the page on which the citation occurs.
- If you use footnotes, place them at the base of the page where the superscript number appears. Single space within individual footnotes but double space between different ones.
- Indent each note five spaces from the left margin. Follow the number with space. Bring subsequent lines of an entry to the margin, indenting only the first line.

Basic Format for Footnotes and Endnotes

For the first reference to a source:

Author's name in normal word order followed by a comma, the title of the source, the publication information in parentheses, and the page numbers. (See the Benton reference on p. 173.)

For the second and subsequent references to a source:

Author's last name and the page number(s) separated only by a space. When you use this short form for multiple citations to more than one work by the same author, include an abbreviated title in the entry.

Example

```
Benton, Menagerie 66.
Benton, Terrors 14.
```

Note the comma between author and short title in each entry.

Here are sample citations for different kinds of sources you may need to note among the documented sources in your paper.

Books

Book with One Author

¹Janetta Rebold Benton, *The Medieval Menagerie: Animals in the Art of the Middle Ages* (New York: Abbeville, 1992) 57.

Book with Two or Three Authors

²Janetta Rebold Benton and Robert DiYanni, *Arts and Culture: An Introduction to the Humanities* (Englewood Cliffs NJ: Prentice Hall, 1998) 256.

Book with More Than Three Authors

³Sheryl Adams et al., *The Humanities for the New Millennium* (London: Faber, 2000) 24.

Book with an Anonymous Author

⁴The World Almanac and Book of Facts (New York: NEA, 1983) 34-35.

Book with an Author and an Editor

⁵George Orwell, Orwell: *The War Commentaries*, ed. W.J. West (New York: Pantheon, 1985) 210.

Book with an Editor

⁶Robert DiYanni, ed. *Modern American Poets: Their Voices and Visions*, 2nd ed. (New York: 1993) 12.

Selection from an Anthology

⁷Robert Hollander, "Dante's Authority," *Lectura Dantis: Inferno*, ed. Allen Mandelbaum, Anthony Oldcorn, and Charles Ross (Berkeley: U of California P, 1998) 33.

Multivolume Work

⁸Joseph Blotner, *Faulkner: A Biography*, vol. 1 (New York: Random, 1987) 257.

Periodicals
Article in a Journal Paginated by Volume

⁹Adelia Williams, "Jean Tardieu: The Painterly Poem," *Foreign Language Studies* 18 (1991): 119

Article in a Journal Paginated by Issue

¹⁰Daniel Bender, "Diversity Revisited, or Composition's Alien History," *Rhetoric Review* 12.1 (1987): 115.

Review

¹¹Edward Rothstein, "Blood and Thunder from the Young Verdi," rev. of *I Lombardi*, Metropolitan Opera House, New York. *New York Times* 4 Dec. 1993: C11.

Bibliography and Works Cited List

If you use a footnote or endnote format, you will list your sources at the very end of your paper (following your text and endnotes if you have those) on a separate sheet headed "Bibliography." Alphabetize your sources according to the last name of the author. Blend all sources in a single alphabetical listing, regardless of whether they are books or periodical articles from journals.

If you use the MLA in-text citation format for your notes, list your sources at the end of the paper and head the page "Works Cited." Alphabetize and blend as described above.

In both Bibliography and Works Cited lists, double space between the title and the first entry. Single space within each entry, but double space between different entries.

Begin each entry flush with the left margin, but indent all subsequent lines of the five character spaces. Sample entries for books, periodicals, and other sources, including electronic sources, follow.

Books

Book with a Single Author

Benton, Janetta Rebold. *The Medieval Menagerie: Animals in the Art of the Middle Ages*. New York: Abbeville, 1992.

Book with Two or Three Authors

Benton, Janetta Rebold and Robert DiYanni. *Arts and Culture: An Introduction to the Humanities*. Englewood Cliffs, NJ: Prentice Hall, 1998.

Book with More Than Three Authors

Adams, Sheryl, et al. *The Humanities for the New Millennium*. London: Faber, 2000.

Book with an Anonymous Author

The World Almanac and Book of Facts. New York: NEA, 1983.

Book with an Author and an Editor

Orwell, George. *Orwell: The War Commentaries*. Ed. W. J. West. New York: Pantheon, 1985.

Book with an Editor

Foner, Eric and John A. Garraty, eds. *A Reader's Companion to American History*. Boston: Houghton, 1991.

Selection from an Anthology

Hollander, Robert. "Dante's Authority." *Lectura
 Dantis: Inferno*. Ed. Allen Mandelbaum,
 Anthony Oldcorn, and Charles Ross. Berkeley:
 U of California P, 1998. 25-35.

Multivolume Book

Malone, Dumas. *Jefferson and His Time*. 6 vols.
 Boston: Little, 1943-77.

Translation

Wilhelm, Richard. *Confucius and Confucianism*.
 Trans. George H. Danton and Annina Periam
 Danton. New York: Harcourt, 1931.

Revised Edition

Holloway, Mark. *Heavens on Earth: Utopian Communi-
 ties in America, 1660-1880*. 2nd ed. New York:
 Dover, 1966.

Article in a Reference Book

"Cochise." *Encyclopedia of Indians of the Ameri-
 cans*. St. Clair Shores, MI: Scholarly, 1974.

Periodicals

Article in a Journal Paginated by Volume

Williams, Adelia. "Jean Tardieu: The Painterly Poem."
 Foreign Language Studies 18 (1991): 114-125.

Article in a Journal Paginated by Issue

Bender, Daniel. "Diversity Revisited, or Composi-
 tion's Alien History." *Rhetoric Review* 12.1
 (1987): 108-124.

Review

Rothstein, Edward. "Blood and Thunder from the
 Young Verdi." Rev. of *I Lombardi*. Metropoli-
 tan Opera House, New York. *New York Times* 4
 Dec. 1993: C11.

Other Sources

Interview

Salter, James. "James Salter: The Art of Fiction
 XCCCIII." Interview. *Paris Review* 127 (1993):
 54-100.
Selzer, Richard. Telephone interview. 7 Jan. 1992.

A Published Letter

Keats, John. "To Benjamin Bailey." 22 Nov. 1817.
 Letter 31 of *The Letters of John Keats*. Ed.
 Maurice Buxton Forman. 4th ed. London: Oxford
 UP, 1952. 66-69.

Unpublished Dissertation

Martin, Rebecca E. "The Spectacle of Suffering: Rep-
 etition and Closure in the Eighteenth-Century
 Gothic Novel." Diss. CUNY, 1994.

Published Dissertation

Kauta, John B. *Analysis and Assessment of the Con-
 cept of Revelation in Karl Rahner's Theology:
 Its Application and Relationship to African
 Traditional Religions*. Diss. Fordham U, 1992.
 Ann Arbor: UMI, 1993. 9300240.

Dissertation Abstract

Jenkins, Douglas Joseph. "Soldier Theatricals:
 1940-1945." Diss. Bowling Green State U. *DAI*
 53 (1993): 4133A.

Performance

In the Summer House. By Jane Bowles. Dir. JoAnne
 Akalaitis. Perf. Dianne Wiest, Alina Arenal,
 and Jaime Tirelli. Vivian Beaumont Theatre,
 New York. 1 Aug. 1993.
Slatkin, Leonard, cond. St. Louis Symphony Orches-
 tra. Concert. Carnegie Hall, New York. 23
 Oct. 1994.

Musical Composition

Beethoven, Ludwig van. Symphony no. 5 in C minor, op. 67.

Mozart, Wolfgang Amadeus. *Don Giovanni*.

Work of Art

Bernini, Gianlorenzo. *Apollo and Daphne*. Galleria Borghese, Rome.

Moses, Grandma. *The Barn Dance*. Hammer Galleries, New York. *Grandma Moses*. By Otto Kallir. New York: Abrams, 1973. Illustration 940.

Film

The Age of Innocence. Dir. Martin Scorsese. Prod. Barbara DeFina. Perf. Daniel Day-Lewis, Michelle Pfeiffer, and Winona Ryder. Columbia, 1993.

Scorsese, Martin, dir. *The Age of Innocence*. Prod. Barbara DeFina. Perf. Daniel Day-Lewis, Michelle Pfeiffer, and Winona Ryder. Columbia, 1993.

Television or Radio Program

48 Hours: State of Fear. Narr. Dan Rather. CBS. WHDH, Boston. 8 Dec. 1993.

Chantilly Lace. Dir. Linda Yellen. Prod. Steven Hewitt. Perf. Lindsay Crouse, Jill Eikenberry, and Martha Plimpton. Showtime. New York. 18 July 1993.

Friedson, Michael, and Felice Friedson. *Jewish Horizons*. WWNN-AM, Fort Lauderdale. 19 Sept. 1993.

Recording

Bartoli, Cecilia. *The Impatient Lover: Italian Songs by Beethoven, Schubert, Haydn, and Mozart*. Compact disc. London, 440 297-2, 1993.

Gaines, Ernest. *A Gathering of Old Men*. American Audio Prose Library, 6051, 1986.

Videotape or Videocassette

The Dakota Conflict. Narr. Garrison Keillor.
 Videocassette. Filmic Archives, 1992.

Map or Chart

France. Map. Chicago: Rand, 1988.

Cartoon

Trudeau, Garry. "Doonesbury." Cartoon. *Boston
 Globe* 19 Sept. 1994: 23.

Electronic Sources

Formats for citations of electronic sources, especially Internet
sources, remain variable. Consult recent guides, such as the *MLA Hand-
book for Writers of Research Papers*, for updates on appropriate formats.
You can use the following samples, however, to guide you in formatting
electronic source citations.

CD, Tape, or Diskette Produced as a Single Publication

DeLorme Mapping. "Vestfirdhir [Iceland]." *Global
 Explorer*. CD-ROM. Freeport, ME: DeLorme, 1993.

CD, Tape, or Diskette Updated Periodically

Lacayo, Richard. "This Land Is Whose Land?" *Time*
 23 Oct. 1995: 68-71. *Academic ASAP*. CD-ROM.
 Infotrac. Dec. 1995.

Online Sources

Shimabakuto, Jim, ed. "Internet in 10 Years—Essays."
 Electronic Journal on Virtual Culture 3.1
 (1995) : 62 pars. Online. BITNET. 20 Oct. 1996.

APPENDIX I

Writing Essay Examinations

Certainly the most common form of writing you will do, perhaps as frequently as you write essays, papers, and reports, is writing essay examinations, often in class. Writing strong essay examination answers is essential for success in many college humanities courses. Answering essay exam questions poses a challenge because you are often writing under the pressure of time. By following a few guidelines, you can improve your chances of doing well when you write essay exams.

- Be sure you understand the question. Make certain that you know what is expected of you. If you are unsure about a question, ask the instructor to clarify the test.
- Budget your time so you can answer all essay questions. Essay questions typically count heavily in an exam. Leaving out an entire question can seriously compromise your grade.
- Think before writing your essay answer. This may be difficult, because your tendency may be to begin writing immediately. But even in two or three minutes of silent thought, as you jot a few quick notes, your mind begins calling up evidence and ideas, and you can begin selecting key points and organizing them.
- Provide specific details and examples to support your general assertions. This is critical. Essay answers that omit specific references or concrete examples often reveal a lack of depth and persuasiveness. On the other hand, essay responses that contain only specific information may reveal a lack of understanding of connections and relationships among ideas and

evidence. You need both facts and explanations—specific details in support of the ideas they explain and illustrate.

- Avoid padding your answer with irrelevant details. Instructors do not reward off-topic responses. Nor are they pleased by answers padded with unnecessary repetition. Include in your response only those details—facts, statistics, examples—that are relevant to the question.
- Write legibly, and proofread your answers. Avoid the temptation to write so fast that your writing becomes illegible. Check your paper for errors of spelling, punctuation, grammar, mechanics, and usage. Error-ridden answers can be distracting to readers. They also reveal a lack of control on the part of the writer.

These guidelines must be seen in relation to how much time you have to write each essay question. If you are unsure of how much time is allotted for essay questions, ask your instructor. To understand the nature of the task prompted by the question, study its wording carefully.

PREPARING FOR AN EXAM

You begin preparing for an exam long before you study specifically for it a day or a week before. Your real exam preparation occurs in the classwork and homework you do throughout the course. Effective exam preparation includes careful note taking during class and during assigned reading. In reviewing your notes for an essay exam, be alert for patterns and connections among facts, examples, concepts, and theories as explained in lectures and readings. Essay exams will often require you to synthesize information and to explain relationships among important events and critical ideas. They may also ask you to evaluate ideas and events.

Review and study the course material carefully. You may wish to form a study group with a few other students. Study groups allow you to compare your notes with those of other students to assess your understanding of concepts and the relationships among ideas. Study groups also give you a chance to create sample questions and to test each other. This kind of practice not only helps prepare you for the types of questions that may appear on the exam, but it also may help to reduce your anxiety in taking the actual examination.

The most important kind of preparation you can do for any type of essay examination is to find ways to relate and connect the information, examples, and concepts you have learned. You need ways to fit the various parts and pieces together. For example, in learning

about the id in a psychology class, be sure you understand its relationship to the ego and superego. In learning about the social causes of the Russian Revolution, consider the importance of economic and political contexts as well. In studying the Russian Revolution in a course on modern revolutions, relate its various causes to the causes of other early twentieth-century revolutions such as the Mexican Revolution. Make connections and identify relationships as much as you can during every phase of preparing for an exam.

EXERCISE

Look back over notes for one of your current courses. In the left margin use a different color ink to make connections with facts, information, and concepts on different pages by cross-referencing them.

REVIEWING THE QUESTIONS

Read the questions carefully—two or three times, if possible. Avoid jumping immediately to a conclusion about what the instructor is asking. Look carefully at the wording of each question. Does it ask you to "discuss," "define," "compare," "evaluate"? Perhaps it asks you to "define and analyze," "compare and contrast," "identify and explain." Be sure that you understand precisely what the question requires you to do. If you are unsure, ask.

Many college exam questions ask for analysis and interpretation. For such questions you are expected not merely to give back information, but to use information to make a general analytical or interpretive point—to explain, that is, the significance of information. For example, you can expect not merely to summarize the plot of a novel but to analyze its structural relationships; that is, how its parts or sections develop and fit together.

Here are some examples of common terms used in essay exams and the kinds of questions in which they often appear.

Identify means "to name, indicate, or specify." Some essay exams include "identify" as part of a question that asks you to "identify and explain" or "identify and discuss."

Example

Identify and explain the significance of the following quotation: "If a man does not keep pace with his companions, perhaps it is because he hears the sound of a different drummer. Let him step to the music which he hears, however measured or far away."

Explain means "to give reasons for, to relate causes and effects, to identify a process." Explanations can be simple or complex, brief or elaborate. The time limit for an essay response requiring explanation will determine how fully developed your explanation can be.

Example

Explain why Georg Friedrich Handel began writing oratorios and stopped writing operas. Explain also the difference between an opera and an oratorio.

Discuss means "to write about." This generalized instruction seems more general than other exam instructions. Often, however, "discuss" is used to mean "identify and explain."

Example

Discuss the structure and function of sonata form.

For this topic, you would be expected to identify the elements of sonata form and to explain how composers used sonata form in their symphonies, sonatas, and concertos.

Define means "to provide a definition, to point out characteristic features, to identify limits, or to put something into a category or class." Definitions can be brief or extended. An essay question that asks you to define a term or a concept may also require you to explain, exemplify, characterize, or further discuss various aspects or element of your definition.

Example

Define the concept of affirmative action. Discuss the historical roots of the concept, and consider the social and cultural issues and forces that have led to its emergence as a contemporary problem.

Compare means "to consider similarities and differences between two things." More precisely, the word *compare* invites consideration of similarities and the word *contrast*, differences. But often *compare* is used to mean "identify and explain similarities and differences between X and Y."

Example

Compare Michelangelo's sculpture of David with Bernini's.

Analyze means "to break into parts." You identify the individual components of a painting, for example, the better to understand each

element and the better to understand the relationship of the parts or elements to the work as a whole.

Example

Analyze Velazquez's *Las Meninas*. Be sure to consider the elements of space and light the painter has created in this work, as well as his positioning of figures.

Evaluate means "to assess or make a judgment about." You may be asked to evaluate the claims made by competing theories, such as creationism and evolution as explanations of the origins of human life. You may be asked to evaluate the persuasiveness of an idea or argument. Sometimes evaluation may involve comparison and contrast.

Example

Evaluate the performance of Mel Gibson in the role of Hamlet.

(Here, for example, you might compare Gibson's performance in this role with that of other actors such as Lawrence Olivier or Kenneth Branagh—if you saw their film versions of *Hamlet*. Or you might compare Gibson's performance in the role of Hamlet with his performance of a major role in another of his films.)

WRITING YOUR ANSWER

Once you have read and understood the question, take a few minutes to think before you begin writing your answer. Consider what you want to say and how you might use your knowledge to support an idea you have. Collect your thoughts, recall information, and begin to sort and relate facts and ideas.

Taking account of the time allotted for the question, plan on developing an answer accordingly. For a sixty-minute exam with three essay questions, unless otherwise stipulated, allot twenty minutes to each.

Begin with some preliminary writing, jotting a few rough notes. You can arrange your notes, after you think of a number of details, examples, and ideas, simply by numbering them before you write your essay response. The act of putting pen to paper will help you think of what to write—as long as you are well prepared. You will discover additional connections as you write, but even before beginning, you should have a general idea of how to start and conclude, with a few points to cover in between. Making a rough preliminary outline of where you are heading in your answer and how to get there will decrease the chances that you will forget something important.

It is very important to make your thesis, the central point of your essay, clear from the start. Because essay exam questions have strict time constraints, make sure to get your major point across clearly and quickly.

As you write, be sure to respond directly to the question. Avoid vagueness and bland generalizations that say very little. Also avoid trying to throw everything you can think of into your answer, in the hopes that a scattershot approach will score at least a partial hit. Instead, tackle the question head on.

Example

Discuss the political factors that led up to the French Revolution.

This question requires an answer that addresses political factors only—not military, economic, or social ones (unless, of course, you can show how those other kinds of factors directly relate to the political issues the question asks about).

On the other hand, you should not answer a broad question too narrowly. Respond to a question that asks for a discussion of the central tenets of European Romanticism by including references to more than a single country and a single artistic area. Don't limit yourself, for example, to discussing only Romantic music in Austria or Romantic poetry in England.

ADDITIONAL ADVICE

Because you will have time for only a single draft in writing essay exams, it is important to stay focused on the question, to include the most important ideas and kinds of evidence, and to conclude your answer by reiterating a key point or explaining an important or interesting ramification of it.

Be sure to reserve some time to review your answer. Try to allow for even a few minutes for reviewing your writing. In your review you may discover that you overlooked a telling detail, a significant issue, or a critical fact. Or you may realize that you omitted a word or phrase where the omission makes your sentence unintelligible. By leaving out a word like *not*, you may actually suggest the opposite of what you intend.

When you run short of time in an essay exam, map out the direction your essay would take if you had the time to complete it. Provide an outline that shows your instructor what you intended to discuss. Depending on how specific you can make the outline and on how accurate and thorough your answer has been up to that point, you are

more likely to be given the benefit of the doubt and score higher than if you were simply to stop midway through.

The following guidelines summarize key strategies for writing essay examinations.

- Prepare yourself for the exam well in advance.
- Read and analyze the question carefully.
- Think before writing.
- Make some notes and a scratch outline to start.
- Identify your central idea or thesis early on.
- Respond directly to the demands of the question.
- Review and check your answer.

EXERCISE

Analyze the following questions:

1. Explain Darwin's theory of evolution by natural selection. In your answer include specific examples of species that Darwin and other scientists observed to lead them to their evolutionist conclusions.
2. Analyze the logic of organization of Dante's Hell (Inferno). Consider the principle of symbolic retribution, and supply examples to illustrate your remarks.
3. Explain the change in Hamlet's behavior that emerges from the beginning to the end of the play. Explain what prompts Hamlet's change of mind/attitude/behavior, and consider its significance.
4. Discuss the way nature is depicted and characterized in two of the following:

 a. Chinese landscape painter

 b. Japanese gardens

 c. European or American painter of the nineteenth century

 d. European or American poet of the nineteenth or twentieth century

5. Compare and contrast the Renaissance painting styles prevalent in Holland and Italy.
6. Define the term *Impressionism*. Identify its most notable practitioners in two different fields of the arts. Explain how their work fits the definition of Impressionism you provide.

Appendix II

Making Oral Presentations

In many college courses you will be required to make oral presentations. Everything you have learned about writing from this book and from other sources can be applied to preparing your oral presentations. For example, follow the advice given in Chapters 1 and 2 about analyzing your topic, considering your audience, choosing your tone, and selecting appropriate details to support your ideas or thesis.

Attend as well to the organization of your presentation, using your beginning to grab the attention of your audience and ending it with something you want them to remember. Use the middle of your presentation to explain, illustrate, support, and otherwise develop your ideas.

When you speak before a group, however, there are other considerations. The following are among the most important:

- Reducing nervousness
- Speaking from notes or from a prepared text
- Maintaining posture and using gestures
- Using a rostrum, lectern, or desk
- Using visuals and props
- Making team presentations

REDUCING NERVOUSNESS

To some degree, most people become nervous when they speak in public. This is partly the result of the greater formality of the "oral presentation." To reduce this nervousness, think of your audience as

interested listeners in an extended conversation. You talk first; their turn comes later. To increase a conversational feeling into your presentation, insert a few questions into your text, even if you do not actually expect your audience to answer them. And leave time for questions and answers at the end of your talk.

Other strategies for staying calm include taking a few deep breaths before beginning, speaking a bit more slowly than usual, and focusing on one or two friendly faces in the audience. Among the most important ways to reduce nervousness is to be completely prepared—to know your presentation inside and out.

USING NOTES OR A PREPARED TEXT

You may be required to speak with or without notes, with or without a fully prepared text. Or you may be given a choice. When you use notes, it is easiest to read them from index cards arranged in sequence. Write outlines or brief key phrases on the cards, and write larger than usual.

If you work from a script or a written text, make a relatively narrow column with wide margins, and mark your text for emphasis. Type with triple spacing for greater ease in reading. **Boldface** key words. Use caps for EMPHASIS. Underline words you want to <u>stress</u>. You can also add reminders, for example, to S L O W down or — PAUSE—at strategic places.

End each page of your text with a sentence to give yourself time to turn or shift a page. Finally, keep note cards in your hands, placing completed cards at the bottom of the stack. Do the same with pages you have completed reading.

BODY LANGUAGE: POSTURE AND GESTURE

When you stand (or sit) before your audience, do so with your head up and shoulders back. Stand tall and erect. Don't be afraid to smile, and be sure to look at your audience. Many speakers have a tendency to look only at one member of the audience or toward one side of a room. Be sure to shift your gaze to different members of the audience, looking to both sides as well as to the front and back.

To what extent you use hand gestures will depend in part on the kind of talk you are giving. A persuasive speech, for example, may benefit from more emphatic gestures than you might use in an informative speech. Your use of gesture will also depend on your general tendency to use your hands when you talk. People who gesture a lot in normal conversation may wish to temper this tendency in oral presentations.

Conversely, those who gesture little in ordinary speaking situations may wish to increase their use of gesture when speaking in public.

USING A ROSTRUM OR LECTERN

Some oral presentations are given from behind a lectern or rostrum. In others the presenter must stand with no place to lean against, hide behind, or place notes or a prepared text. Be sure you know whether you will or will not have this kind of physical support for yourself and your notes.

Knowing the physical circumstances of your presentation can help you decide how to prepare your notes or text. It might also affect decisions about how you dress for the presentation. Will your feet or legs be showing? Will your head and shoulders be emphasized, for example, in standing behind a lectern?

If you use a lectern or rostrum, you may wish to or need to step out from behind it during the course of your presentation. You might do this to emphasize a point, to use a visual display, or perhaps to establish a closer intimacy with your audience.

USING VISUALS

You may be required to use visuals in an oral presentation, or you may opt to do so. Visuals can enhance a presentation. They can also separate a speaker from his or her audience, with disastrous results.

In preparing visuals for a presentation, make sure they are large enough for your audience to see easily. What is readily viewable by you at close range will not be seen at all by a person thirty or forty feet away. Also, be sure that your visuals are clearly written, legible, and not overly cluttered. As with notes you make for yourself, keep the information on your slides to the key points. You can elaborate with details either from your notes or from memory.

In using an overhead projector, be careful that you are not in the line of vision of any members of your audience. In using a chart, diagram, or blackboard with images behind you, be careful not to turn your back repeatedly to your audience. Instead, stand to the side of your visual display so your audience can see you and it at the same time. Use a pointer or finger to highlight key words or visual details.

Making Team Presentations

More and more often in classes and in the business world, team presentations are common. If you are part of a team making an oral presentation, be sure to meet with the other team members to discuss

your individual roles and responsibilities. Make sure you understand what is expected of you, and be sure that you know what is expected from each of the other members, including the kinds of sources, materials, visuals, and handouts each will be preparing. Devise your part of the presentation to complement rather than duplicate those of your team presenters.

CREDITS

Chapter 2

p. 23: "The Starry Night" from *All My Pretty Ones* by Anne Sexton. Copyright © 1962 by Anne Sexton, renewed 1990 by Linda G. Sexton. Reprinted by permission of Houghton Mifflin Company. All rights reserved.

p. 31: "The Erl-King" by Franz Schubert from *The Penguin Book of Lieder,* pp. 34–35, 32 lines, edited and translated by Edward Connery Lathem. Copyright © 1964 by S.S. Prawer. Reproduced by permission of Penguin Putnam, Inc.

Chapter 3

p. 61: Joan Breton Connelly, "Let's Look to Ancient Forms for a Memorial Wall." *Wall Street Journal,* Oct/Nov 2002. Reprinted by permission.

Chapter 4

p. 70: From "As the Spirit Moves Mahalia," from *Shadow and Act* by Ralph Ellison. Copyright © 1995 by Ralph Ellison. Used by permission of Vintage Books, a division of Random House, Inc.

p. 73: Anthony Tommasini, "Voigt's *Aida* is Assured." *TheNew York Times,* January 18th, 2003. © 2003 *The New York Times.* Reprinted by permission.

p. 74: Ben Ratliff, "Keith Richards Keeps the Stones Rolling." *The New York Times,* January 18th, 2003. © 2003 *The New York Times.* Reprinted by permission.

Chapter 5

Chapter 6

Chapter 7

INDEX